Coach Houses
of Toronto

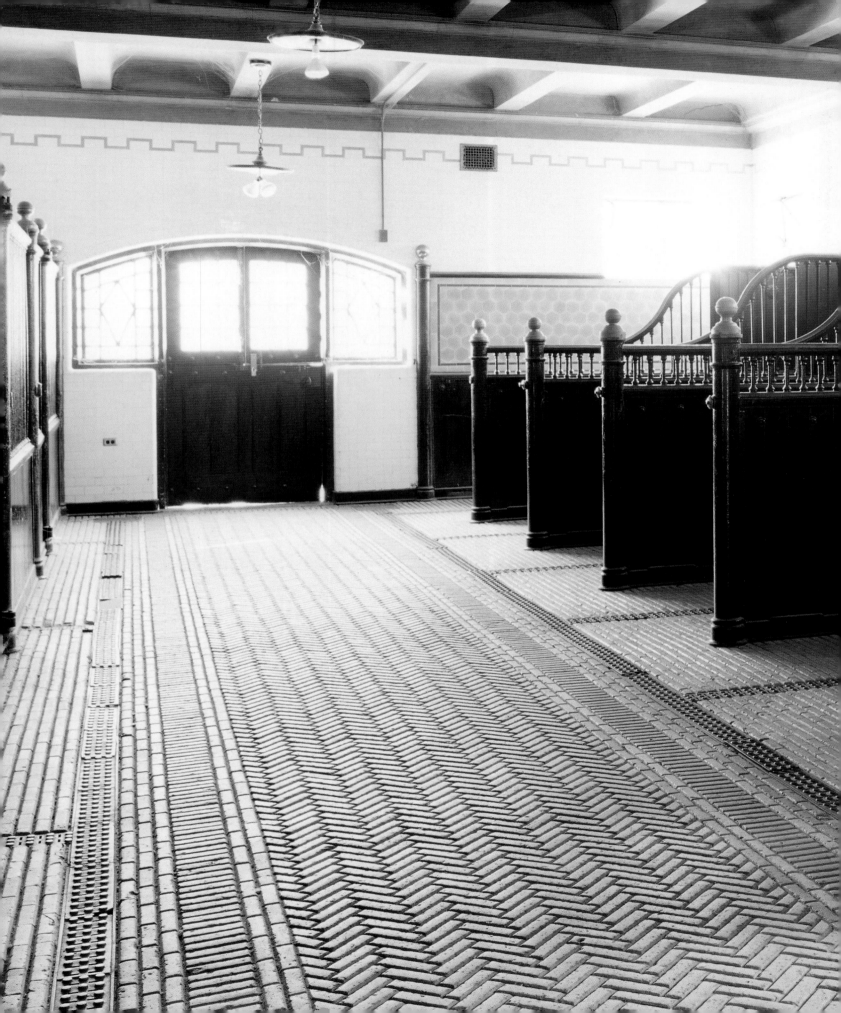

Coach Houses of Toronto

Margo Salnek
Photography by Donna Griffith

The BOSTON
MILLS PRESS

Dedicated to Brian

A Boston Mills Press Book

First printing

In Canada:
Distributed by Firefly Books Ltd.
66 Leek Crescent
Richmond Hill, Ontario, Canada L4B 1H1

In the United States:
Distributed by Firefly Books (U.S.) Inc.
P.O. Box 1338, Ellicott Station
Buffalo, New York 14205

Published by Boston Mills Press, 2005
132 Main Street, Erin, Ontario N0B 1T0
Tel: 519-833-2407 Fax: 519-833-2195
e-mail: books@bostonmillspress.com
www.bostonmillspress.com

The publisher gratefully acknowledges the financial
support for our publishing program by the Canada
Council for the Arts, the Ontario Arts Council and
the Government of Canada through the Book
Publishing Industry Development Program.

Printed in Singapore

**Library and Archives Canada Cataloguing
in Publication**

Salnek, Margo

Coach houses of Toronto / Margo Salnek ;
photography by Donna Griffith.

Includes index.

ISBN 1-55046-427-2

1. Small houses—Ontario—Toronto—Pictorial works.
I. Griffith, Donna II. Title.

NA8340.S34 2005 728'.9 C2005-901535-7

Publisher Cataloging-in-Publication Data (U.S.)

Salnek, Margo.
 Coach houses of Toronto / Margo Salnek ;
photography by Donna Griffith. —1st ed.
[160] p. : col. photos. ; cm. Includes index.

Summary: A pictorial tour of twenty-two of Toronto's
most attractive 19th-century coach house homes,
formerly home to horses and carriages or fine
motorcars, some lovingly preserved, others carefully
restored, and most extensively renovated. A blend of
architectural history and decorating style ideas.

ISBN 1-55046-427-2

1. Small houses—Ontario—Toronto—Pictorial works.
I. Griffith, Donna. II. Title

728.9 dc22 NA8340.S35 2005

Design by Alice Unger
and by PageWave Graphics Inc.

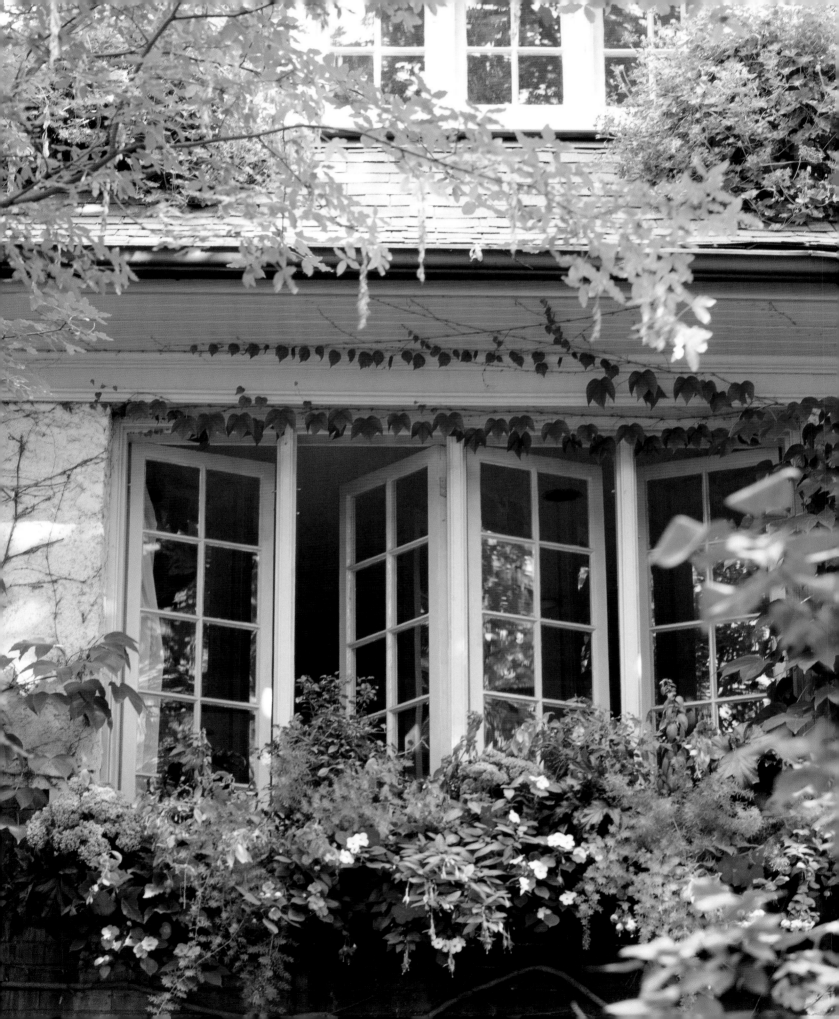

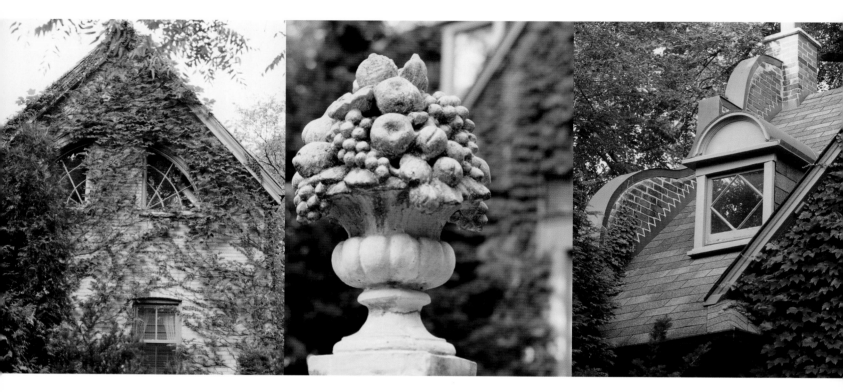

Contents

A Secret World

Hidden behind and beside magnificent historic houses in old, established enclaves in the city of Toronto is a world few people know exists. It is the secret world of the coach house.

A coach house was a building originally constructed to house the family's carriage and pair. Often the groomsman and his family lived above the horses, on the upper floor. These charming buildings architecturally mirrored the parent house, and were not usually noticeable from the main entrance. The distinguishing mark of an authentic coach house is the cupola on the roof. The cupola was built originally as an air vent for the hayloft of the building.

With the invention of the horseless carriage in the early 20th century, these beautiful buildings usually became grand garages. The groom's quarters above served to store family memorabilia and collectibles and, during the Great Depression, provided extra living space.

Many of the city's grander pre First World War garages, built at a time when a motorcar was a novel luxury reserved for the wealthy, and the design of the garage was as important as that of the house, are also known as coach houses. Their upper floors might have housed the chauffeur and his family.

After the Second World War, however, as suburban living became the lifestyle of choice, many of the beautiful homes of the 19th and early 20th centuries were converted into rooming houses, leaving the coach house to fall into disrepair.

In the 1960s, artists and students in search of cheap rent began to inhabit the groom's quarters. It wasn't long before these unusual and charming buildings were sought out by local architects and designers, who began to restore and renovate the interiors into offices, studios and residences. Because so many of the century coach houses had been torn down or renovated to the extent that they were no longer recognizable, the Toronto Historical Board acted to protect the façade and integrity of these beautiful century-old buildings.

Today, coach houses are home to movie stars, designers, architects, artists, authors, business executives, clergy, and people who love to live in unusual urban spaces. I am one of those lucky people. It was a brisk afternoon in late October when I parked my car on a busy side street in the heart of downtown Toronto. Hidden behind a vintage iron gate and a massive oak tree ablaze with fall colours stood a vine-covered structure, barely noticeable from the street. The real estate agent opened the gate and introduced me to the secret world of the coach house, and within forty-eight hours my husband and I were the new owners.

Our coach house is reminiscent of the mystical English cottage, complete with climbing vines, lush gardens and intimate interior spaces. It is rich with the history of our ancestors. Best of all, it is tucked away beside a magnificent historical home in the centre of Toronto, a soothing retreat from the busyness of the city.

Whether you live in your own coach house, dream of owning one, or simply wish to find inspiration for your own home in these pages, I hope you will enjoy this collection of beautiful exteriors, interiors and gardens that our team has lovingly put together.

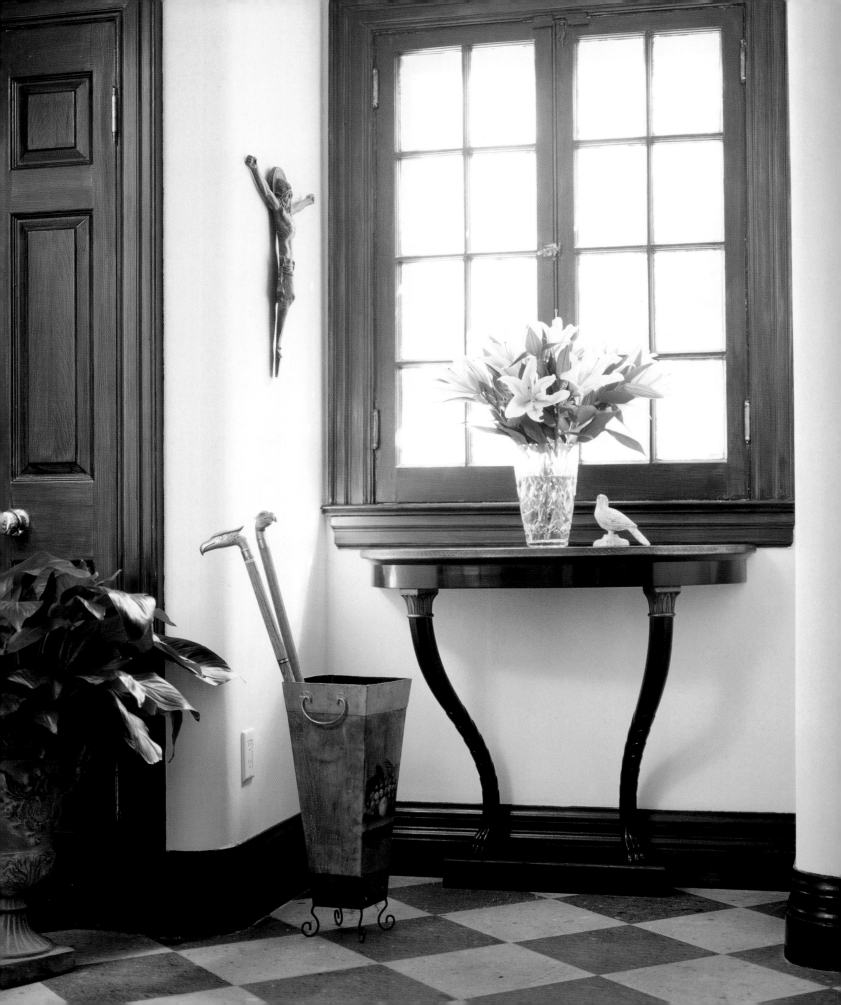

The English Cottage

Located in the Annex, this beautiful English Cottage style coach house, a perfect mirror of the main house, is unusual in that it sits alongside the main house rather than behind it. Built in 1905 for one of Toronto's most affluent retail families, it has a simple design not typical of the massive arches, soaring turrets and large verandahs that were popular at the time. The family commissioned renowned architect Eden Smith, who, inspired by his native England and by the tenets of the Arts and Crafts movement, designed turn-of-the-century houses evocative of 16th-century English residential architecture. In the early 1980s the coach house was severed from the main house and a massive interior renovation was begun. The goal of the renovation was to maintain the English Cottage feel throughout the interior while preserving the original staircase, windows and fireplace. This was done by opening up ceilings, adding windows and creating intimate romantic spaces. The result is a delightful urban residence complete with climbing vines, lush gardens, floral fabrics and a sense of history.

The original hand-cut stone floor and entrance casement window are still beautiful and practical even after a hundred years. A crystal vase of lilies looks lovely set on a simple black-and-gold art deco table. The crucifix, circa 1800, was once part of a gravestone in the French countryside.

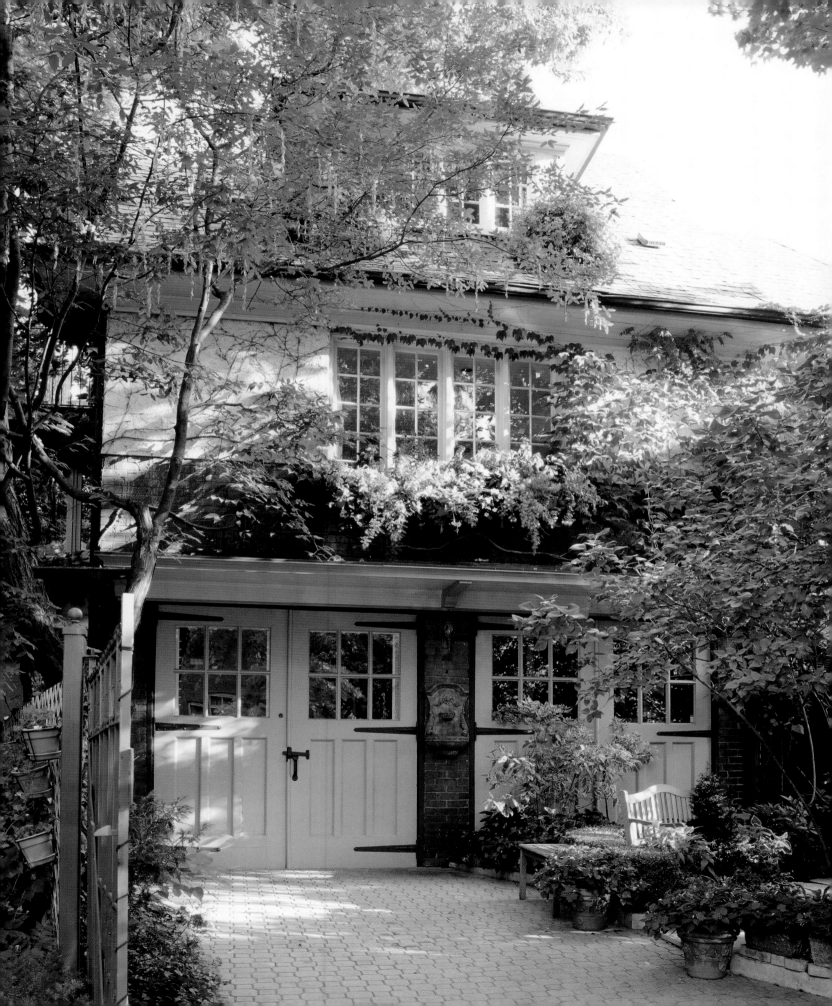

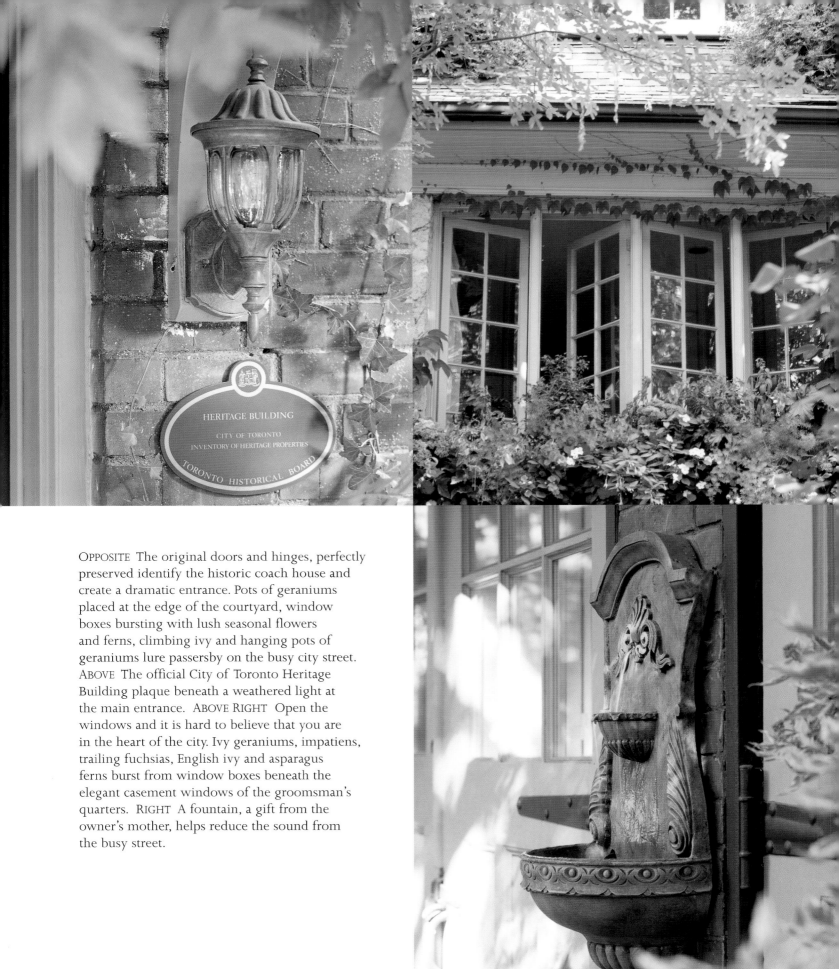

OPPOSITE The original doors and hinges, perfectly preserved identify the historic coach house and create a dramatic entrance. Pots of geraniums placed at the edge of the courtyard, window boxes bursting with lush seasonal flowers and ferns, climbing ivy and hanging pots of geraniums lure passersby on the busy city street. ABOVE The official City of Toronto Heritage Building plaque beneath a weathered light at the main entrance. ABOVE RIGHT Open the windows and it is hard to believe that you are in the heart of the city. Ivy geraniums, impatiens, trailing fuchsias, English ivy and asparagus ferns burst from window boxes beneath the elegant casement windows of the groomsman's quarters. RIGHT A fountain, a gift from the owner's mother, helps reduce the sound from the busy street.

HERITAGE BUILDING

CITY OF TORONTO
INVENTORY OF HERITAGE PROPERTIES

TORONTO HISTORICAL BOARD

BELOW The cozy sitting room, just beyond the main entrance. A multi-paned window was added to give light to the sitting room. The panes were faux finished to match the original tin trim of the fireplace. Slipcovered antique chairs create an understated casual feeling. The Queen Anne chair, bought on a Saturday morning outing to a local antique market, is covered in lush leather. On the windowsill, the owner proudly displays gold-framed watercolours painted by her eighty-seven-year-old mother. OPPOSITE A gentleman's chest, perfectly positioned between chairs in the sitting room, displays favourite family photos and a faux silver terra cotta pot of hydrangeas. A gilt-edged mirror, a Saturday morning garage-sale find, reflects the chandelier and mirror above the fireplace.

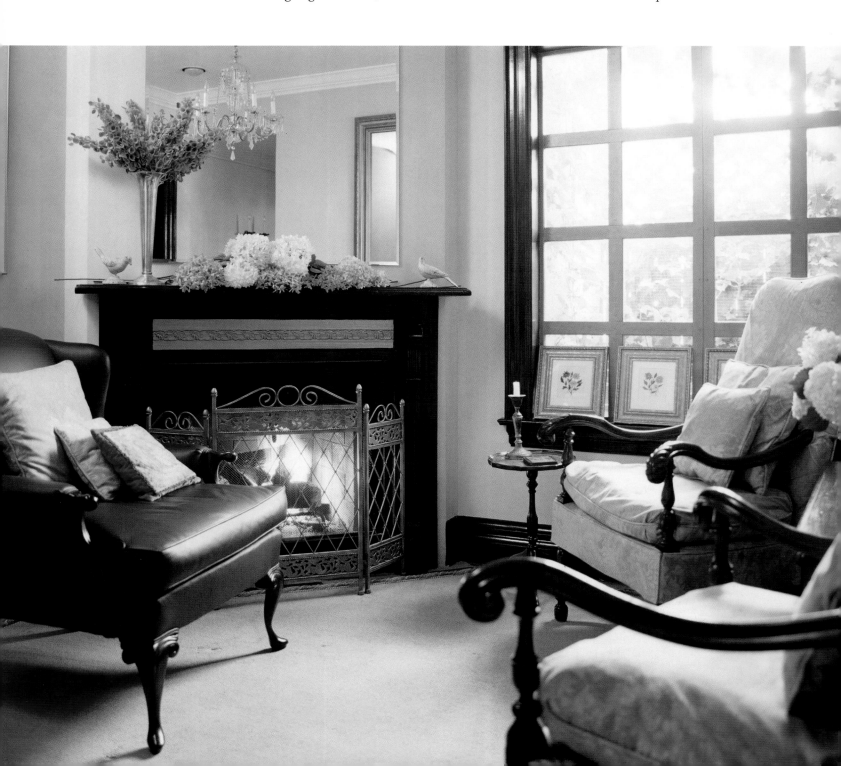

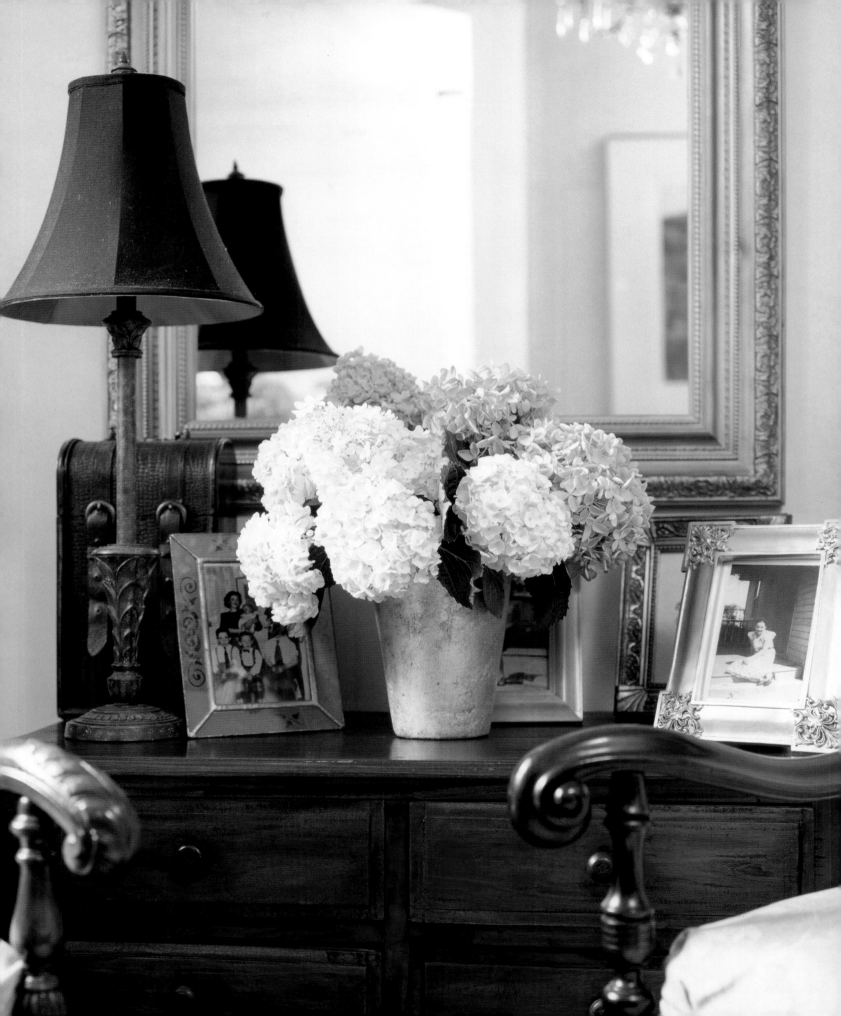

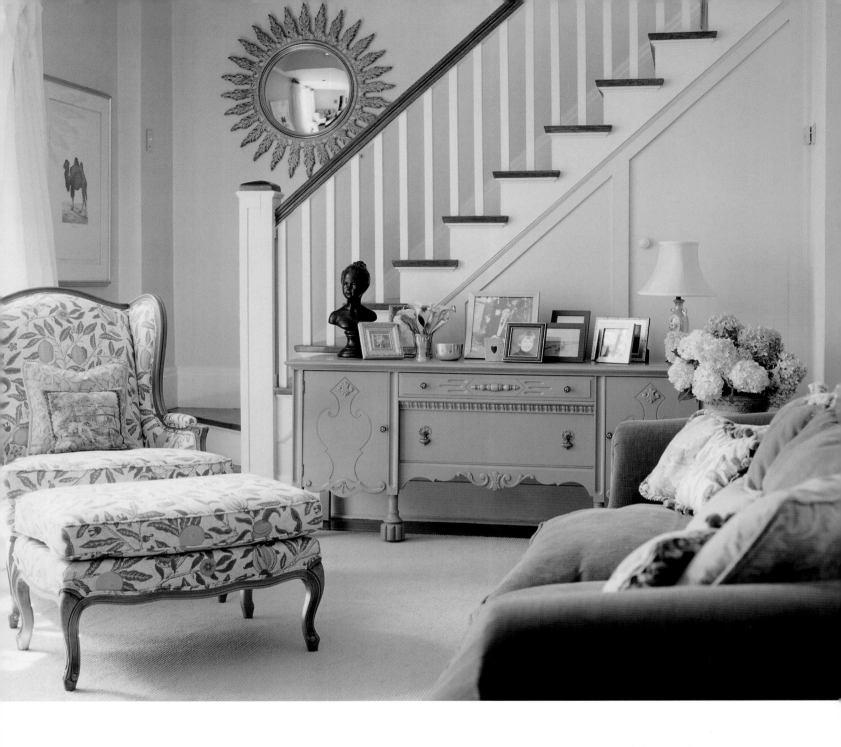

ABOVE In keeping with the English Cottage style of the coach house, the owner carefully chose beautiful classic English fabrics for her living room. The antique sideboard, hand-painted by a local artist to complement the beautiful fabrics, holds a generous display of family photos and memorabilia. A vintage sunburst mirror once belonging to the owner's mother hangs on the staircase wall. She was a great fan of the 1950s *Donna Reed Show* and purchased a mirror just like the one in Donna's living room. OPPOSITE Afternoon sun pours through the magnificent open windows into the living room. Wispy translucent curtains add romance and privacy, shielding the room from the busy street below.

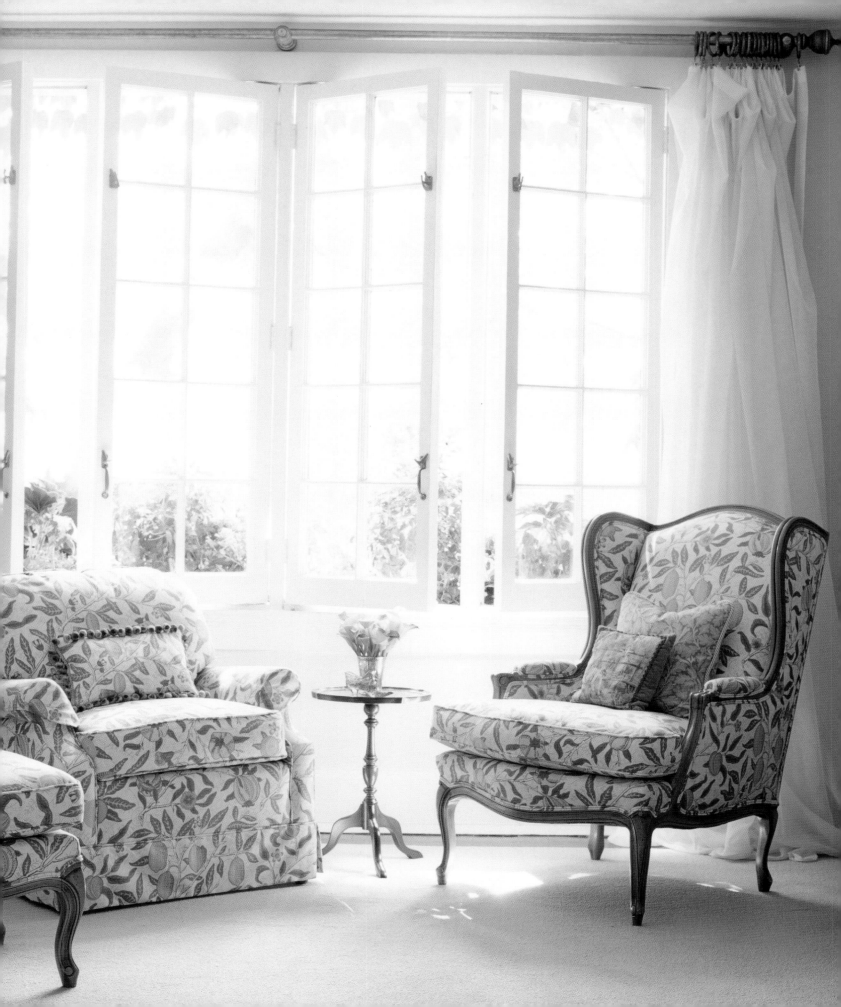

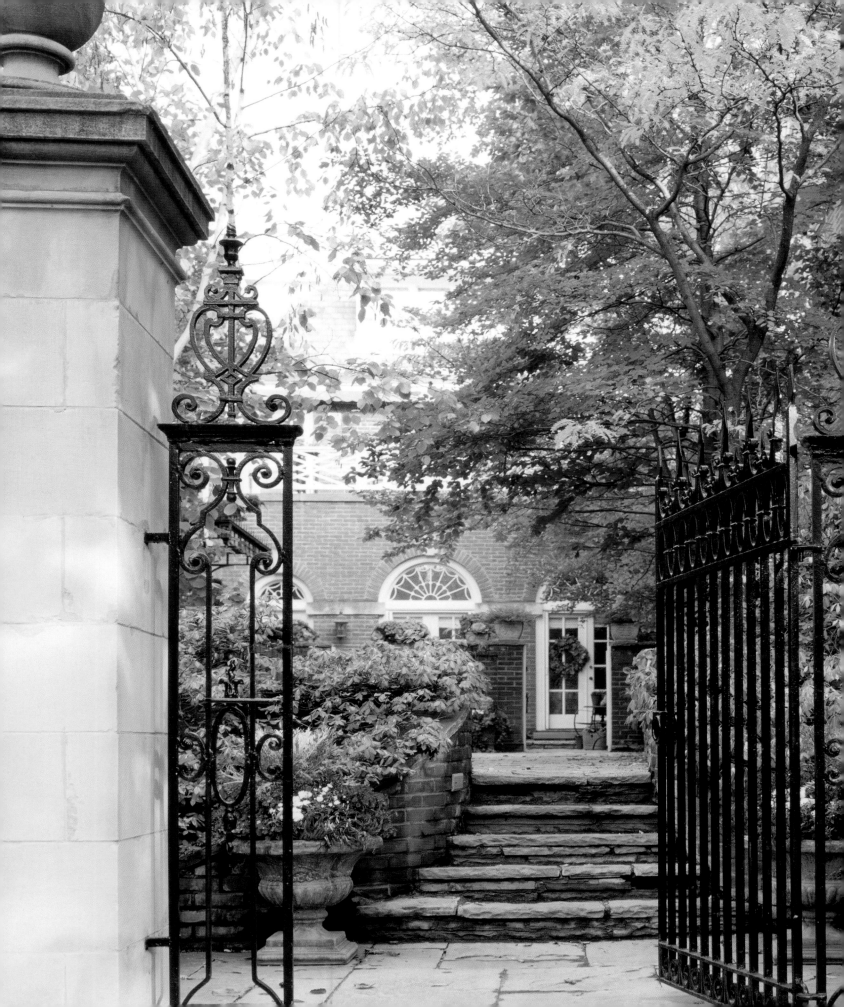

The Bachelor Pad

This Georgian Revival style coach house was originally a grand garage attached to a thirty-room neo-Georgian mansion belonging to James Ryrie, a prominent Toronto financier and jeweller. In 1915, Ryrie purchased the plot on which stood the magnificent villa of Senator David Lewis Macpherson, a railway baron and land developer of the Chestnut Park suburb, now part of Rosedale. He tore down the villa and built his mansion. In 1987, a developer purchased the property, converting the mansion into three condominium residences and creating a fourth residence in the attached coach house. The present owner purchased the renovated coach house in 1996. Its location, charm and one-of-a-kind uniqueness made it a must-have for the bachelor executive. He hired a local architect and interior designer, who successfully combined family heirlooms, antiques and art with a nautical theme, further enhancing an already splendid living space worthy of the prominent site.

The original stone column and wrought-iron gate set a tone of grandeur at the entranceway to the coach house.

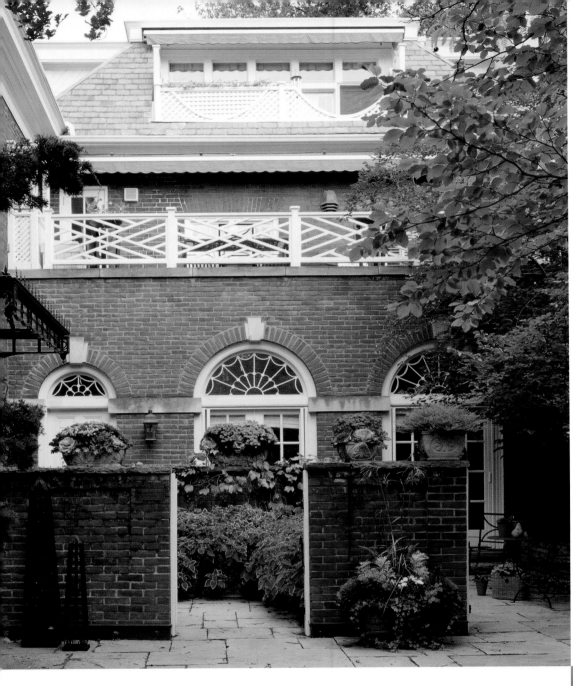

ABOVE The front of the coach house, showing the three garden terraces: a walk-out container garden on the third floor, a rooftop garden and fountain with a Chippendale railing on the second floor, and the ground-floor garden and terrace. A brick wall was constructed to enclose the courtyard and conceal the front entrance. Windows with round-headed fanlights replaced the original garage doors. OPPOSITE The nautical theme is masculine but with a feminine flair, as seen in the lattice-patterned carpet, striped chesterfield and embroidered Bergere chair. Sun shines through the high arched windows to reflect on soft yellow walls and light maple floors. Well-chosen antique brass fixtures and gold picture frames complement the fabrics and the theme.

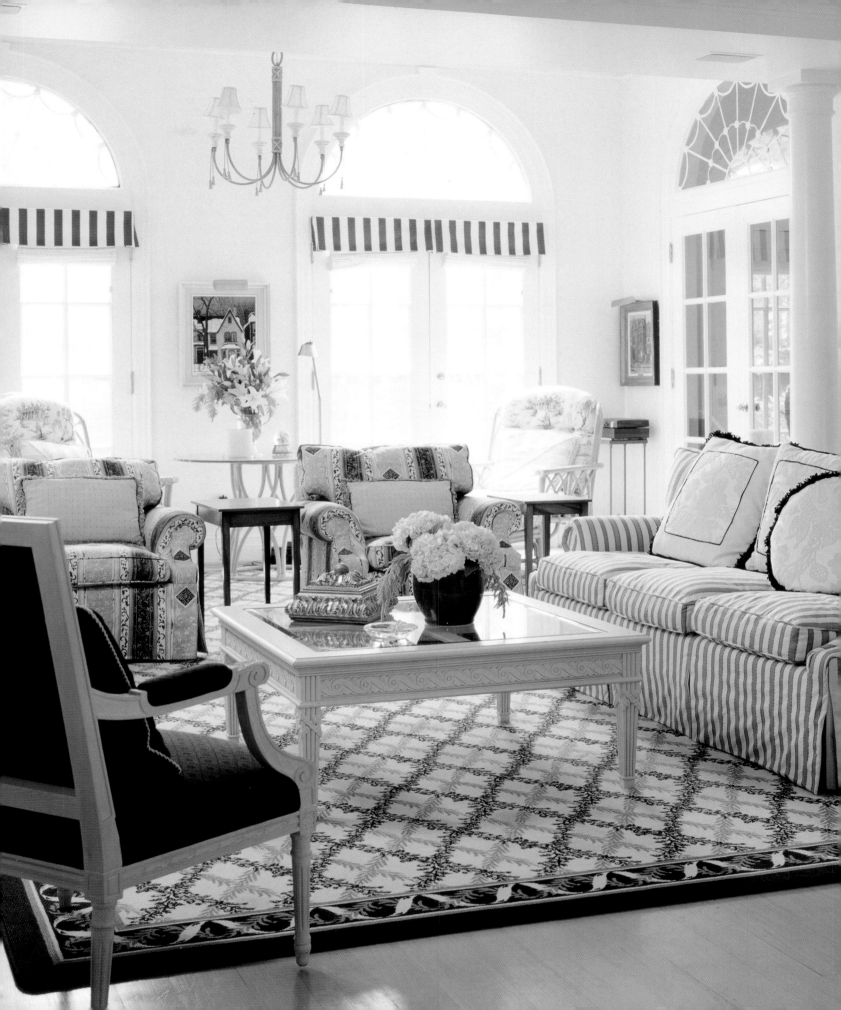

BELOW The designer calls this room "pure fun." Gold stripes were painted on the blue faux-finished walls. Twin beds are draped with flowered striped bedspreads with nine-inch bouillon fringe. Coordinating striped bolster pillows accent the transitional antique headboards. OPPOSITE A treasured oil painting takes pride of place over an antique gentleman's chest in the living room.

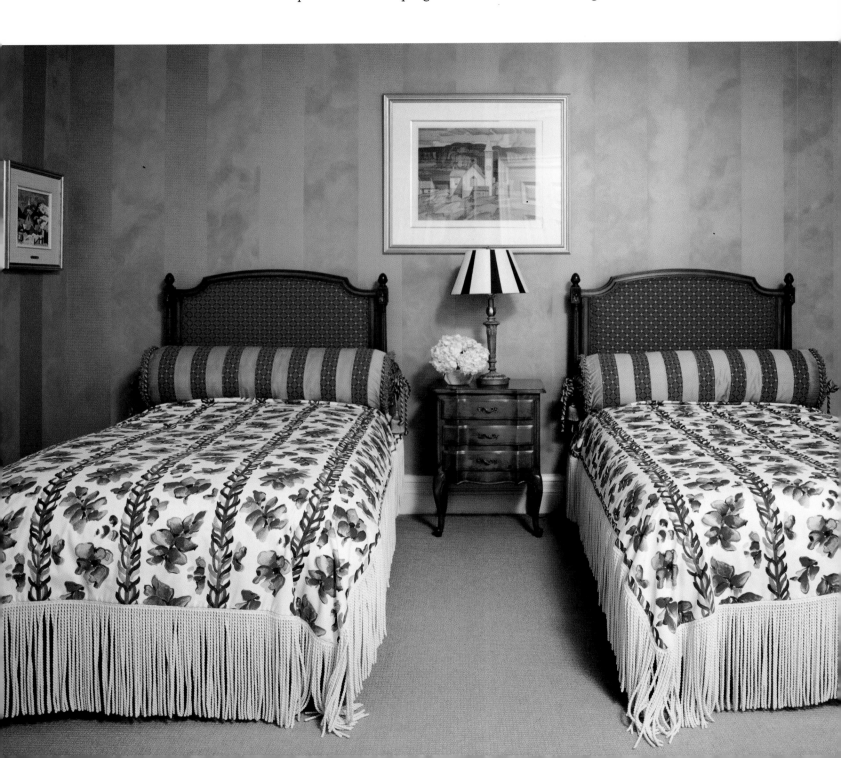

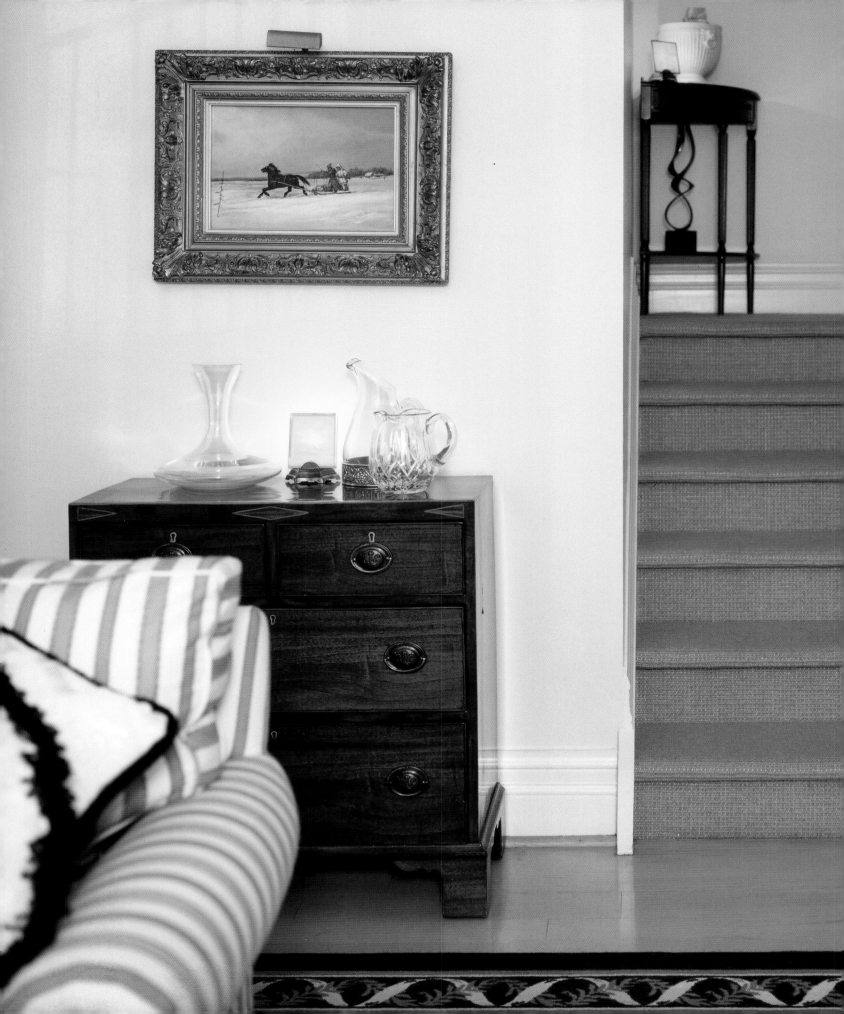

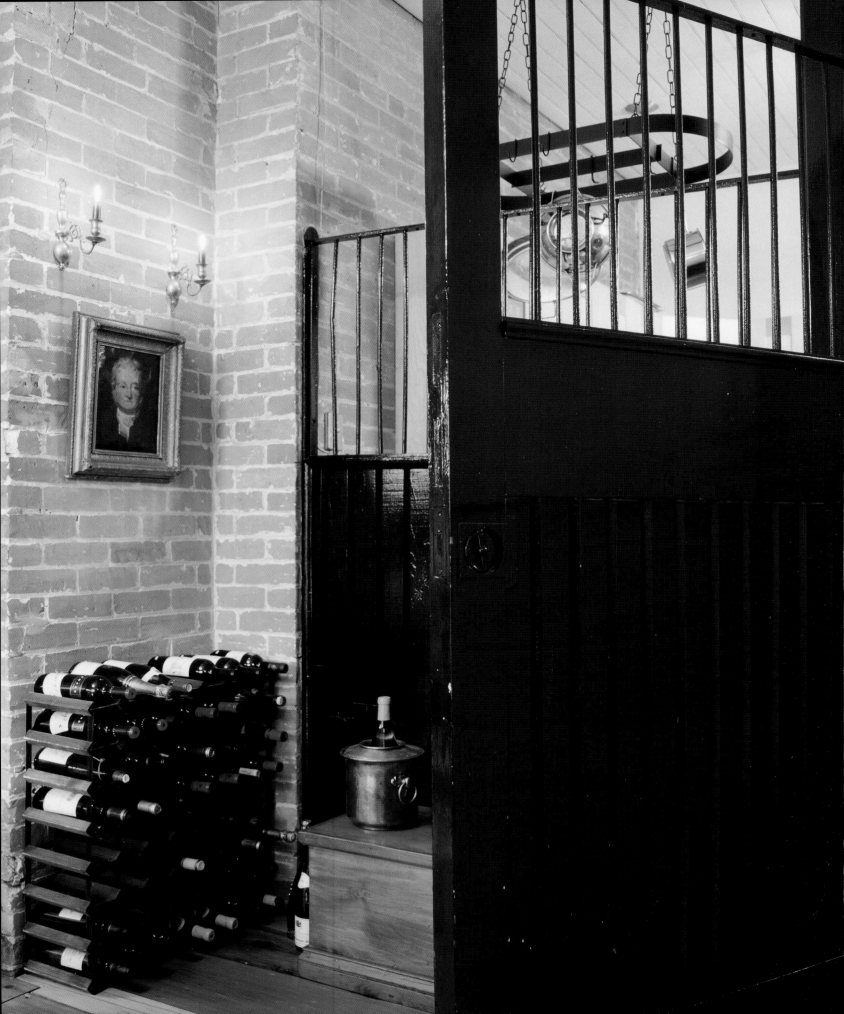

Down on the Farm

This Victorian coach house, located on a prestigious street in the Annex, was built in 1884 behind the main house, which belonged to a prominent lawyer and his wife. It was rumoured that the lawyer, unhappy in his marriage, spent most of his time at the York Club, leaving his wife to live in the house alone until she died in her nineties. Two lawyers purchased the property in the early 1960s and converted the main house into a rooming house. The coach house was used as a hangout and rehearsal hall for a theatre group from nearby Rochdale College, Toronto's first free university. In 1967, a local architect purchased the main house and coach house. He rented the coach house to the son of one of the members of the Group of Seven, who used the space as a residence and studio to paint. In the early 1970s the architect owner began a slow renovation of both houses. Having great respect for the original builder, his main goal was to preserve the interior and exterior of the coach house and incorporate any salvageable contents into the renovation. Today the coach house is home to two very busy lawyers, who fell in love with its "down on the farm" rustic charm, historic quality and close proximity to their offices.

The horse stall, painted a dramatic black, hides a modern kitchen. Exposed brick walls and gleaming cedar plank floors are the perfect backdrop for a portrait painted by a family relative and the owner's collection of favourite vintage wines.

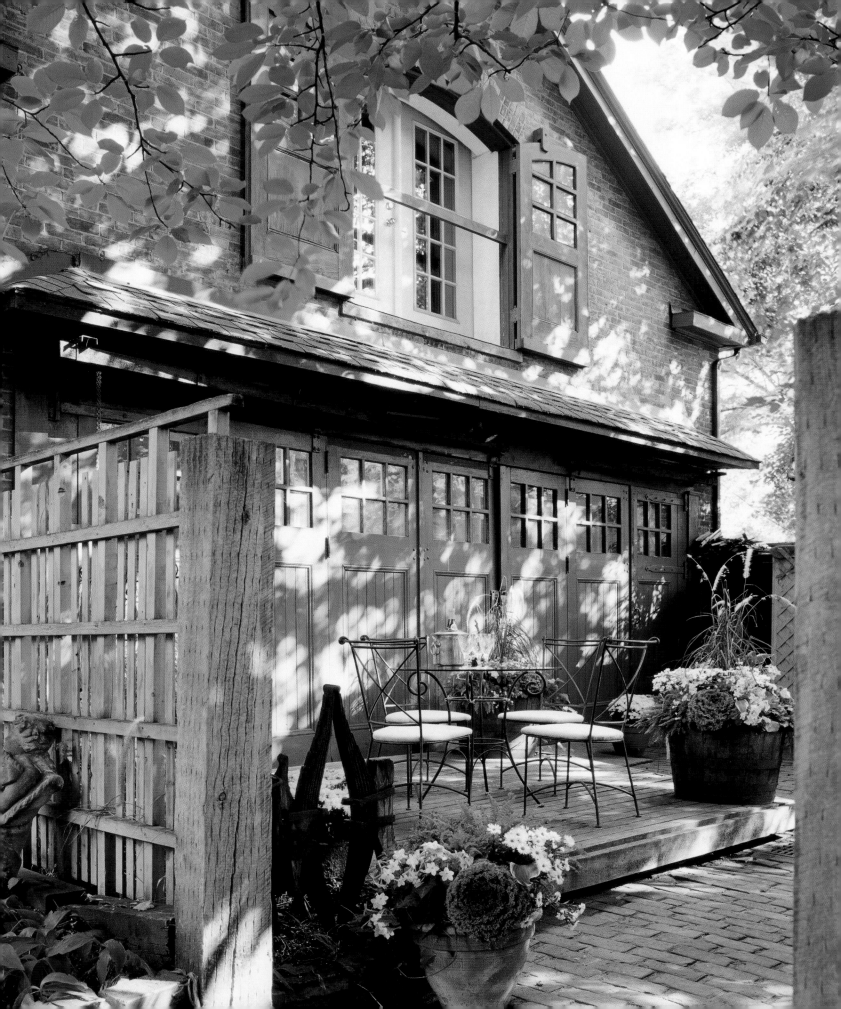

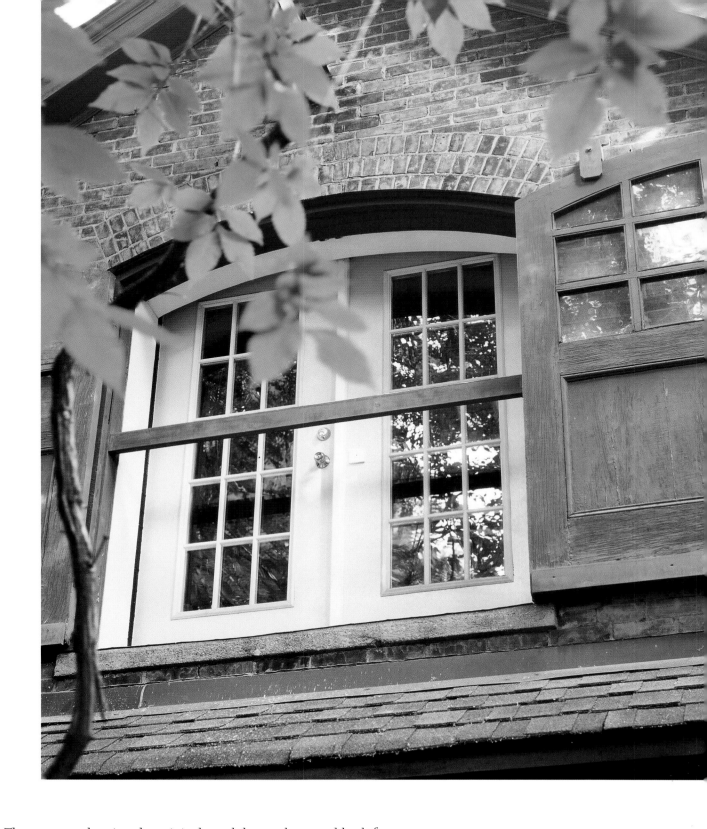

OPPOSITE The entrance showing the original coach house doors and hayloft doors. A large deck with simple iron garden furniture creates an alluring country dining and entertaining space. ABOVE The original hayloft doors, weathered but well-preserved, are now used as shutters to the French windows of the master bedroom.

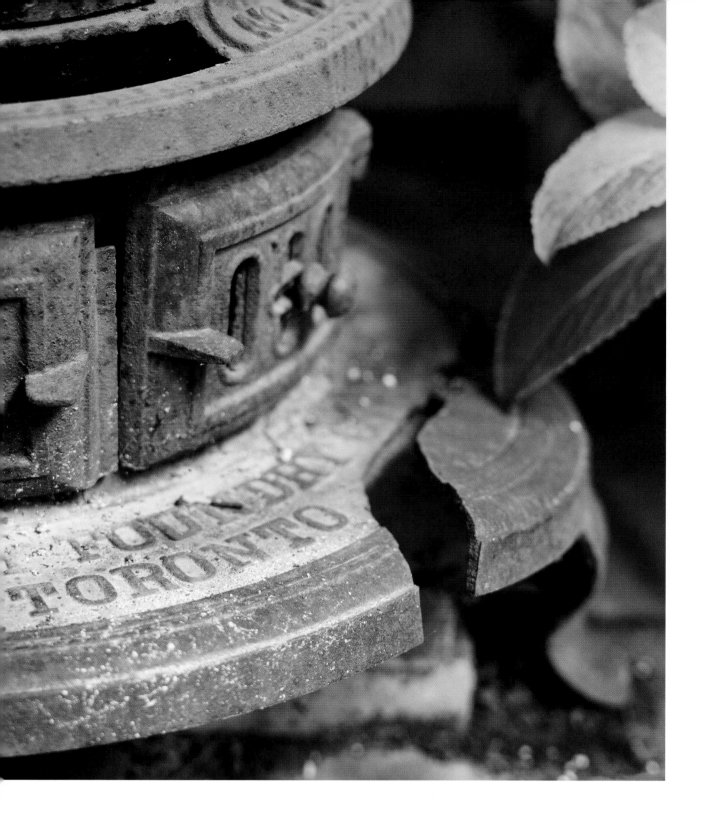

ABOVE The original stove, patent August 21, 1888, that was used to heat the groomsman's residence and water for the horses. Though it is cracked and partially rusted by time, the manufacturer's name, the Guerney Foundry Co. Ltd. Toronto, is still legible. OPPOSITE The cupola, the distinguishing mark of an authentic coach house, as seen from the main residence and garden.

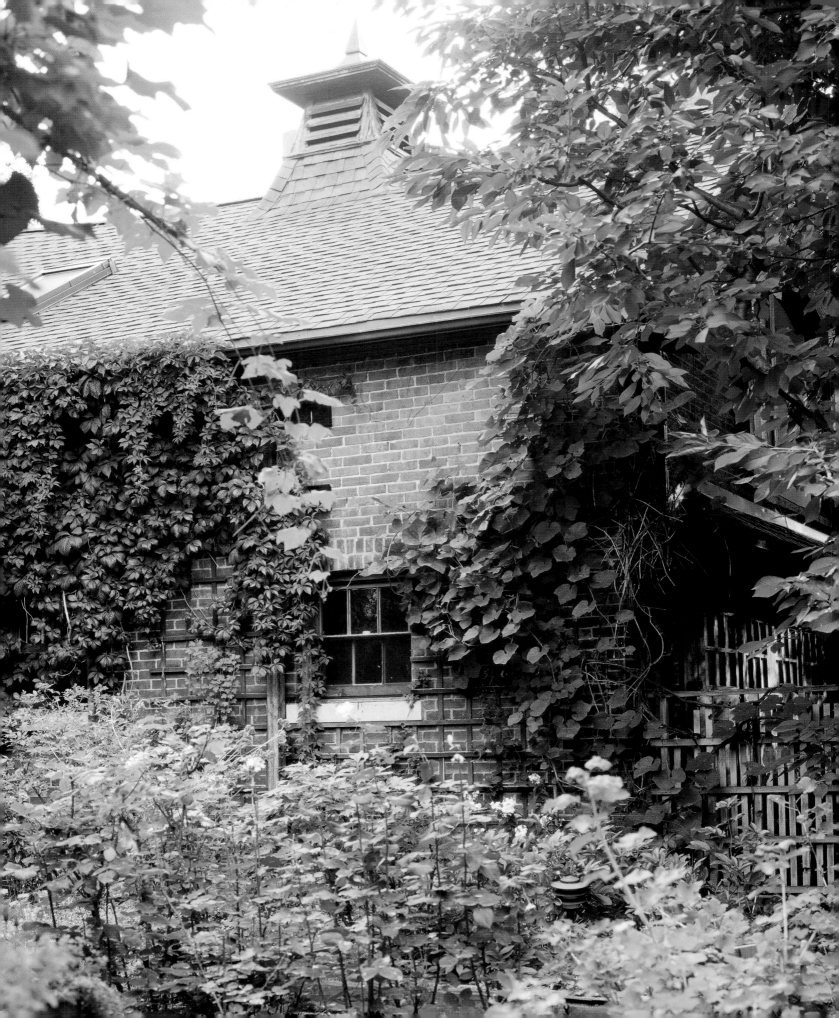

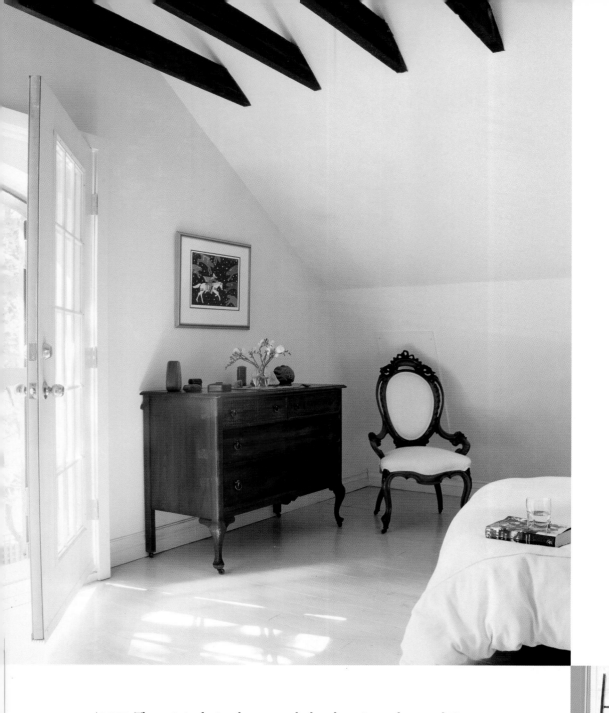

ABOVE The original pine beams, a dark oak antique chest and Queen Anne chair are dramatic against the milk-white walls and painted floor of this simple and elegant master bedroom. French windows open in the hayloft door. RIGHT An antique pine bench, a family heirloom, is used as a coffee table in front of the contemporary oatmeal chesterfield in the living room. *Red Barn Reflected,* an acrylic by Canadian artist Charles Pachter, hangs above a three-person pine school desk from the early 1900s. A decorative ladder rests against the interior walls of the coach house doors, seeming right at home in this "down on the farm" urban living space. OPPOSITE An antique Chinese armoire stands tall next to the staircase leading to the master bedroom. Soft neutral tones blend in perfectly with the milk-white painted pine ceiling. A reclaimed wood-framed mirror reflects light into the hall. The floors are cedar plank.

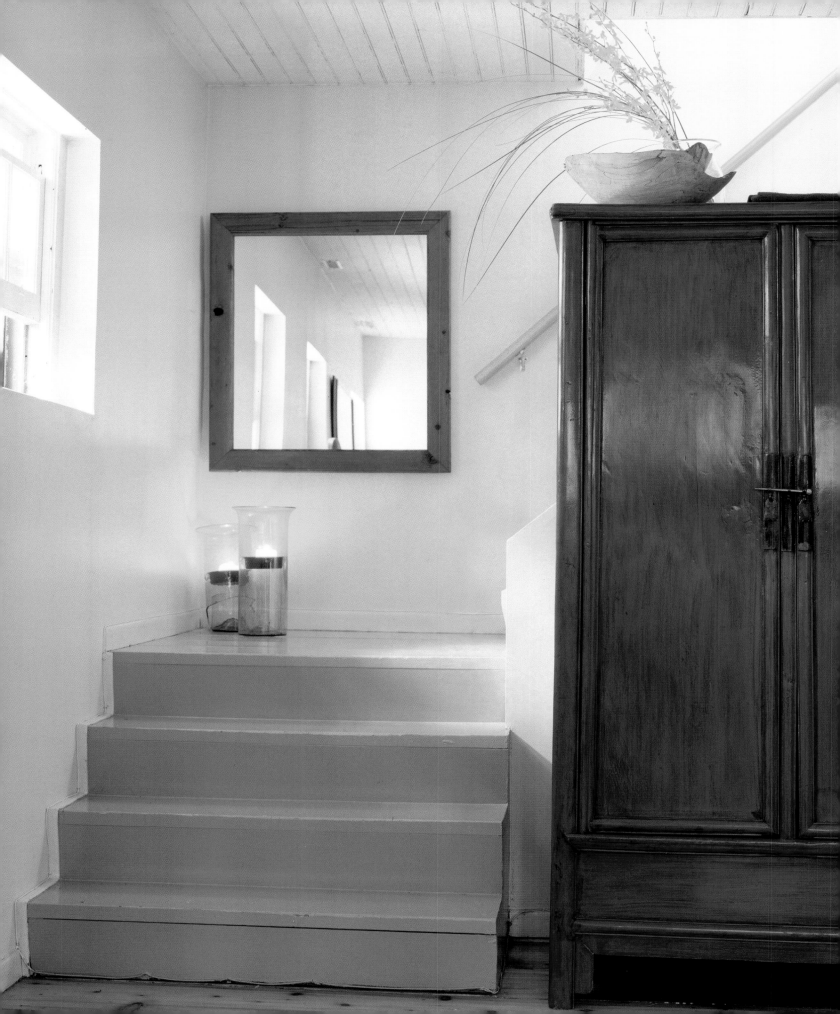

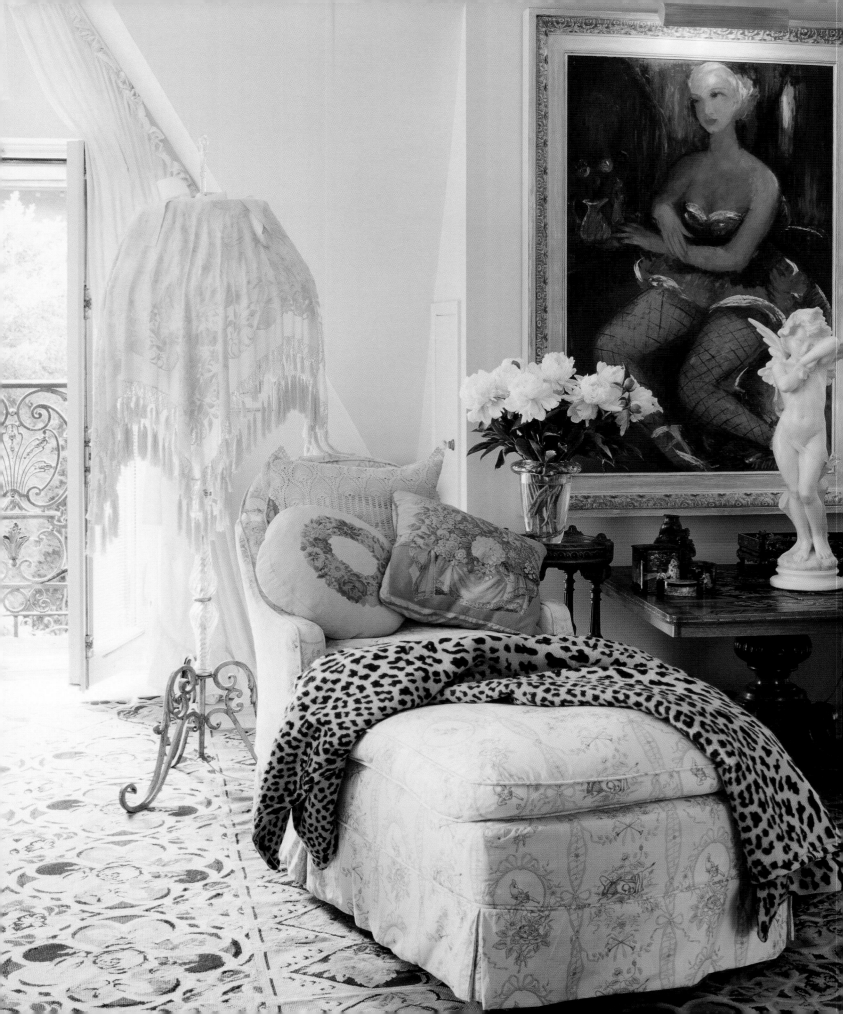

The French Gallery

This stunning Victorian coach house sits at the end of a long driveway, completely hidden from the main house by lush gardens and trees, in Rosedale, a beautiful residential enclave home to some of the wealthiest residents of the city. The main house and coach house were built in 1899 and originally occupied by a judge. In 1993, the present owner was suddenly widowed and decided the main house was too large. Rather than selling, she decided to renovate the coach house and move into it herself. This was a project of great magnitude — applying to the city for severance, having surveys done, and most important, keeping peace with the neighbours. Renovation work began in 1997 and was not completed until two years later, when she finally moved in. A local designer and owner of a prestigious antique gallery, she decided to incorporate many of her favourite French antiques and artifacts from her years of round-the-world travel as well as some of her prized architectural treasures from the main house. The result is one of the most luxurious and beautiful renovations of a coach house in the city.

A portrait by contemporary Latvian artist Tidemanis hangs above a 19th-century figure of a marble angel and a crystal vase of roses. A duchess chaise lounge creates the perfect backdrop for a luxurious tiger throw and French needlepoint cushions. A colourful rug enlivens the bedroom. French windows open to the Juliet balcony.

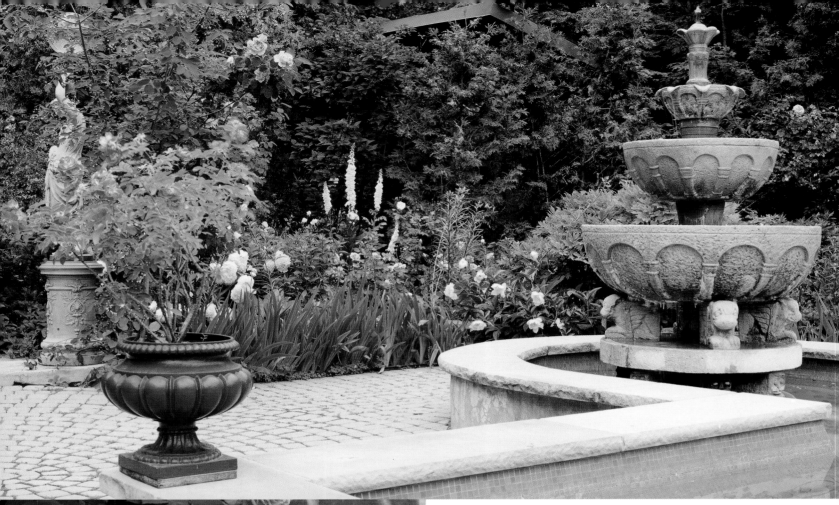

ABOVE The magnificent swimming pool, three-tiered fountain and surrounding gardens of the terrace were inspired by the original Victorian architecture of the coach house. The gardens include an English-style perennial border, complete with spiring foxgloves, spiky iris and three shades of pink peonies, brightening a textured backdrop of established evergreen trees and leafy deciduous shrubs. A rose-filled urn sits on the stone wall of the pool. LEFT Lander pink roses adorn the chimney. OPPOSITE The entrance to the coach house, its exquisite iron gate taken from the main house. The hayloft door was converted to a Juliet balcony of ornate French antique iron, a prized find on one of the owner's trips to the French countryside. A living wall of grapevine and rampant silver lace vines hide the main house garage. Rose bushes, rose trees, a planter of double ivy geraniums and a French antique bench give a European flavour to this beautiful entranceway.

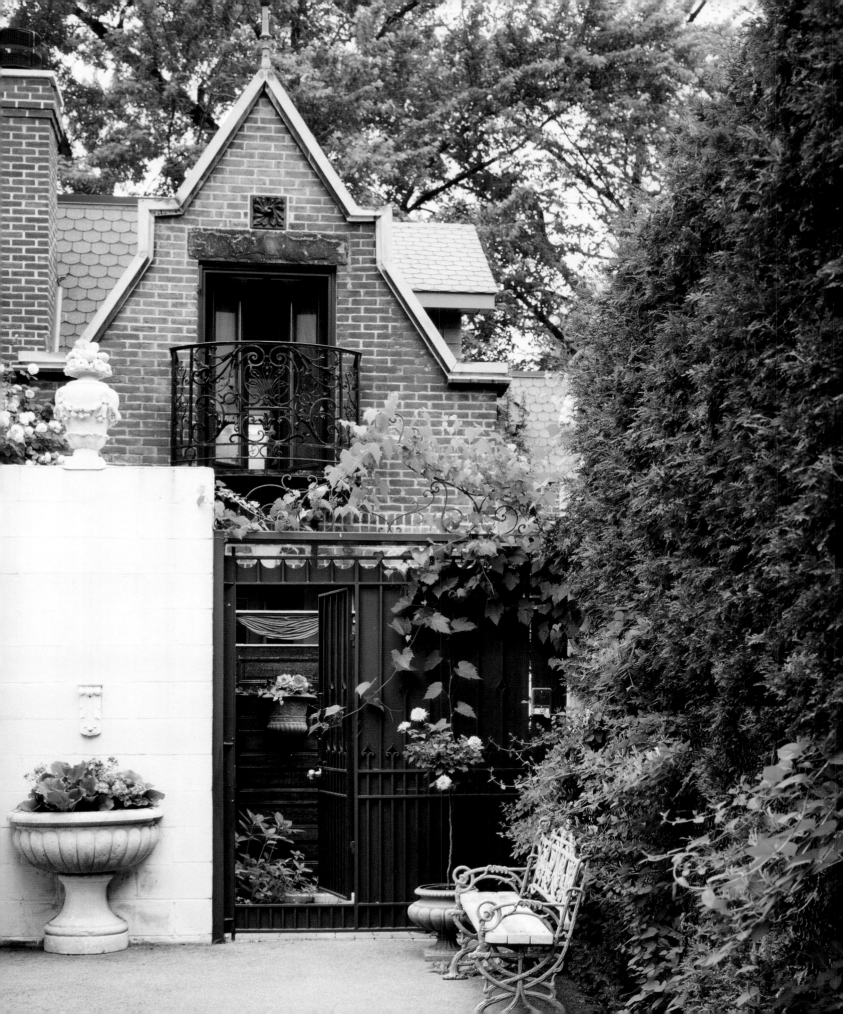

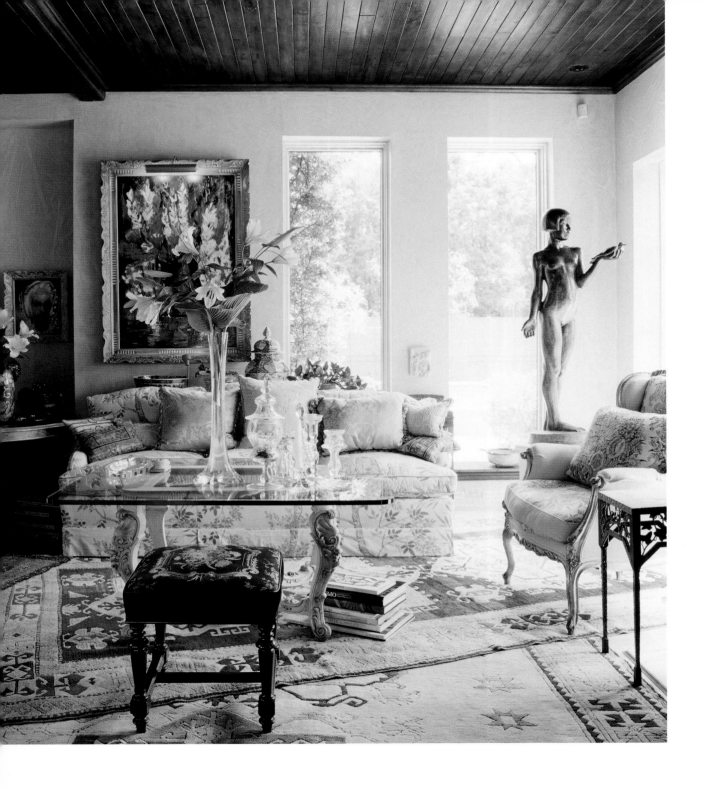

ABOVE The living room, showing the original pine ceiling. When the renovation was complete, the owner could not find anyone to clean and polish the ceiling: "I got on a ladder and spent weeks hand-cleaning, oiling and waxing the ceiling. All it needed was a little bit of love." The living room is a treasure trove of beautiful things: an art deco bronze figure, a Louis XV wingback chair, a French antique petit point footstool and a vibrant blue antique rug. OPPOSITE The view of the light-filled staircase from the living room includes a statue by Canova, a collection of antique Chinese vases and one of several stone columns imported from Italy. The unique oak staircase with its custom-designed iron railing leads to the second floor. To enliven the staircase wall, a local artist was commissioned to hand-paint the ivy and floral trompe l'oeil.

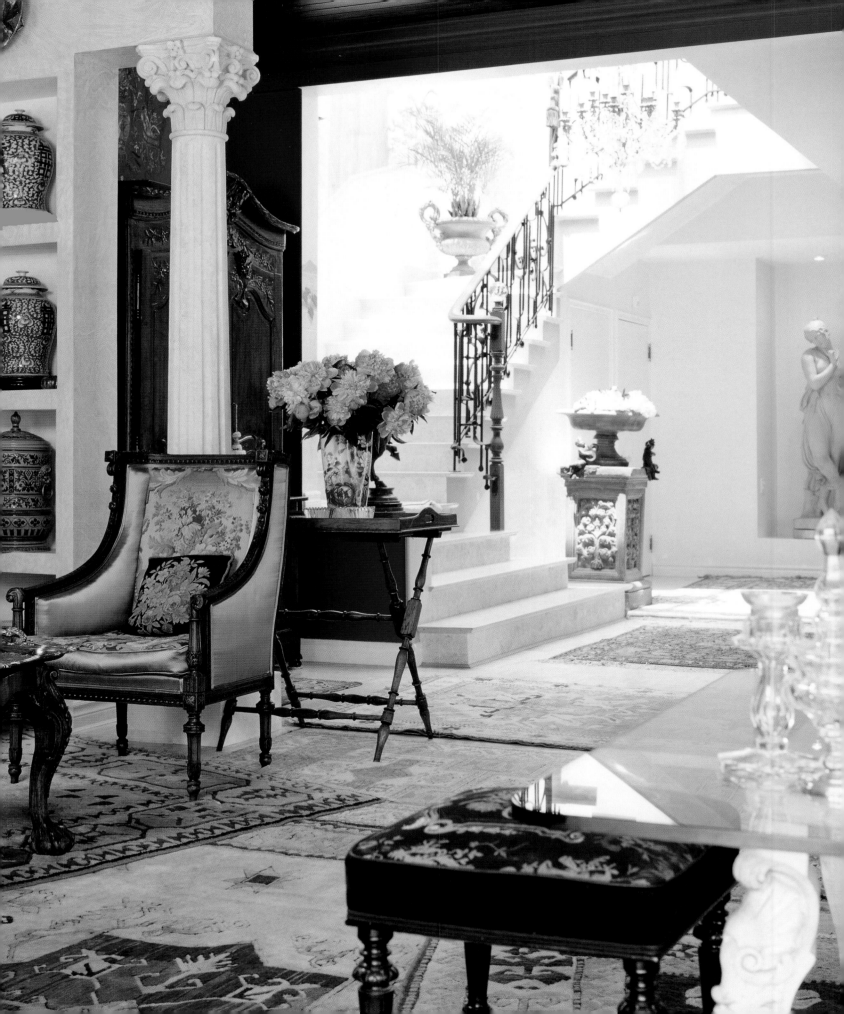

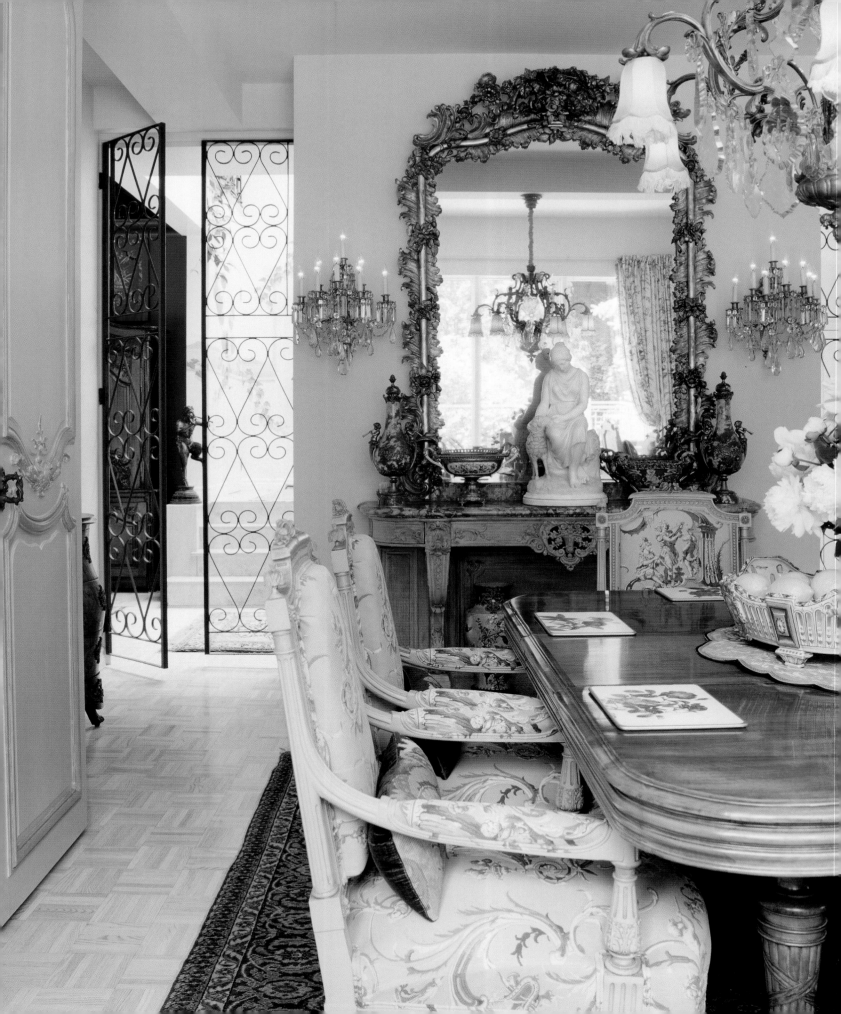

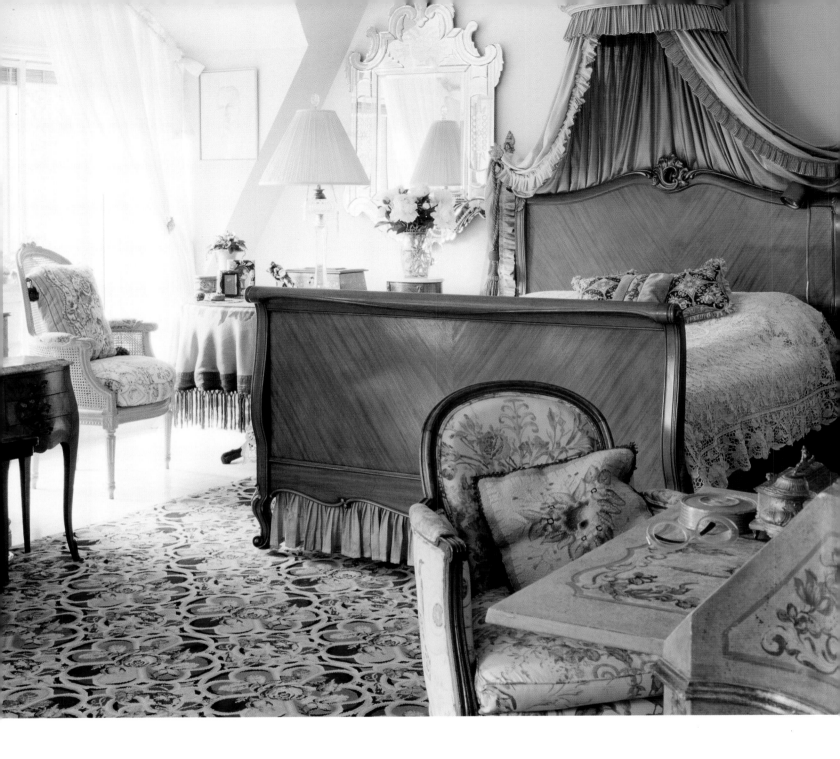

OPPOSITE This view of the dining room reveals the magnificent French antique mirror, a French marble statue of a shepherd and the Louis XV bronze chandelier. A Louis XVI butternut table is beautifully complemented by the paisley tapestry on the antique dining chairs. Hand-painted French antique panels collected from one of the owner's numerous trips to France were installed on the wall to hide the bar. Wrought-iron doors designed by a local artist create an interesting entry from the dining room to the kitchen. ABOVE The master bedroom features a transitional Louis XVI bed with a silk turquoise taffeta canopy, a 19th-century needlepoint carpet, a Louis XVI dinner chair and a Venetian-glass mirror and dressing table.

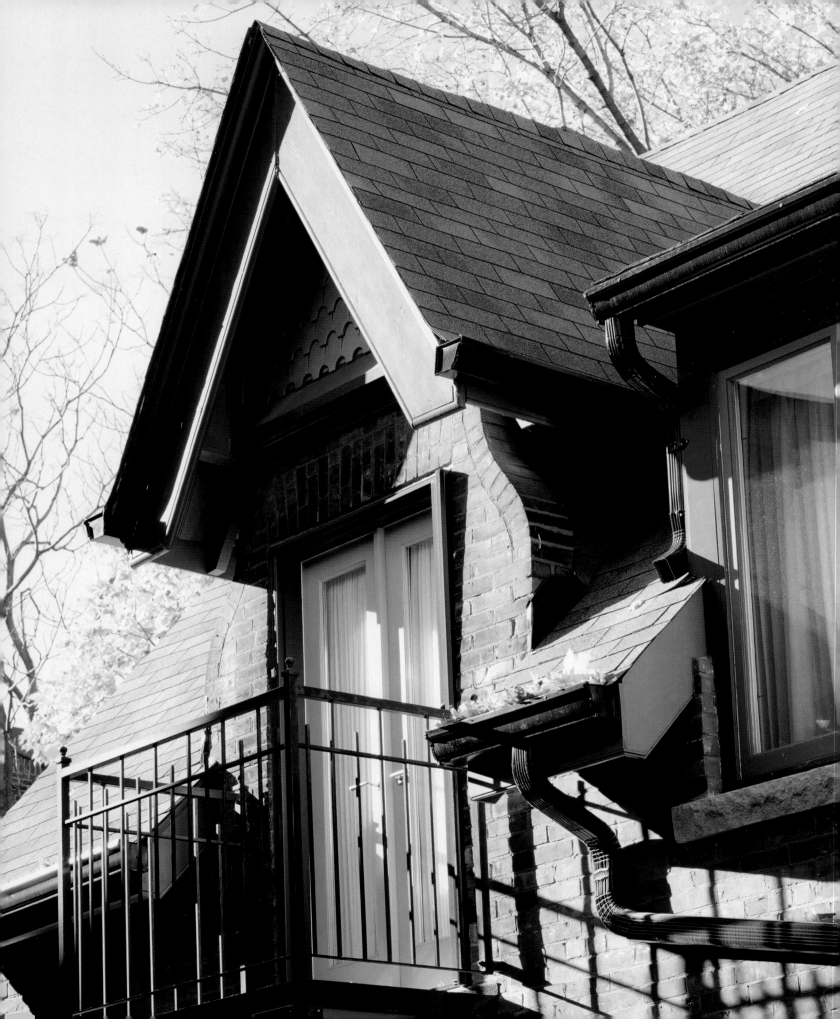

The Reflection Loft

Built in 1889, this colourful, whimsical Queen Anne Revival style coach house sits only steps behind the parent house, an imposing rock-faced manor, in an area of distinguished homes in the Annex. The original occupant was a wealthy estate and financial broker. In 1943, the Sisters of Social Service purchased the property, and the main house became a residence. After many years of trying to convince the City to allow them to renovate the coach house, the Sisters were finally given permission. A local architect was commissioned to work in consultation with the Historical Board to bring new life to the building. In 1999, the coach house was converted into a reflection loft and refuge for those seeking time out from a frenzied world. A recent guest thanked the Sisters — "How can heaven be better than this?" — no doubt returning to her busy life refreshed and rejuvenated in body and spirit.

The hayloft door, now a Juliet balcony with French windows tucked under a peaked dormer

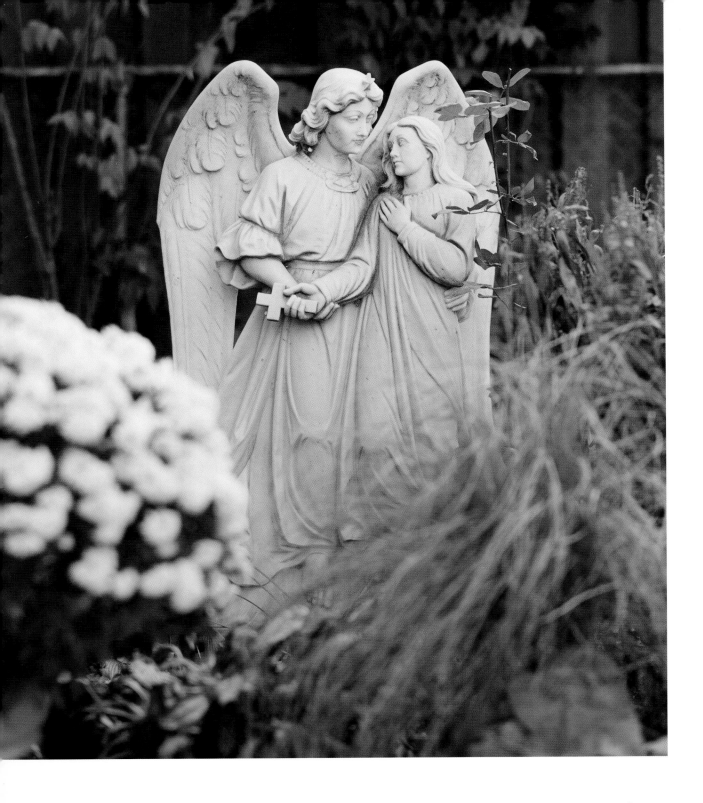

ABOVE A marble statue of an angel leading a little girl to heaven stands guardian among wispy purple fountain grass and potted yellow mums in the courtyard prayer garden. The statue, originally made for a cemetery, was donated to the Sisters by a Hungarian gentleman. OPPOSITE Vibrant paint colours and a mixture of materials make for a visually interesting façade. Terra cotta stone shingles and a mix of brick terra cotta tiles, typical of the Queen Anne Revival style, can be seen on the corner of the main house.

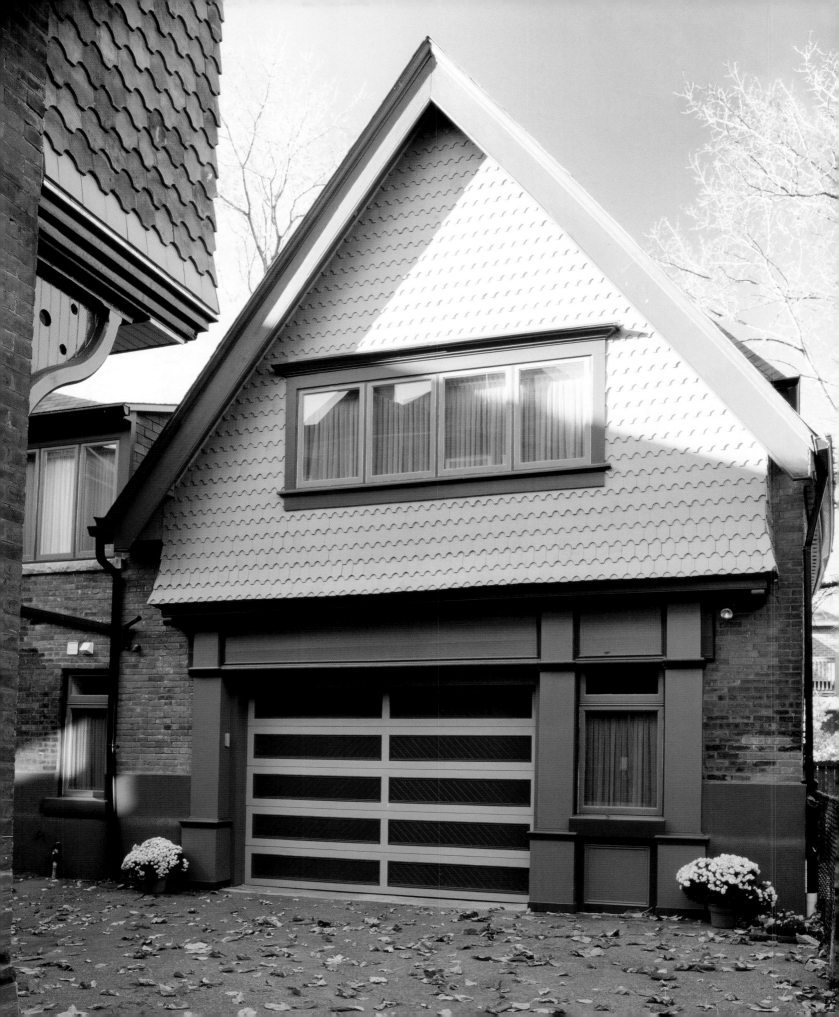

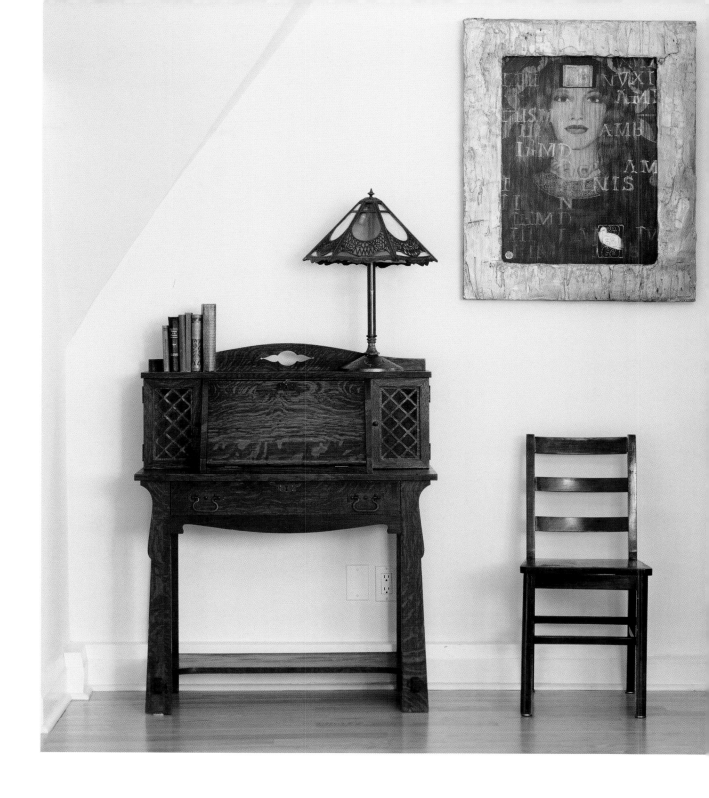

OPPOSITE A blue gingham tablecloth covering an old wooden kitchen set adds vibrancy under a skylight in the simple dining area. The loft was designed with an upward view as a reminder of God's ever-loving presence. ABOVE A portrait entitled *Celtic Queen*, with gold-leaf border, is positioned just above a small ladder chair beneath the sloped ceiling of the loft. An antique oak secretary and tiffany lamp were once part of the main house.

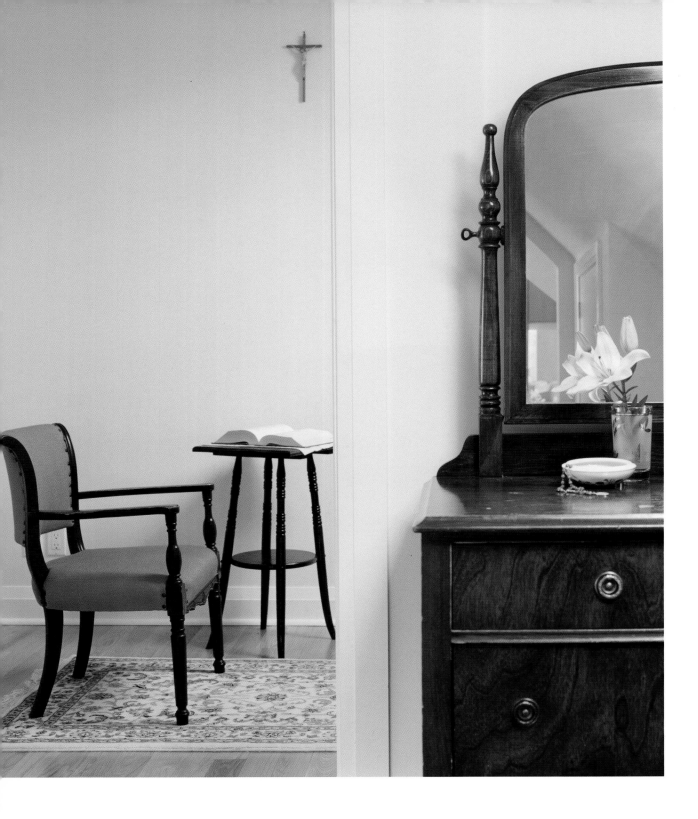

ABOVE A gold crucifix hangs on the chapel wall. The simple furnishings came from the main house when the Sisters purchased the property. OPPOSITE Light filters through the open French windows of the Juliet balcony, once the hayloft door. A chenille bedspread covers the single bed. Select 1950s vintage pieces complete the furnishings of this modest guestroom.

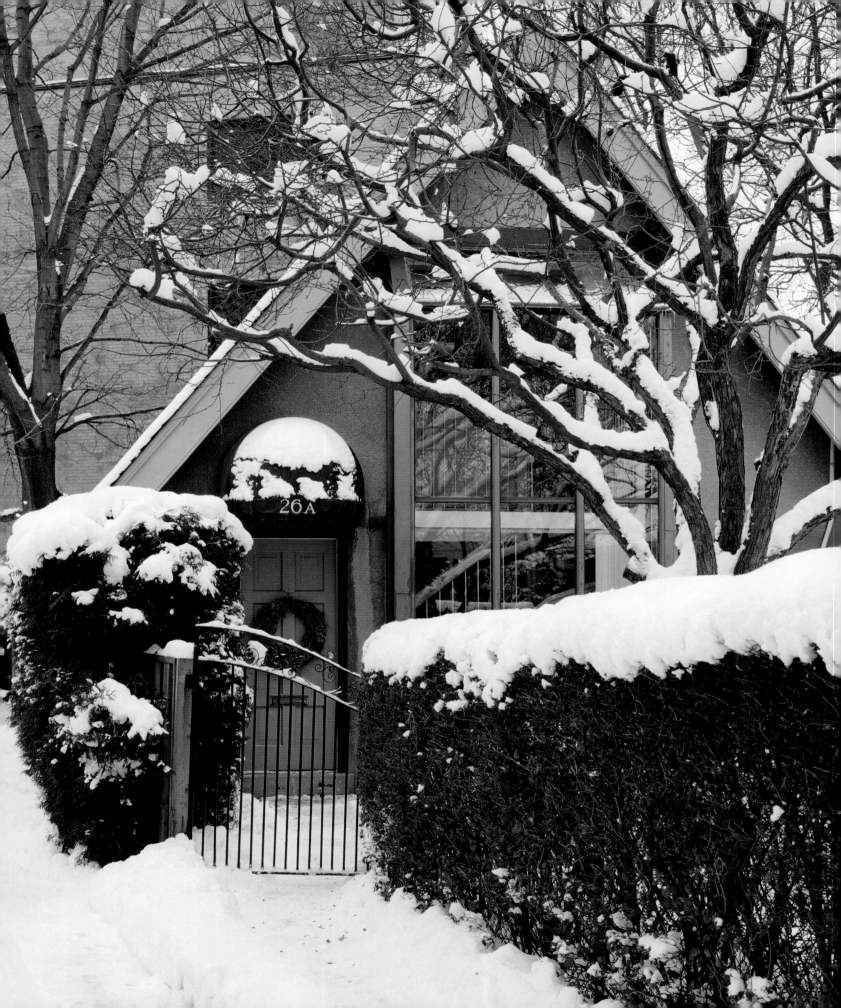

A Movie Star's Getaway

This beautiful coach house hides behind a walled garden, almost completely unseen from the main house, a grand Edwardian built in 1924. Located in an area once known as Millionaire's Row, in the village of Forest Hill, the main house was once the former residence of a royal consular. The coach house served as a garage for the horseless carriage, with accommodations above for the family chauffeur. During the Depression, the coach house was converted to a two-room guesthouse. In the early 1970s, two international designers purchased the property and renovated the coach house for use as an elite country-style retreat close to the heart of the city. With just 800 square feet, the coach house was ingeniously converted into a light-filled, peaceful and elegant guest residence. The walled garden provided full security, the swimming pool, exercise, and the fully equipped kitchen was a dream come true for visiting guests, especially those who loved to cook. For the past thirty years, the coach house has been a favourite pied-à-terre for visiting entertainment personalities and CEOs. A local restaurateur and his family recently purchased the property, and the coach house is now used as a guest house for visiting friends and relatives.

The guest entrance to the coach house through the iron gate. A two-storey bay window replaced the original doors, allowing natural light to flood the interior. A canopy adds elegance above the front door, and festive decorations welcome guests and celebrate the season. A cedar hedge provides privacy from the main house.

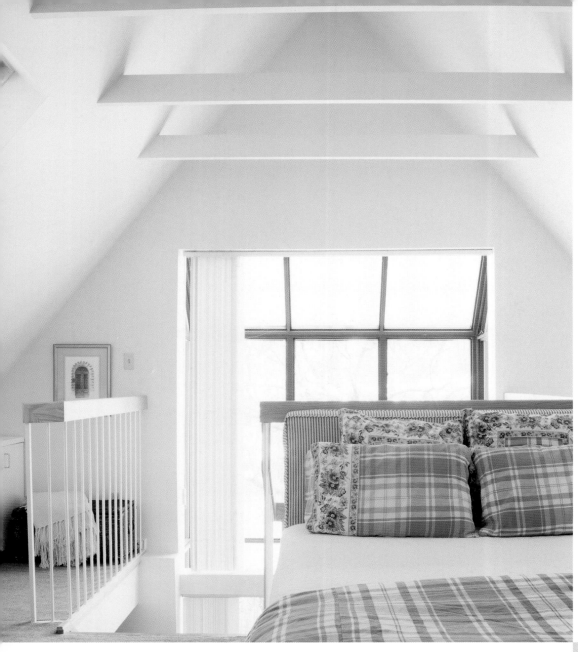

ABOVE View of the loft bedroom showing raised ceilings, white painted beams and the top of the two-storey window. RIGHT In the dining area, a drop-leaf Regency table with an antique lamp, serving tray and urns. A collection of English prints hangs on the wall. Well-chosen fabrics and a colourful rug are evidence of the designer's taste. OPPOSITE A Scandinavian-inspired fireplace, flanked by the owner's collection of prints adds a different touch to the pleasant character of this comfortable living room.

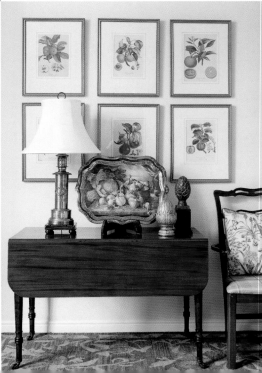

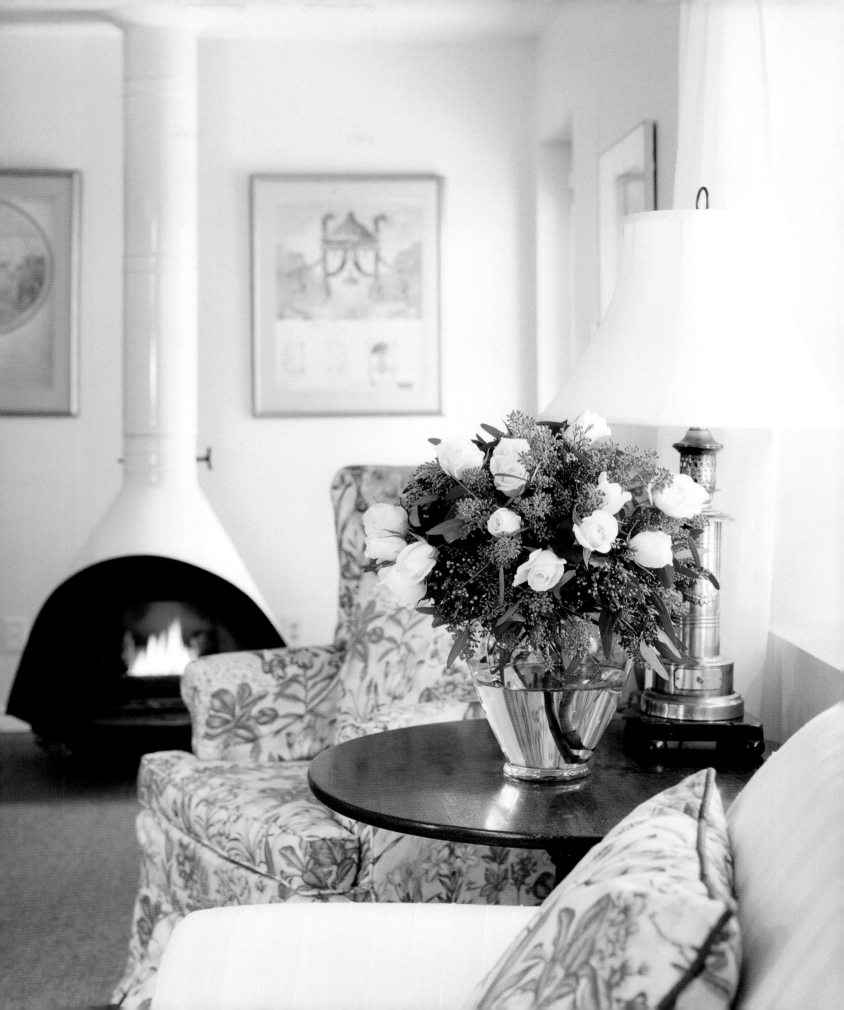

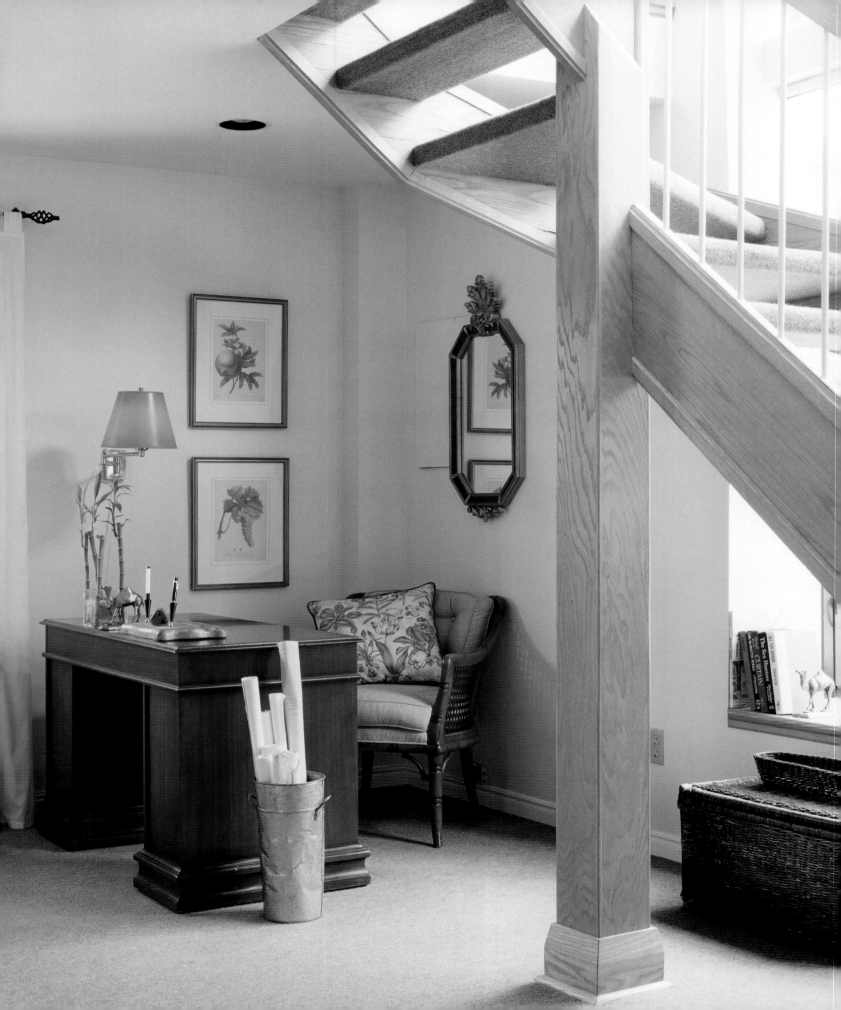

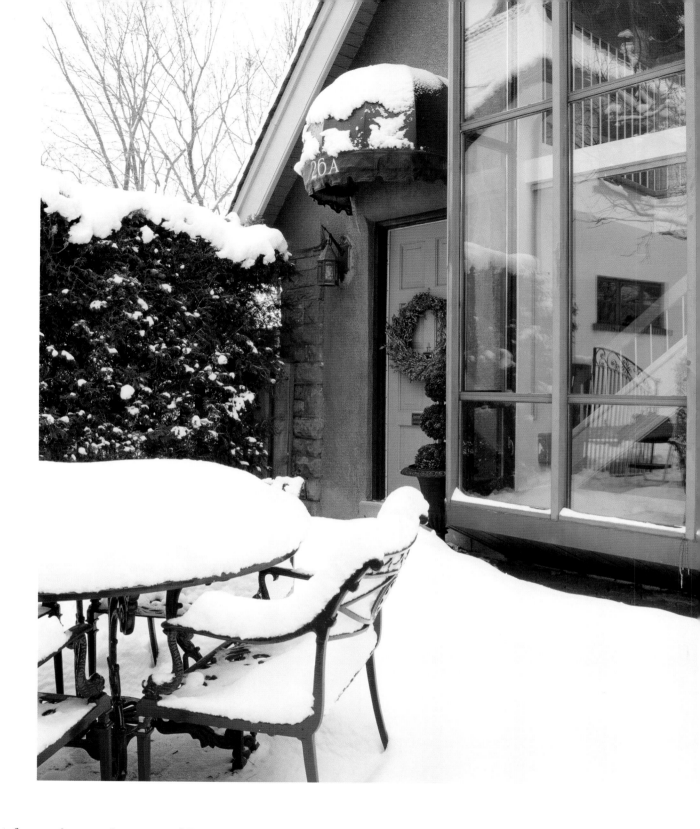

OPPOSITE A freestanding maple staircase follows the two-storey window to the loft bedroom. An antique desk and wicker chair provide a peaceful space for writing. ABOVE An arrangement of iron garden furniture draped in snow is left out year-round to enjoy in this secluded setting. The maple staircase leading to the second-floor loft bedroom is visible through the magnificent two-storey bay window.

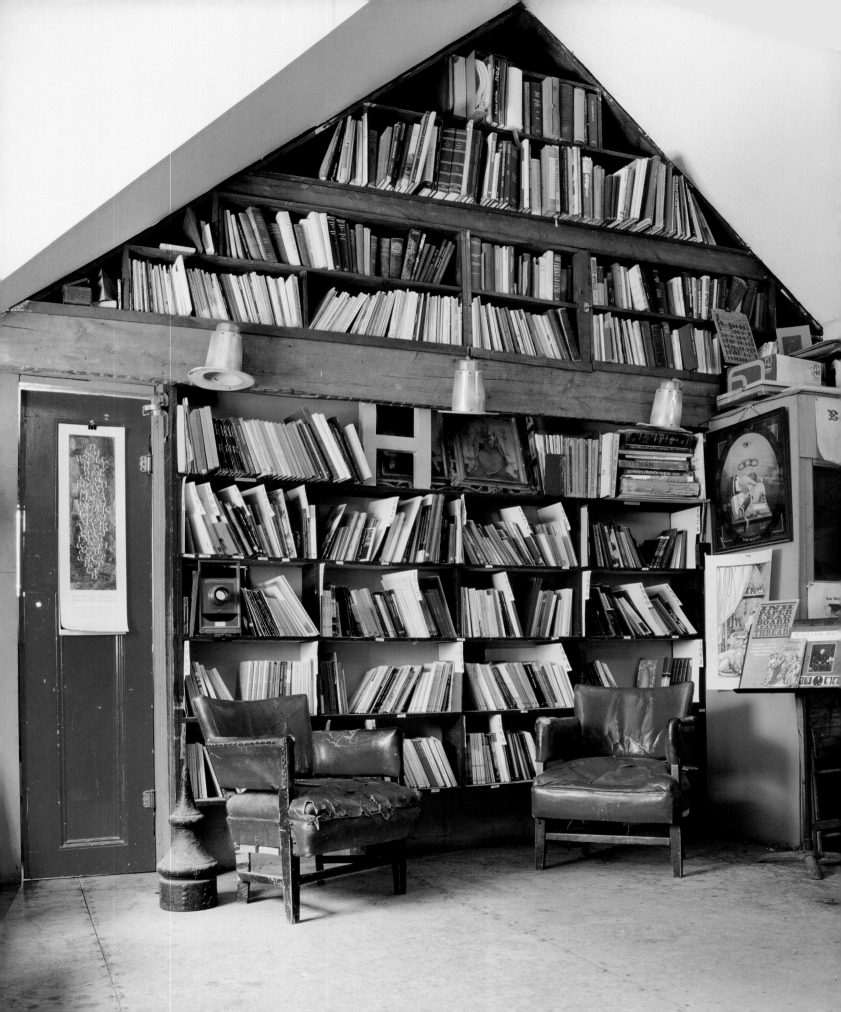

The Coach House Press

This urban coach house, built in 1890 off a laneway in the Annex, is thought to have been a builder's building attached to a livery stable. Sets of doors on either side of the building would allow easy access and exit from the building for horses hauling wood from the lumberyard at the end of the street and delivering carpentry goods. Today the coach house sits in the shadow of what was once Rochdale College, Toronto's first free university, and home to free thinkers of all stripes.

In 1968, a young printer was given permission to use the coach house for his new printing business while waiting for space promised him at Rochdale. He installed his own wiring and primitive plumbing and scoured garbage from local mansions being torn down on St. George Street, retrieving windows, doors, furniture, and just about everything he needed to get the coach house up and running. When space finally became available for him at Rochdale, he declined, and struck a deal with the student co-op to rent the coach house on a month-to-month basis.

Today Coach House Press has come a long way from its meagre beginnings, when it drew visual artists and writers in search of means of production and alternative publishing. Coach House Press continues to publish innovative and experimental Canadian writing, including poetry, fiction, art books and dramas, while preserving the best of the small press tradition, producing finely designed and crafted books in limited editions. Says the owner, "The Coach House is nostalgic and offers a nice pace in the midst of urban madness."

The book-lined library in the loft is crammed to the rafters of its peaked roof. One of the shelves opens to reveal a secret hiding space. The red half door leads to the darkroom. Sally Ann easy chairs and tin lights were street finds.

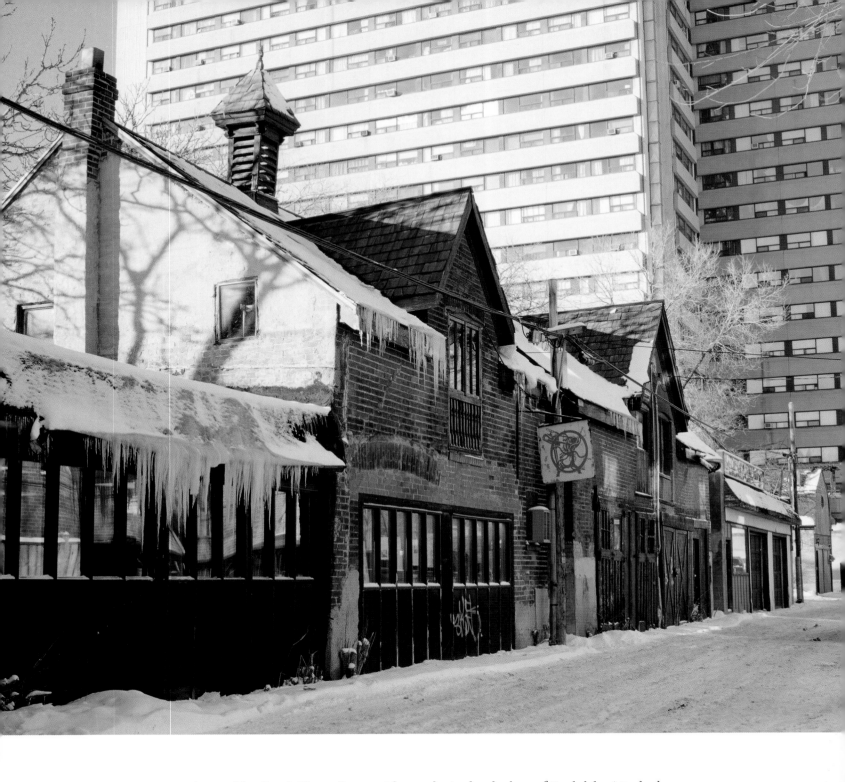

ABOVE The Coach House Press, with cupola, in the shadow of Rochdale. Attached,
a row of coach houses believed to be part of a livery stable. OPPOSITE Close-up
of the snow-covered slate roof and cupola on a perfect January winter day.
A cable just along the slate roof saved the cupola from being destroyed when it
blew down in a wind storm. The staff removed it from the wire and secured
it with heavy-duty rope.

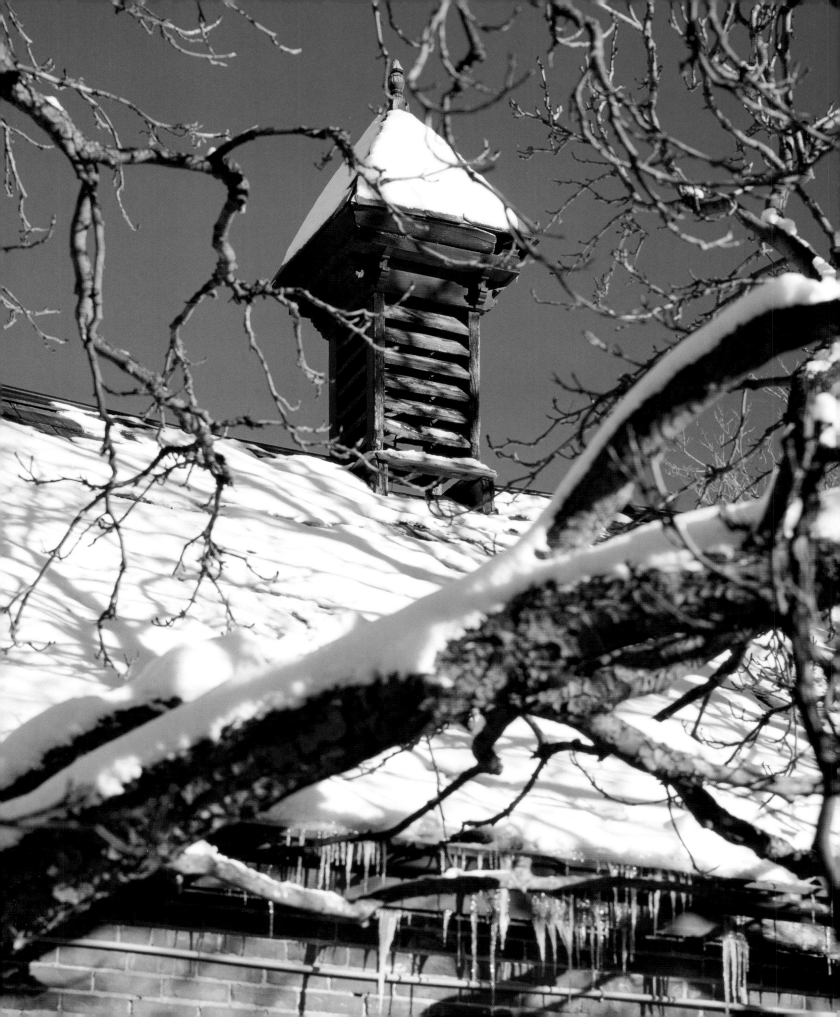

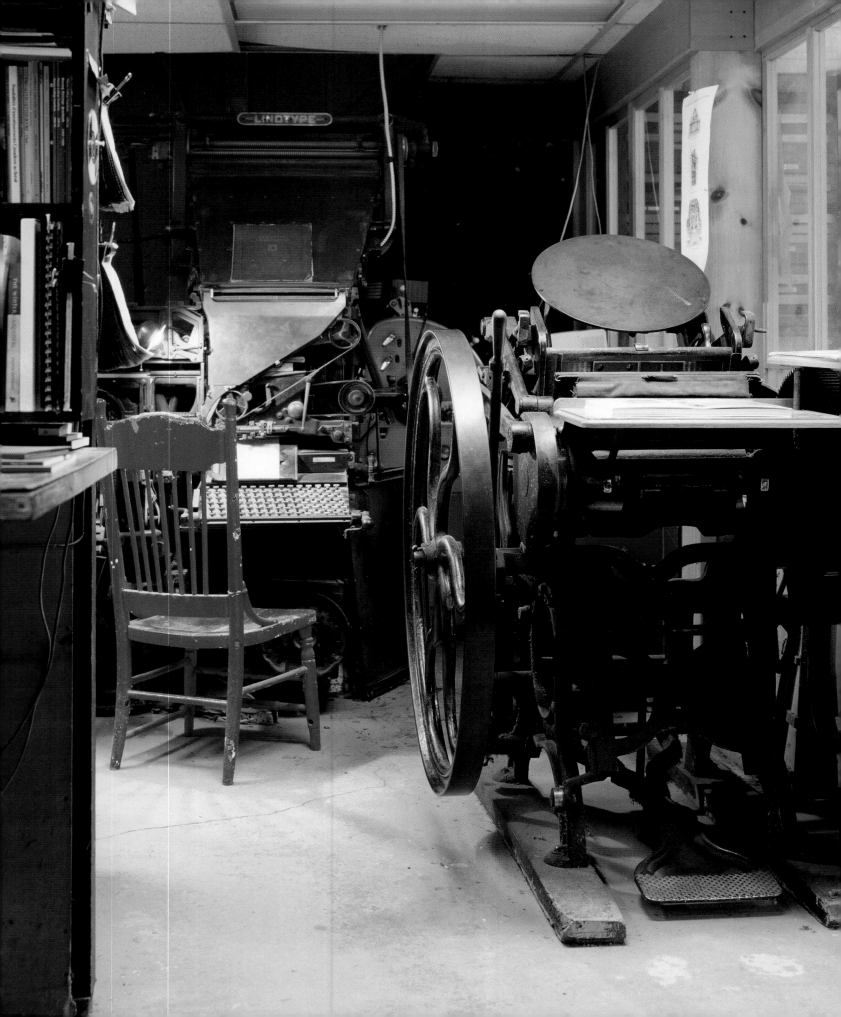

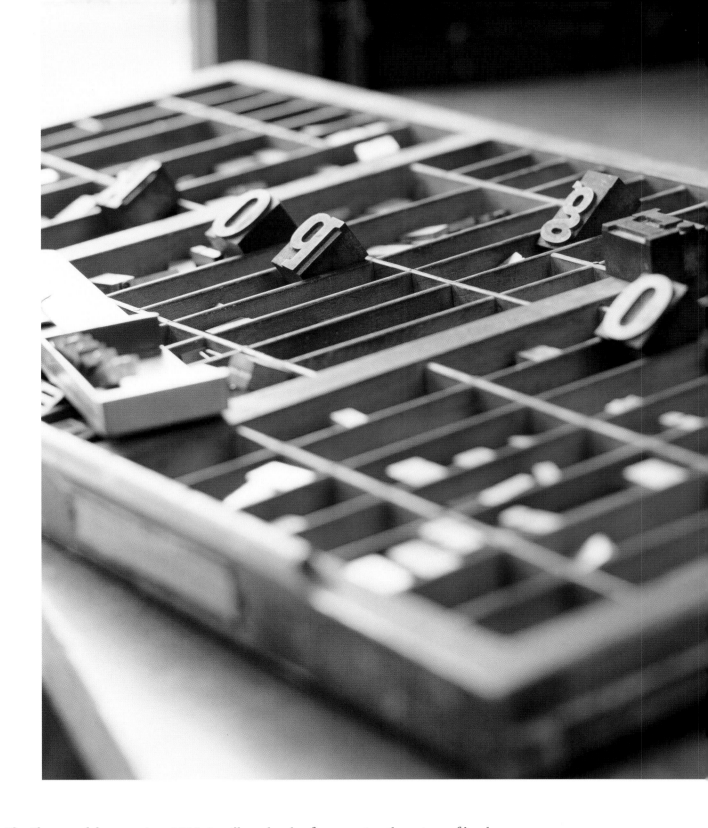

OPPOSITE The Platen pedal press, circa 1880, is still used today for stamping the spines of books. The owner purchased the press in the 1960s for a hundred dollars from a street vendor who just wanted it out of his basement. ABOVE Letters used to typeset Michael Ondaatje's first book, *Dainty Monsters*, in 1966 on the Linotype machine, circa 1917.

ABOVE A library of books published by Coach House Press. As Sarah Sheard wrote in *Toronto Life* magazine, April 1997, "Over the past 36 years, writers, artists, printing and computer techies, photographers, publishers, typographers and everyone else who caressed well-written, well-designed books shared sensibilities and artistic quirkiness in the Coach House." OPPOSITE The editorial room in the loft doubles as a place for staff to gather for coffee and conversation. The chairs, bench and tabletop, an old door, were all found in the garbage.

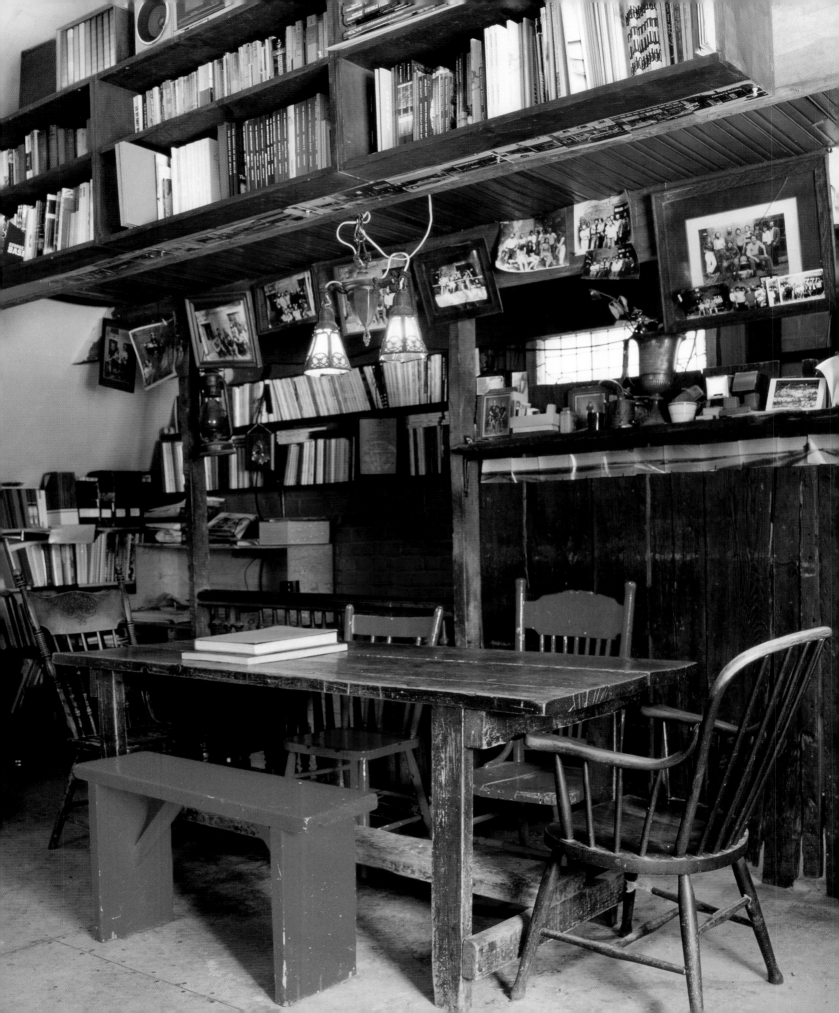

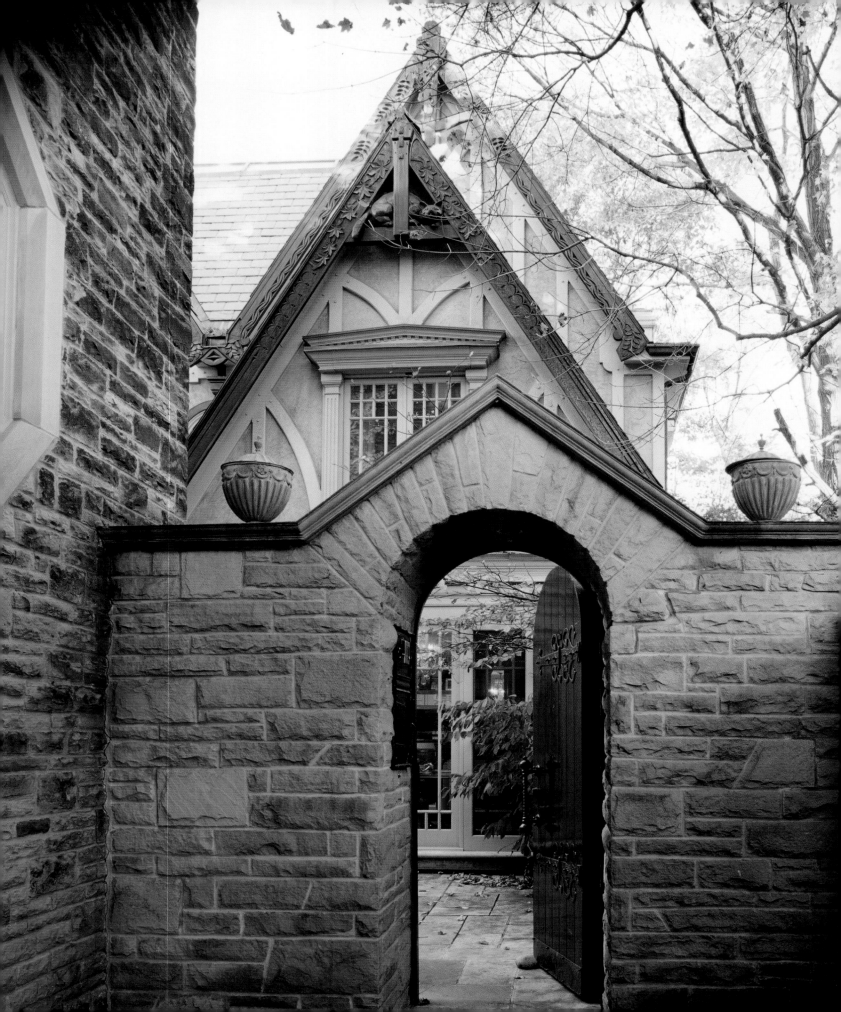

The Grand Garage

Built in 1929 as a grand garage, this magnificent Tudor Revival style coach house sits majestically overlooking Craigleigh Gardens in Rosedale. The main house, an extravagant thirty-room mansion, was built by Norman Seagram, the son of the owner of one of the country's largest distilleries. On his death, the mansion and estate were acquired by the Jesuit Order of Canada. In 1980, a young, ambitious architect purchased the property. He converted the main house into high-end condominiums and began converting the garage into a coach house to use as his residence. As the building was in such disrepair, only the front gable was salvaged from the original façade. The interior structure was reinforced, additions added, and the new exterior covered with coursed stonework to match the main house. The result is a magnificent three-storey Tudor Revival coach house and terrace. An entry gate with a peaked stone wall and arched door was erected to ensure privacy from the main house condominiums.

The entry gate and arched door leading to the coach house.

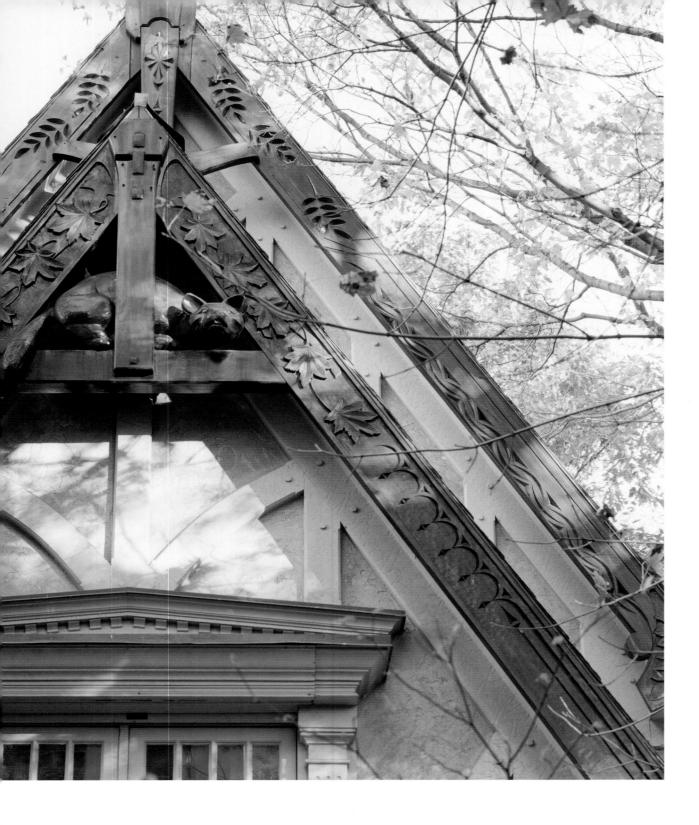

ABOVE A Swiss sculptor was commissioned to add the elaborate wood carving to the trim of the gable of the original garage. The carving features a magnificent stone marten. OPPOSITE Floor-to-ceiling French windows replaced the original garage doors and were also installed in the gable. Urns of flowering ornamental kale decorate the impressive terrace, constructed of reclaimed slate.

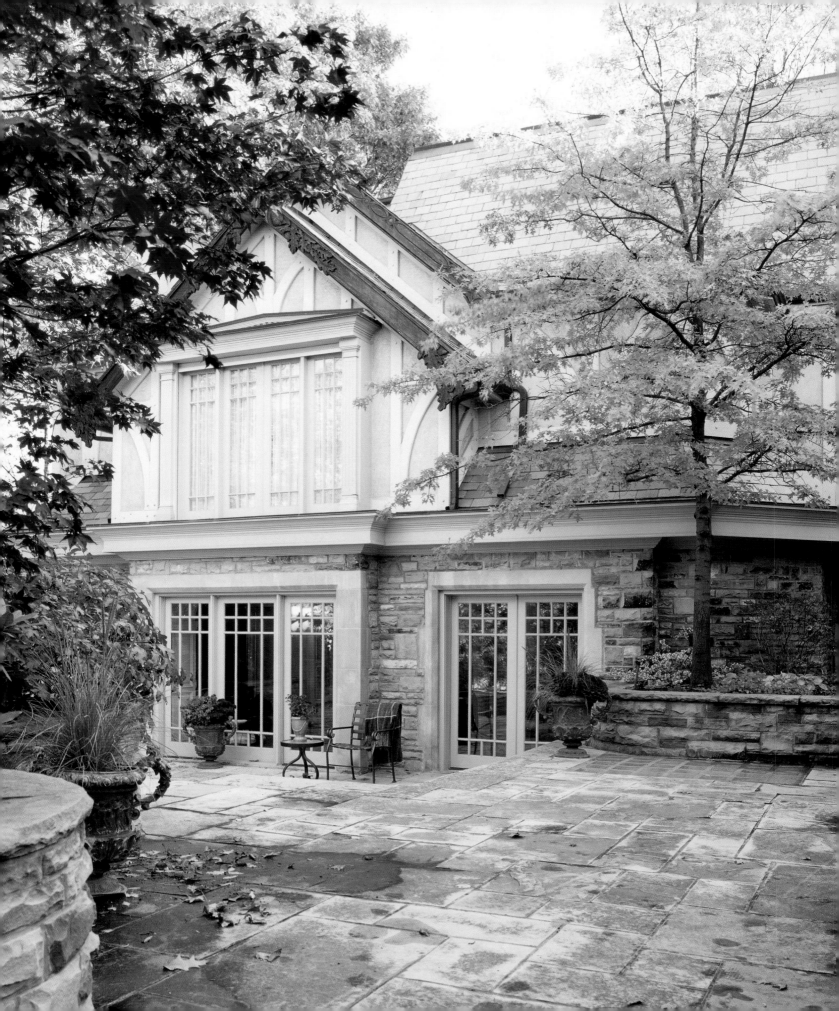

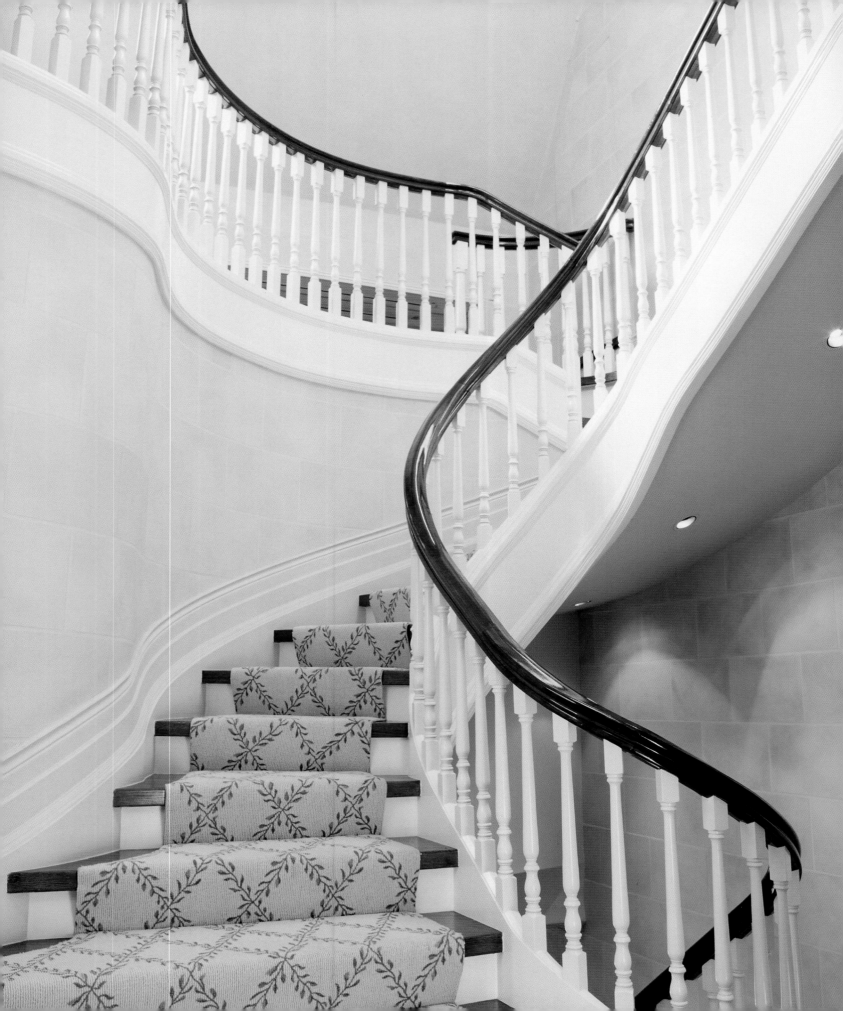

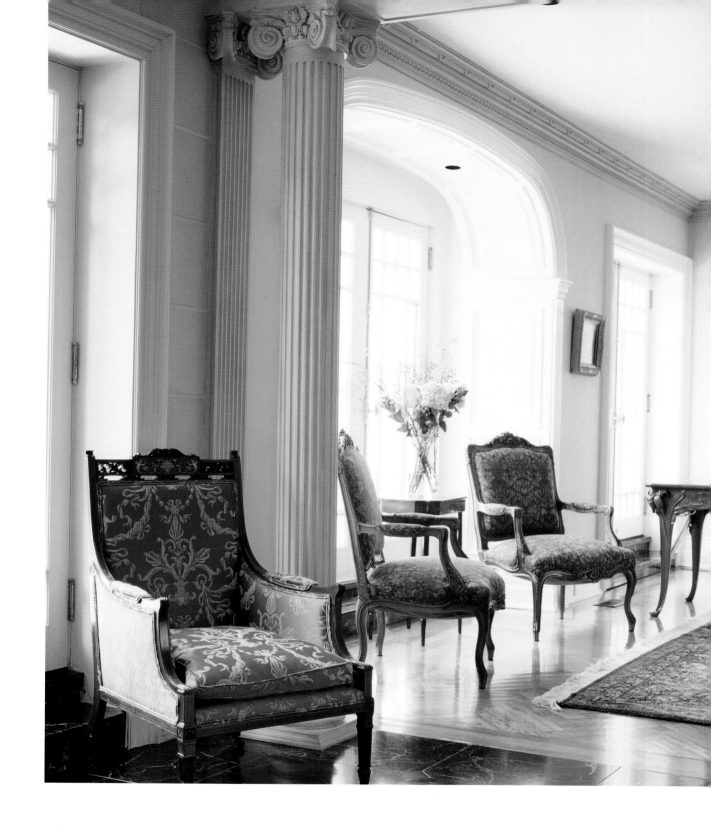

OPPOSITE A magnificent oak staircase with mahogany banister is a continuous
curve from the basement to the third floor. ABOVE A fluted column constructed
to hide a structural beam gives definition at the entrance to the grand living room.
A favourite antique chair upholstered in soft blue brocade and blue marble floors
are striking in the entrance foyer.

ABOVE AND RIGHT Close-up of the Venetian crystal chandelier and one of the two star-patterned bull's eye windows on the staircase wall. OPPOSITE The regal bathroom features a Venetian crystal chandelier, floor-to-ceiling French windows, blue marble flooring, and an ornate faux-painted fireplace.

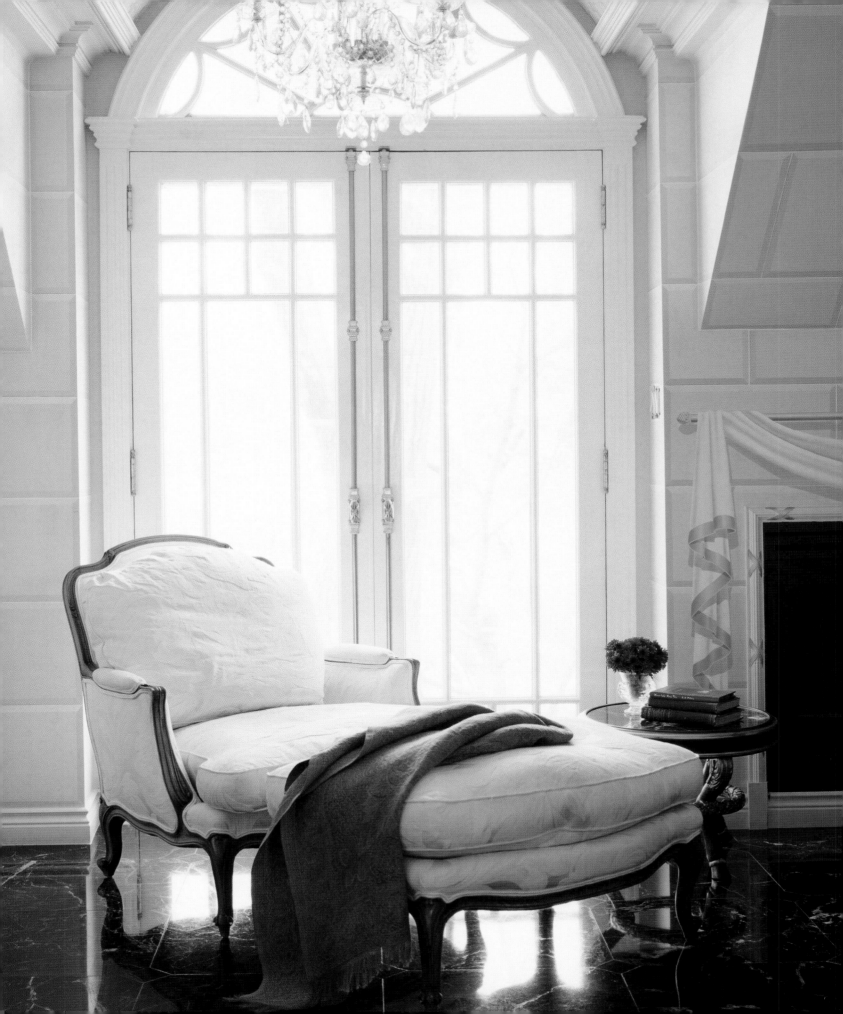

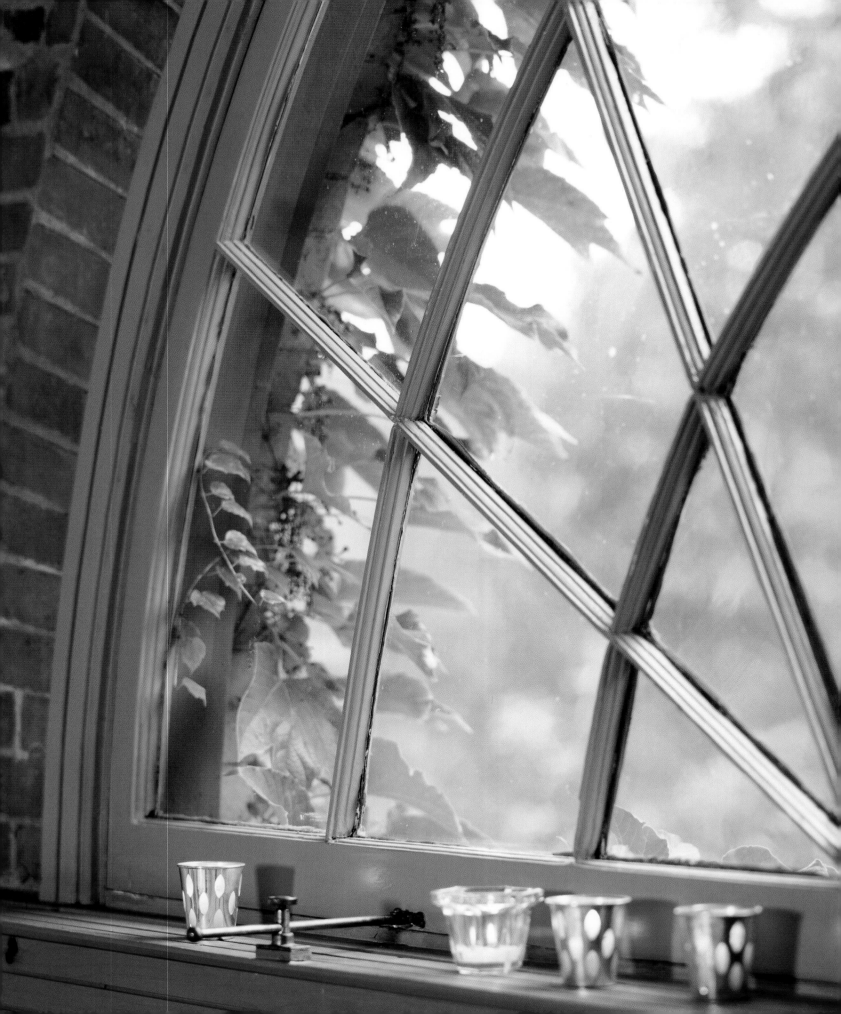

Home Away from Home

This coach house, built in 1882, was once part of a magnificent Victorian country estate owned by a daughter of Sheriff Jarvis and her husband, Lewis Ord, in the then slow-to-develop suburb of Toronto called Rosedale. It is rumoured that the family used the second floor of the coach house as a theatre for performing artists to entertain friends and colleagues. A local architect purchased the coach house in the early 1970s and began one of the first conversions of a coach house in the area. His goal was to create a beautiful office and living space incorporating the cupola, the ornate quarter-round wood windows and much of the original interior brick and façade in a radically new design. The renovation features an elaborate pine cathedral ceiling with exposed beams, a pine circular staircase and a magnificent hearth. The coach house was sold in the late 1970s to new owners, who rent it out as a "home away from home" for movie stars and celebrities on location in Toronto. Today the coach house sits pastorally among gracious inner city mansions in Rosedale, a most desirable area of Toronto.

Fine detail is the signature of this quarter-round wood window.

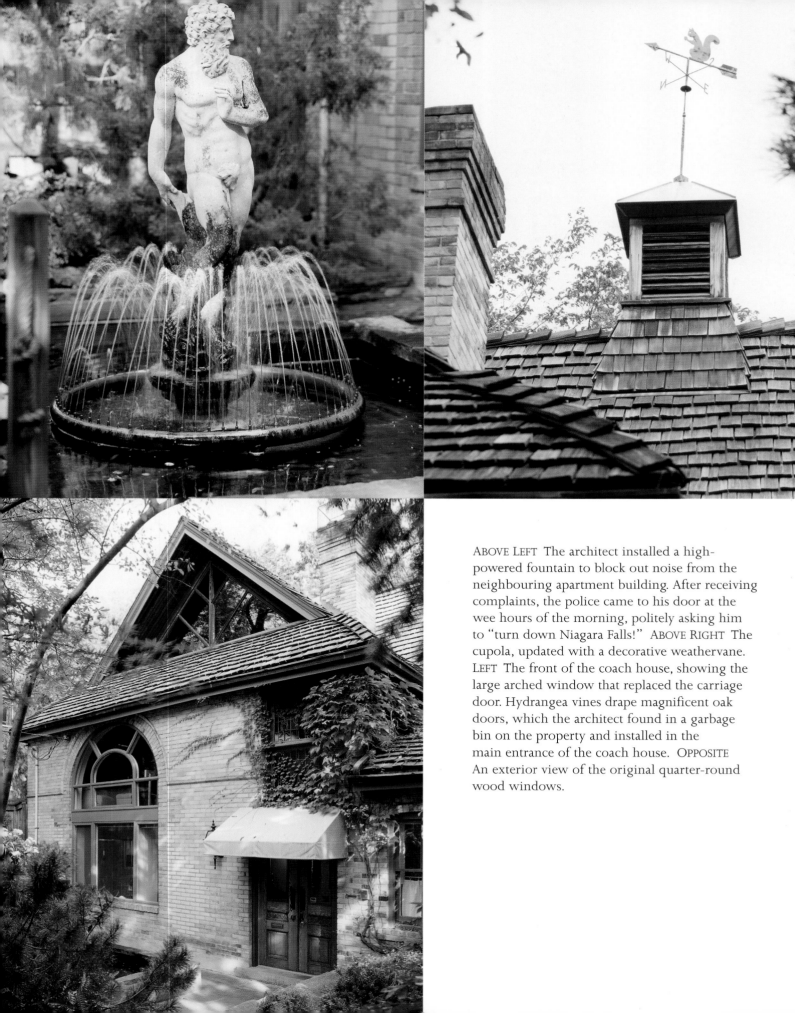

ABOVE LEFT The architect installed a high-powered fountain to block out noise from the neighbouring apartment building. After receiving complaints, the police came to his door at the wee hours of the morning, politely asking him to "turn down Niagara Falls!" ABOVE RIGHT The cupola, updated with a decorative weathervane. LEFT The front of the coach house, showing the large arched window that replaced the carriage door. Hydrangea vines drape magnificent oak doors, which the architect found in a garbage bin on the property and installed in the main entrance of the coach house. OPPOSITE An exterior view of the original quarter-round wood windows.

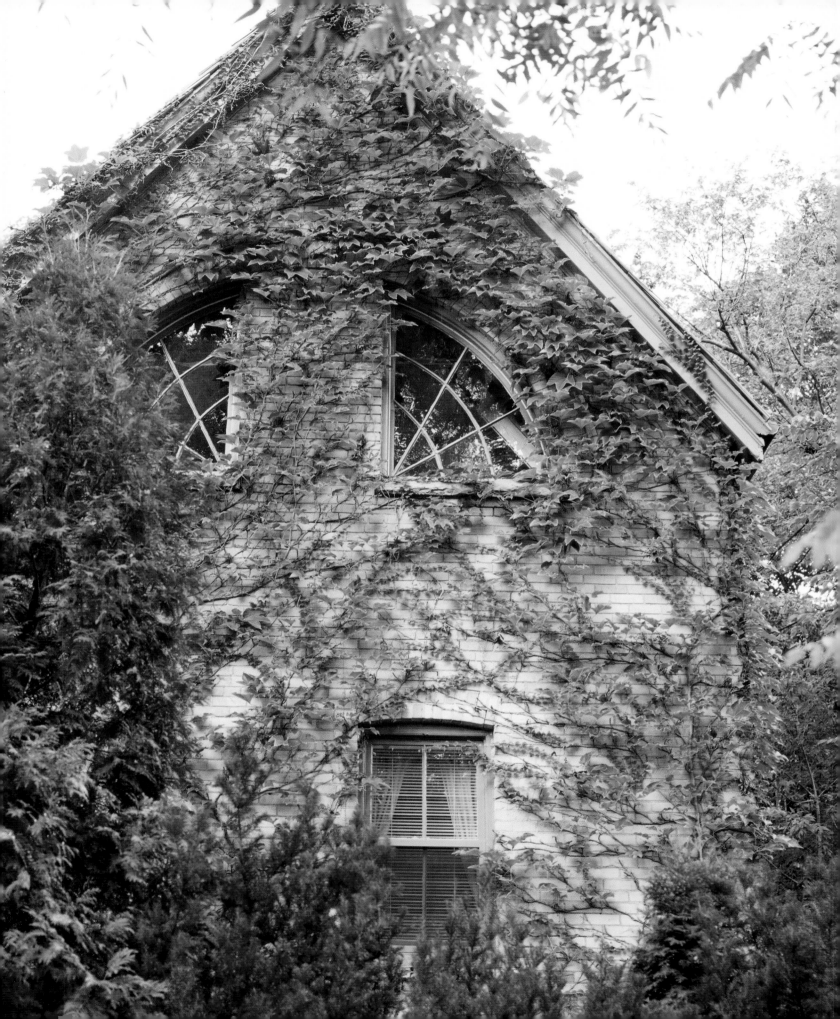

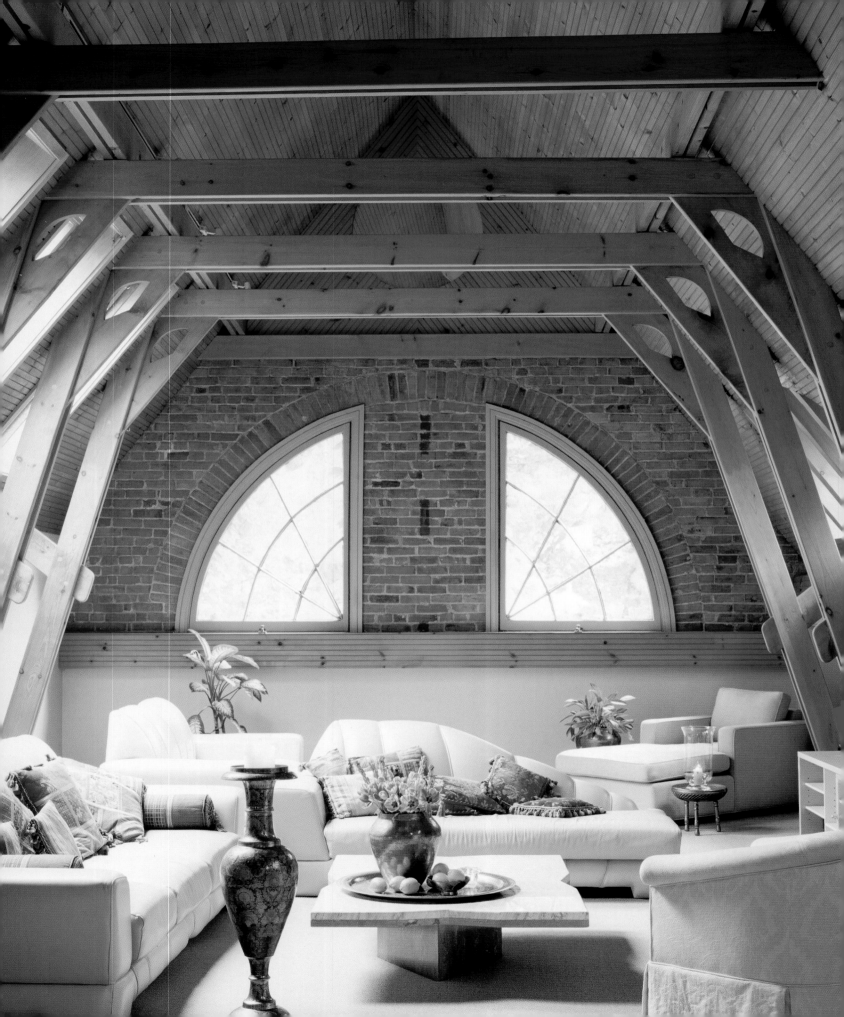

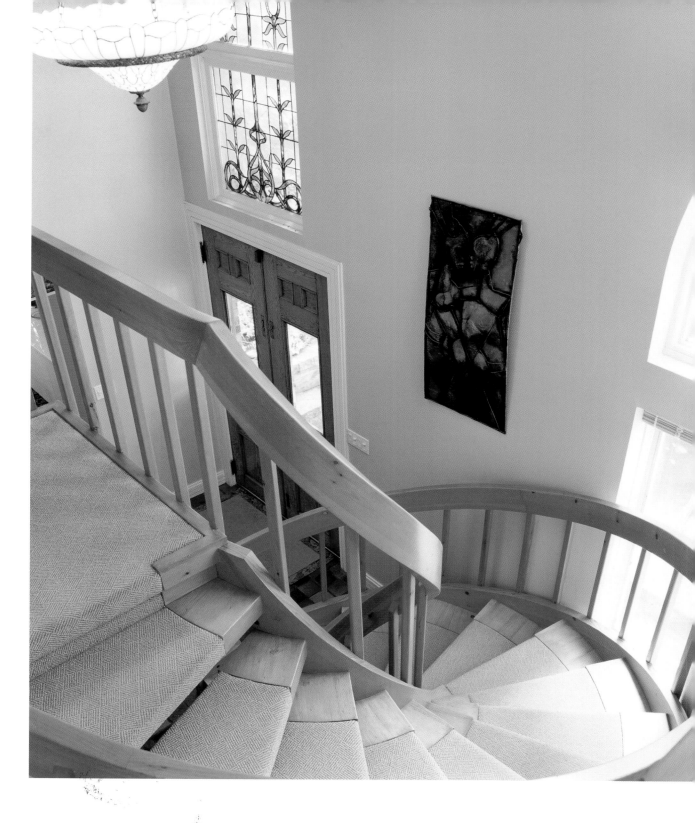

OPPOSITE The living room, once the architect's office, features an elaborate pine
cathedral ceiling, exposed brick and original quarter-round wood windows.
ABOVE The circular pine staircase leading to the second-floor living room.
The hayloft door above the oak doors was replaced with a colourful
hand-painted window.

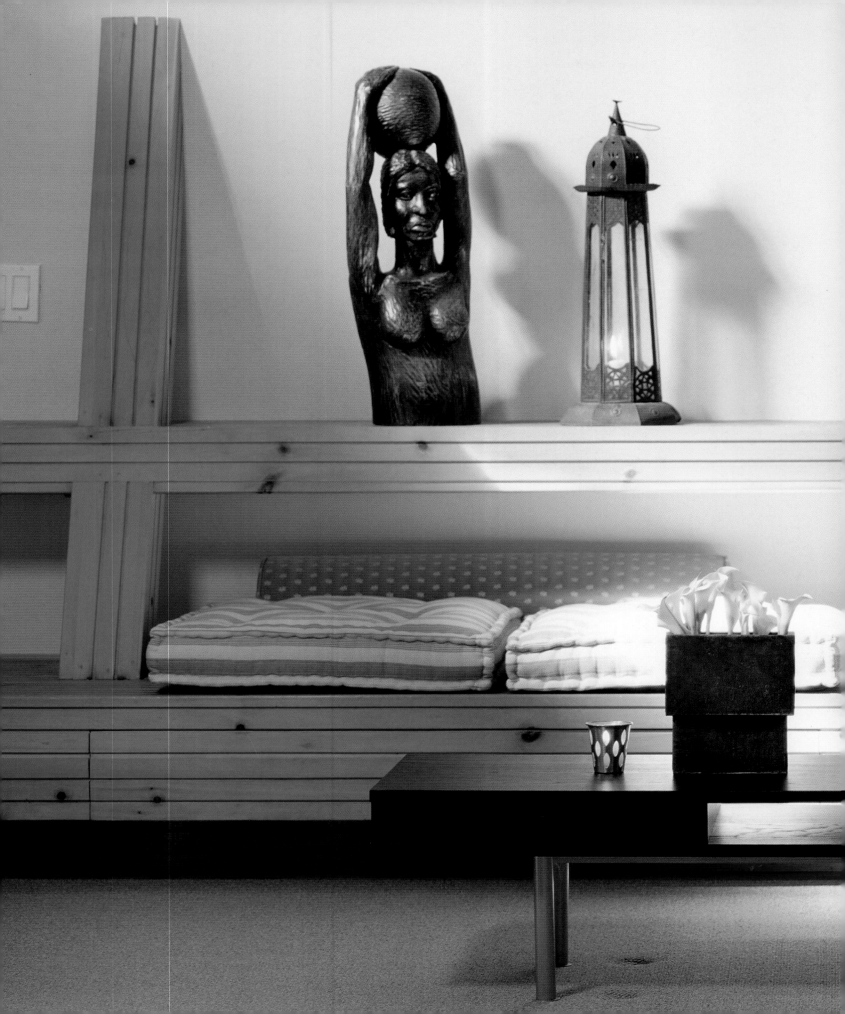

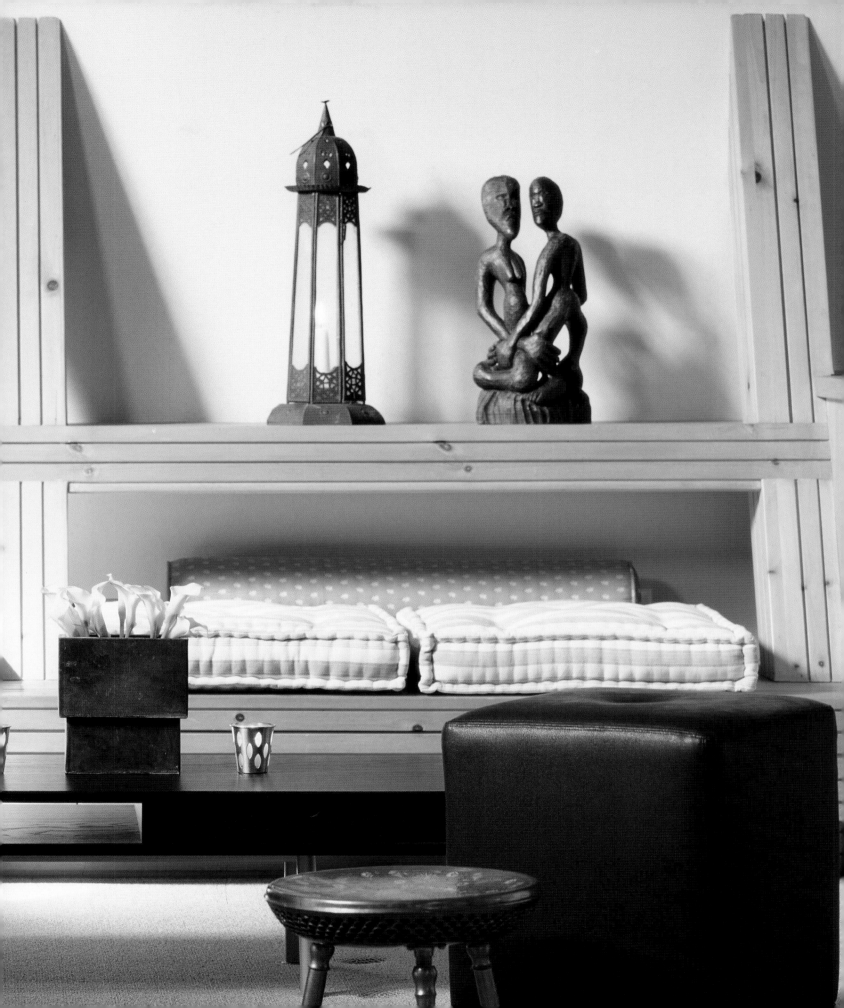

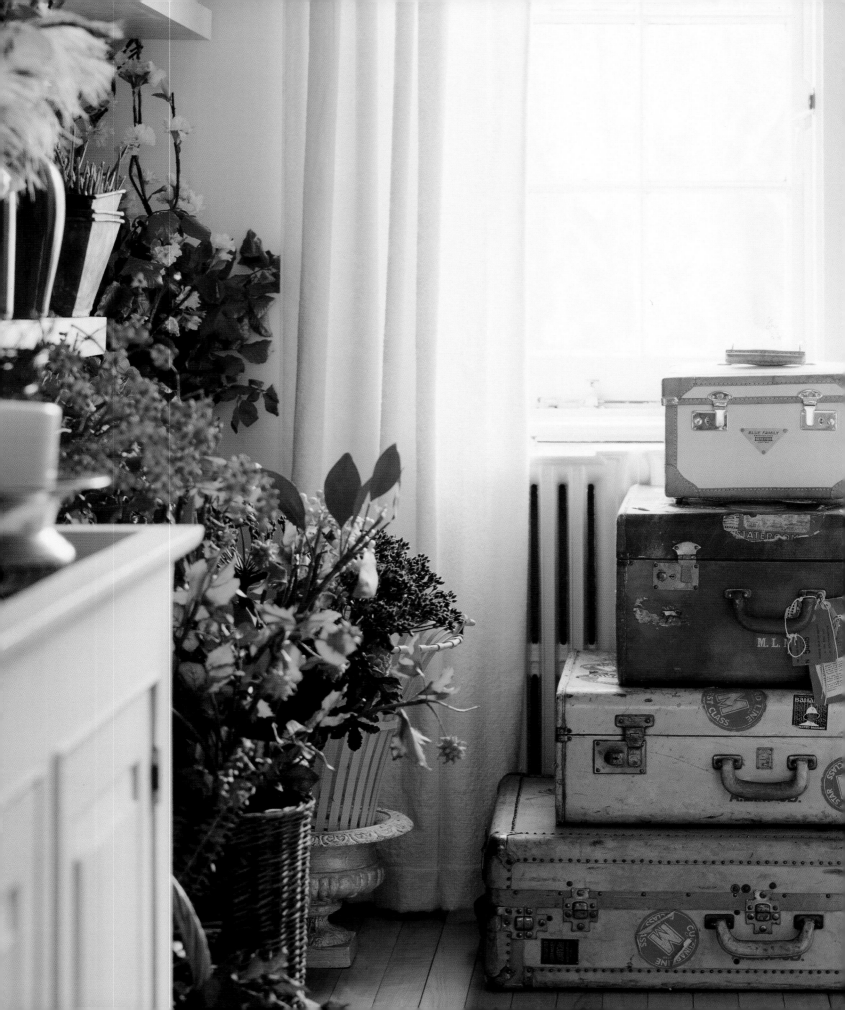

The Rock Star's Guest House

Magnificent gardens embellish this enchanting Edwardian coach house, built in 1907 on land that was once part of the original Chestnut Park estate, now part of Rosedale. The property originally belonged to a prominent watchmaker and retailer. The present owners, lead guitarist for a famous Canadian rock band and his artist wife, purchased the house in 2000 and began an extensive renovation of the coach house and gardens, which are now almost completely hidden from the main house. As the main house was traditional, the goal of the renovation was to create a light and airy casual beach-house feel in the old groomsman's quarters above the existing garage. The owners' son, a local designer, successfully combined a working studio for his artist mother and accommodations for visiting relatives and friends in the sun-filled one-room living and working space. He preserved the original floors, windows and beams, while honouring his mother's decorating requests. The existing gardens were replaced with lush creeping vines and exotic landscaping, complete with fountains, furniture, art and antiquities reflecting the family's many years of travel.

A collection of vintage suitcases, circa 1950, with the original Cunard Lines Piers stickers and check-in tags still attached, is displayed beneath the window beside the island workspace.

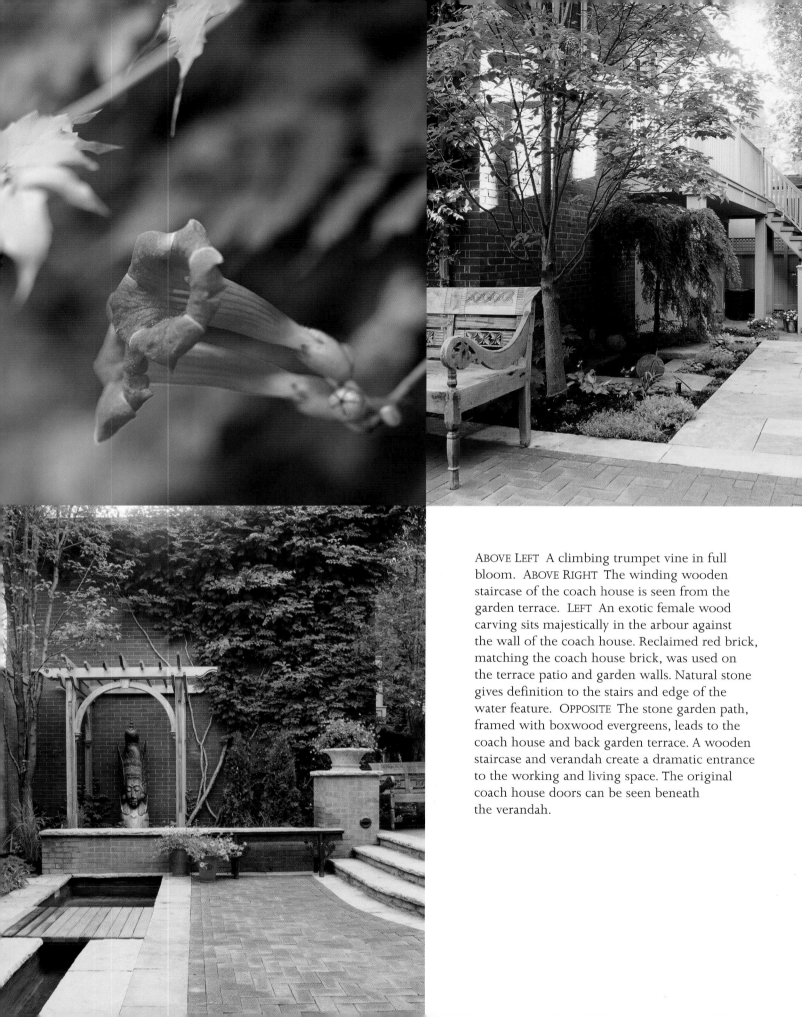

ABOVE LEFT A climbing trumpet vine in full bloom. ABOVE RIGHT The winding wooden staircase of the coach house is seen from the garden terrace. LEFT An exotic female wood carving sits majestically in the arbour against the wall of the coach house. Reclaimed red brick, matching the coach house brick, was used on the terrace patio and garden walls. Natural stone gives definition to the stairs and edge of the water feature. OPPOSITE The stone garden path, framed with boxwood evergreens, leads to the coach house and back garden terrace. A wooden staircase and verandah create a dramatic entrance to the working and living space. The original coach house doors can be seen beneath the verandah.

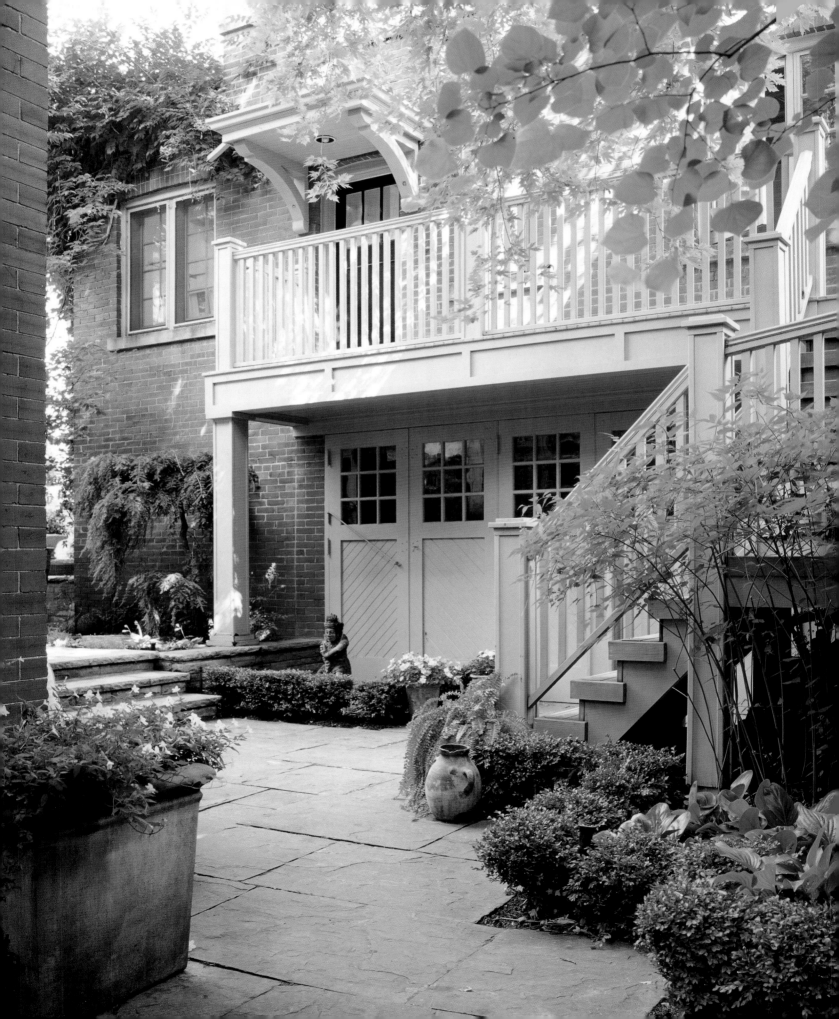

OPPOSITE An island from the kitchen of the main house was distressed, painted white and installed as a workspace for floral arrangements. A pine cabinet, also painted white, displays the owners' collections of vases, containers, wicker baskets and favourite CDs. Additional shelving provides storage for floral paraphernalia and collections of silk plants. Two contemporary glass lights provide extra lighting above the workspace. ABOVE Silk flowers, florals, pots and urns used by the artist. Shadow boxes, painted white, display some of her favourite keepsakes.

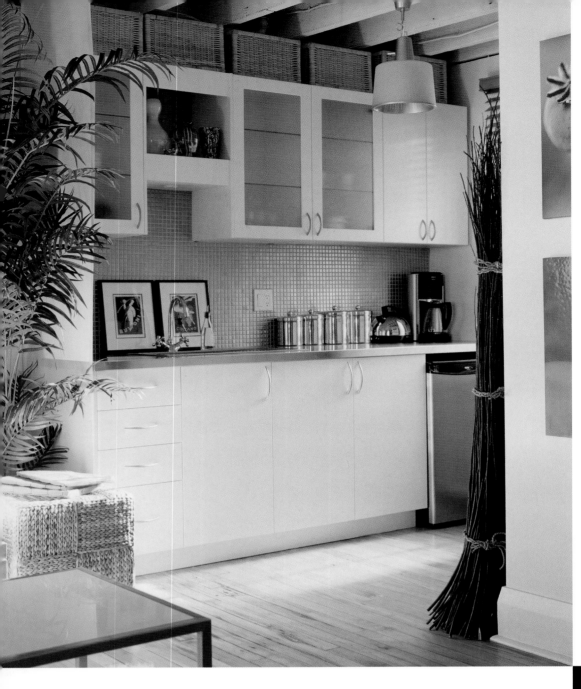

ABOVE Gun-metal mosaic tile and a stainless-steel countertop, sink and
bar fridge suit the contemporary style of the white kitchen cabinets in the
tucked-away kitchen galley. Wicker baskets provide extra storage and add
contrast below the exposed white beams. A modern tin light hangs from
the ceiling. RIGHT Antique Chinese novels, a prize find at a local market,
sit on a rope-cube end table. OPPOSITE An ocean-blue denim club chair
and a steel-glass coffee table displaying a collection of shells are light
and airy in this tiny living room. The drywall, which extends only to
the base of the original exposed beams, is painted white to lend a casual
beach-house sense. A white cotton trundle-bed sofa with an eclectic mix
of colourful Pucci pillows is flanked by silk palm trees. A white-painted,
bevelled walnut mirror reflects the exotic wood carving, moved from
the garden in the late fall, and the workspace, sectioned off by white
fabric sliding panels. Mongolian rugs cover the original pine floors.

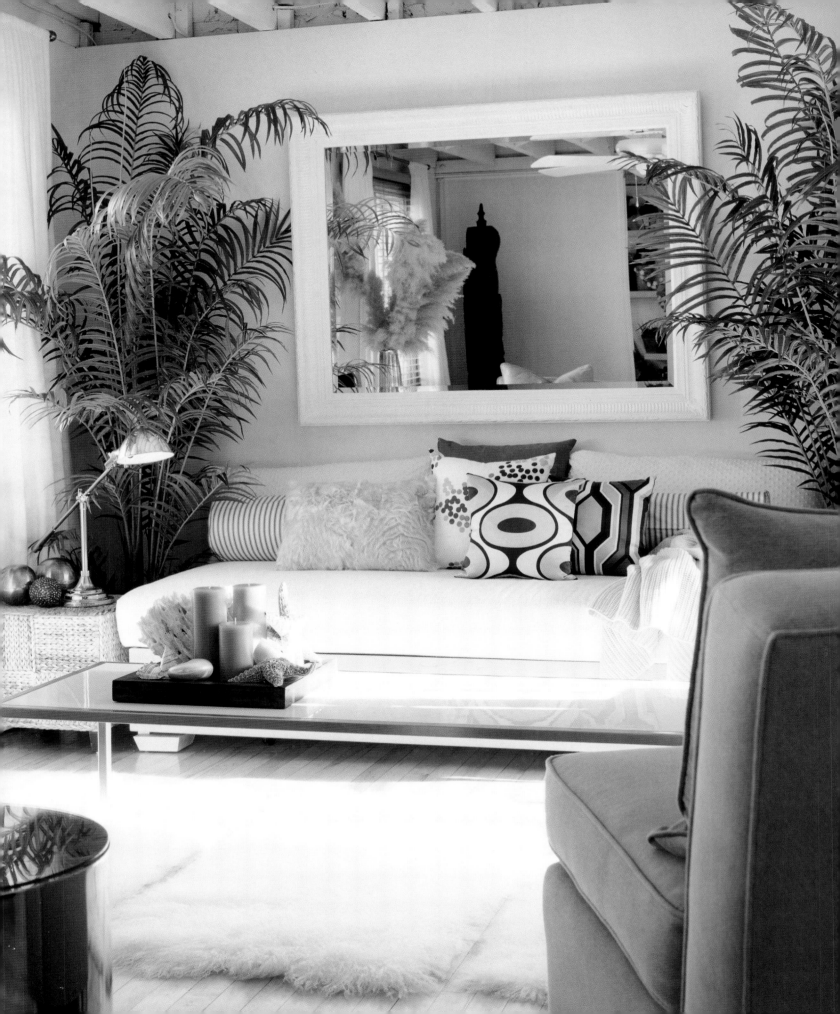

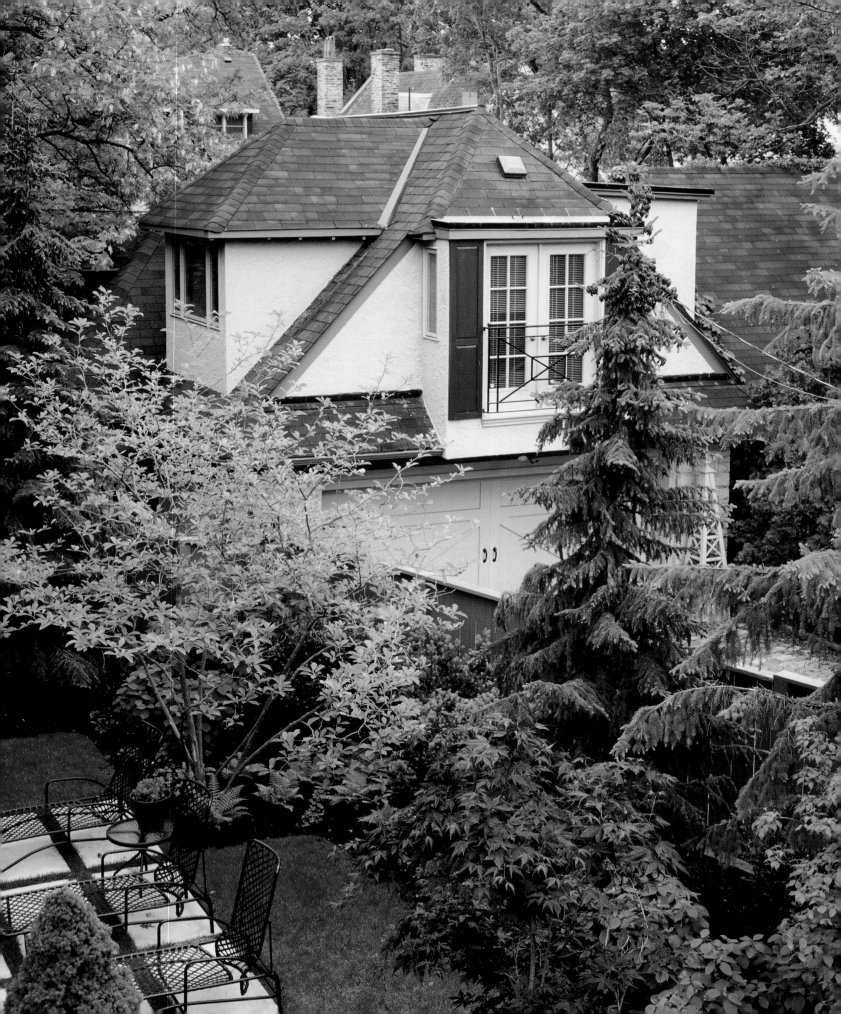

The Housekeeper's Home

Recently renovated by one of the city's internationally renowned residential designers, this grand garage was built in 1913 to house the family's horseless carriage and chauffeur. It sits nestled among the trees behind the main residence in the village of Forest Hill, where many of Toronto's aristocracy once built their country mansions. The present owner purchased the property in 2000 and began an extensive renovation of the main house and coach house. The goal of the coach house renovation was to create a sense of loftiness and spaciousness in just 500 square feet, while preserving the historical importance of the building. This was done beautifully by opening up ceilings, adding new windows and using contemporary furnishings to modernize the coach house. Says the designer proudly: "There is such a sense of privacy, and the coach house does not impose on the main residence. After all, the coach house was renovated to provide a residence for our housekeeper. Wouldn't you like to be our housekeeper?"

A view of the coach house from the second floor of the main residence showing the addition of dormers, new windows and the Juliet balcony on the upper storey. The beautiful miniature woodland of evergreen weeping spruce, ornamental trees, magnolia and Japanese maple provides privacy for the coach house, the pool and the terrace of the main house, yet links the properties together perfectly.

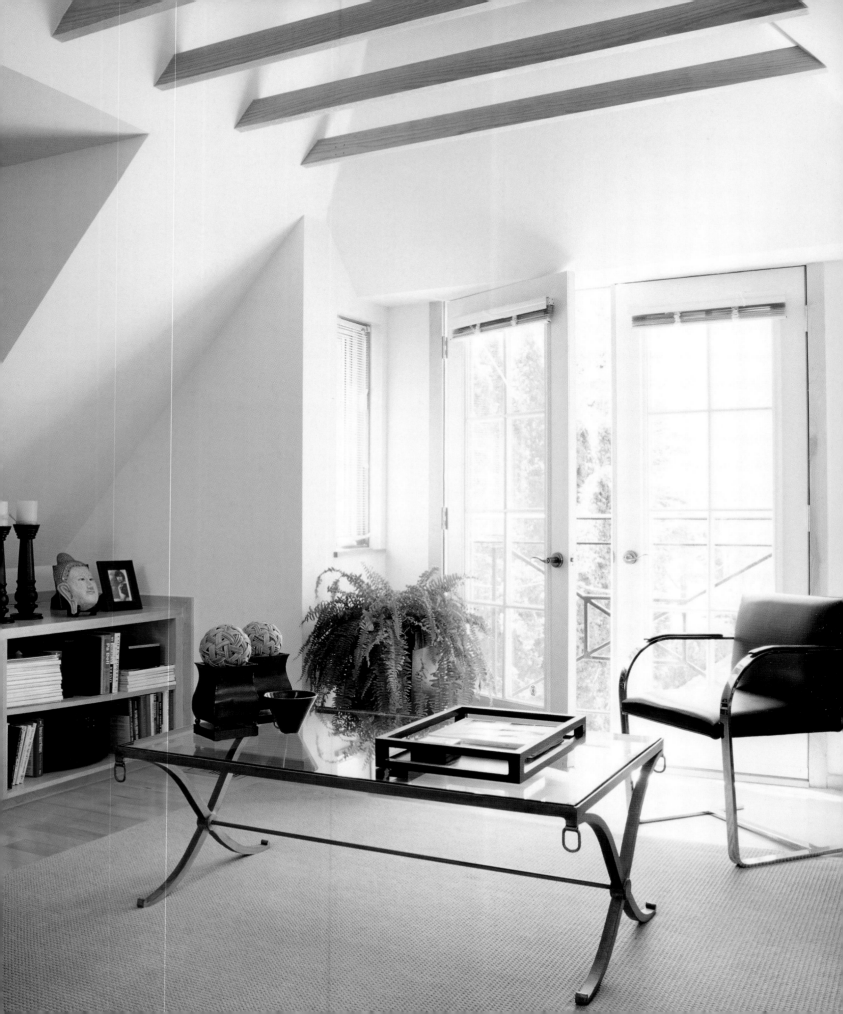

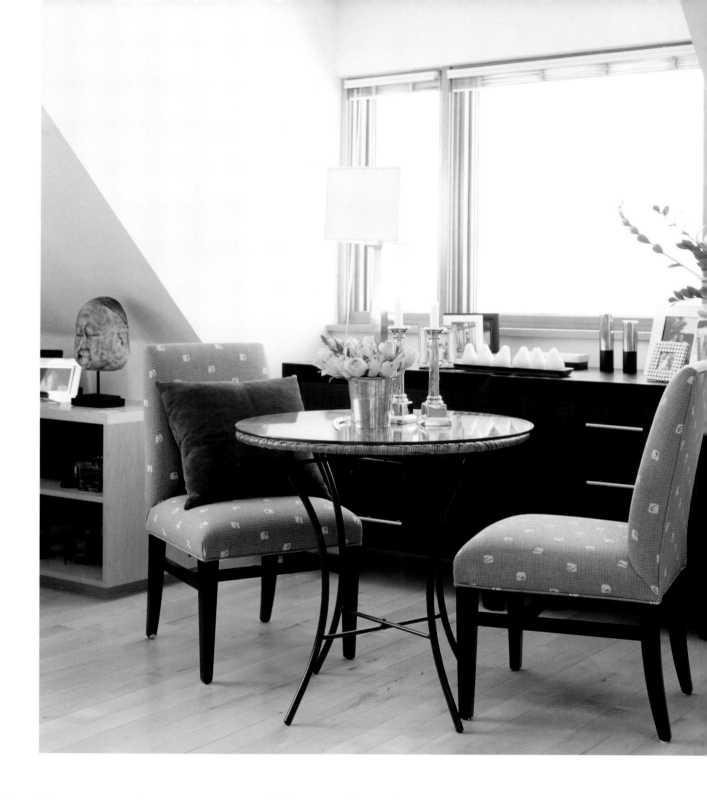

OPPOSITE The ceilings were opened up to create a sense of loftiness. Maple wood floors, beams and cabinets give a light and airy feeling to the small space. A maple cabinet provides storage under the roof slope, and a beautiful black leather 1927 Bruno chair adds contemporary drama to the living room. French windows open to the Juliet balcony. ABOVE The dining area is eclectic and relaxed, pairing two beautiful Parson chairs and a café garden table set with a bouquet of seasonal roses. The ebony cabinets provide extra storage and add contrast to the natural wood.

ABOVE The main house and garden terrace as seen through the French windows of the coach house. OPPOSITE A vintage bicycle with a basket of ivy and white snapdragons sits in front of the garage. A beautiful obelisk, planted with New Guinea impatiens and English ivy, adds interest and complements the stone brick and driveway.

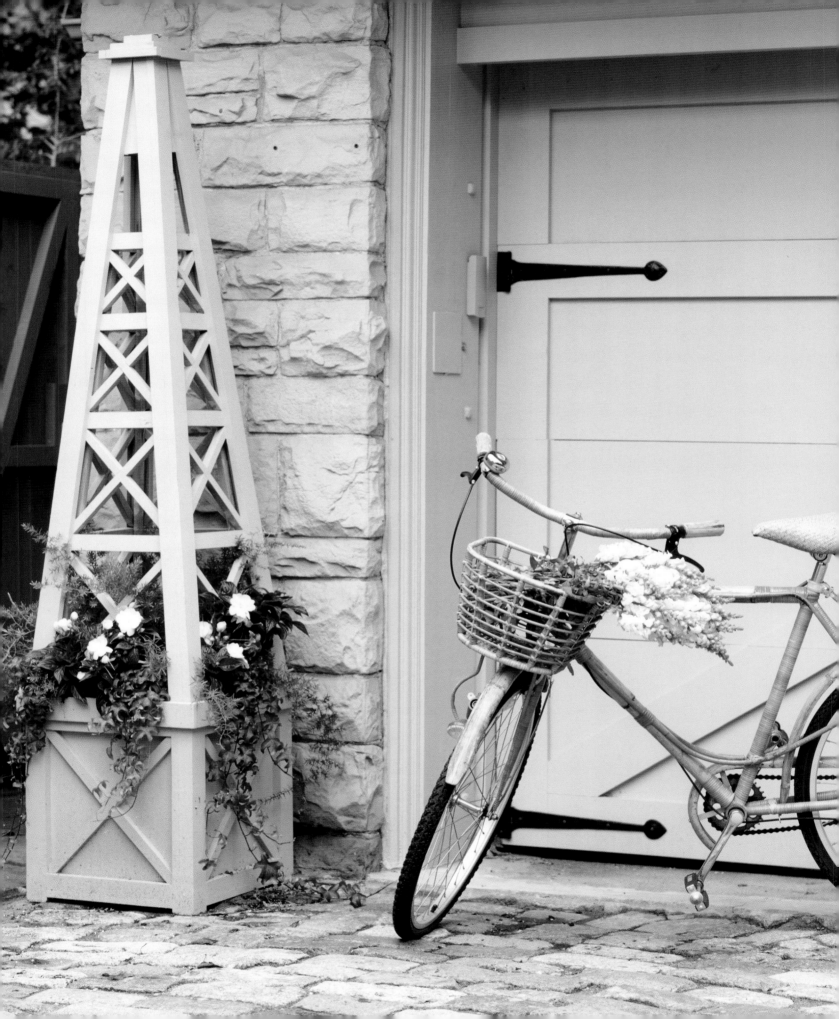

Child's Play

This beautiful Flemish coach house, built in 1903, awaits only steps behind the main house on a shady street in the Annex. The exterior is perfectly preserved, looking almost exactly as it did at the turn of the 20th century when it was used to house the carriage and pair and provide accommodation for the groomsman. The present owners, a professional and his artist wife, purchased the property in 1996. They decided to use the coach house as a playhouse for their children. They updated the interior by installing a wood stove and carpets and painting the walls a cheery pumpkin and eggplant. Extensive copper was added to the eaves, flashing, downspouts and dormer to further enhance the exterior of this charming, vine-covered building. "My children spend hours back here playing and painting," explains the owner. "One day I hope to use the space for a children's art studio."

A decorative concrete urn with fruit on the main house stone terrace railing.

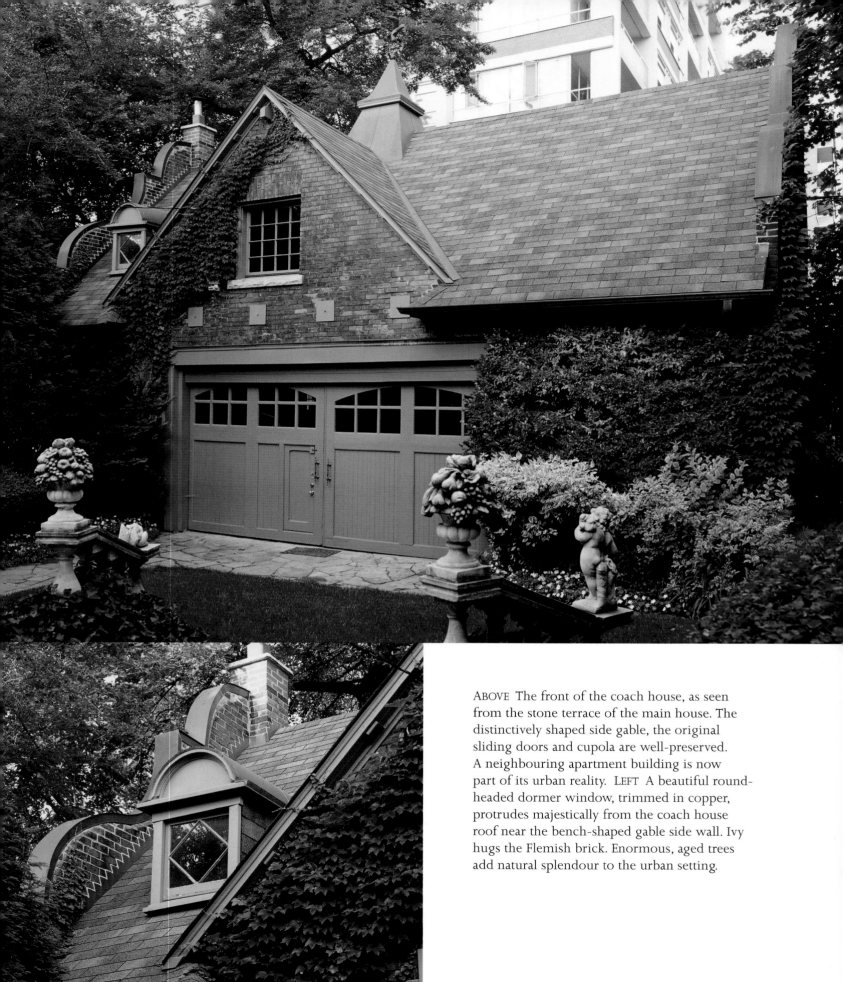

ABOVE The front of the coach house, as seen from the stone terrace of the main house. The distinctively shaped side gable, the original sliding doors and cupola are well-preserved. A neighbouring apartment building is now part of its urban reality. LEFT A beautiful round-headed dormer window, trimmed in copper, protrudes majestically from the coach house roof near the bench-shaped gable side wall. Ivy hugs the Flemish brick. Enormous, aged trees add natural splendour to the urban setting.

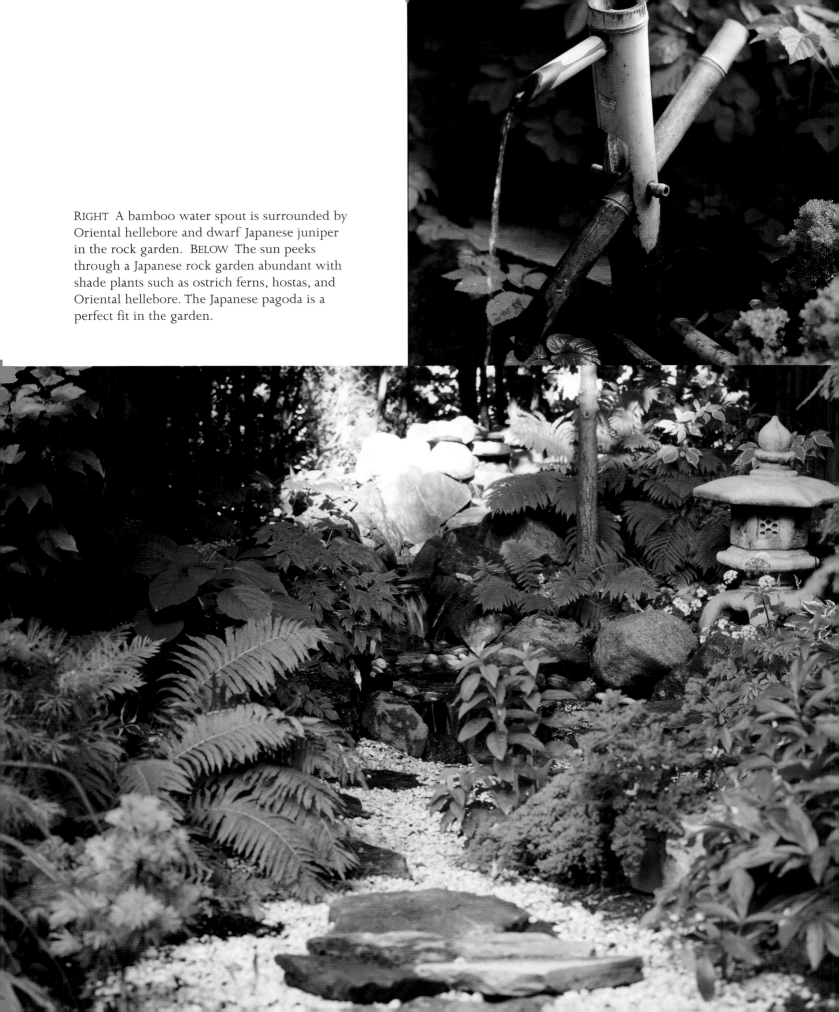

RIGHT A bamboo water spout is surrounded by Oriental hellebore and dwarf Japanese juniper in the rock garden. BELOW The sun peeks through a Japanese rock garden abundant with shade plants such as ostrich ferns, hostas, and Oriental hellebore. The Japanese pagoda is a perfect fit in the garden.

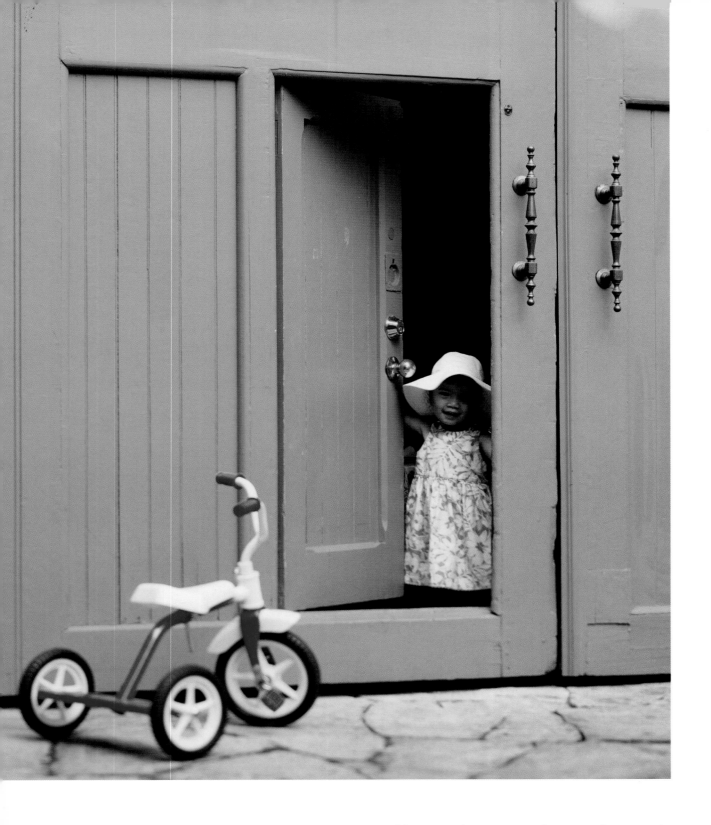

ABOVE Two-year-old Katie strikes a pose in the original passage door, part of the large sliding coach house door. OPPOSITE Seven-year-old Declan, an aspiring artist, touches up one of his masterpieces as Big Bunny and friend wait for Katie to join them for afternoon tea.

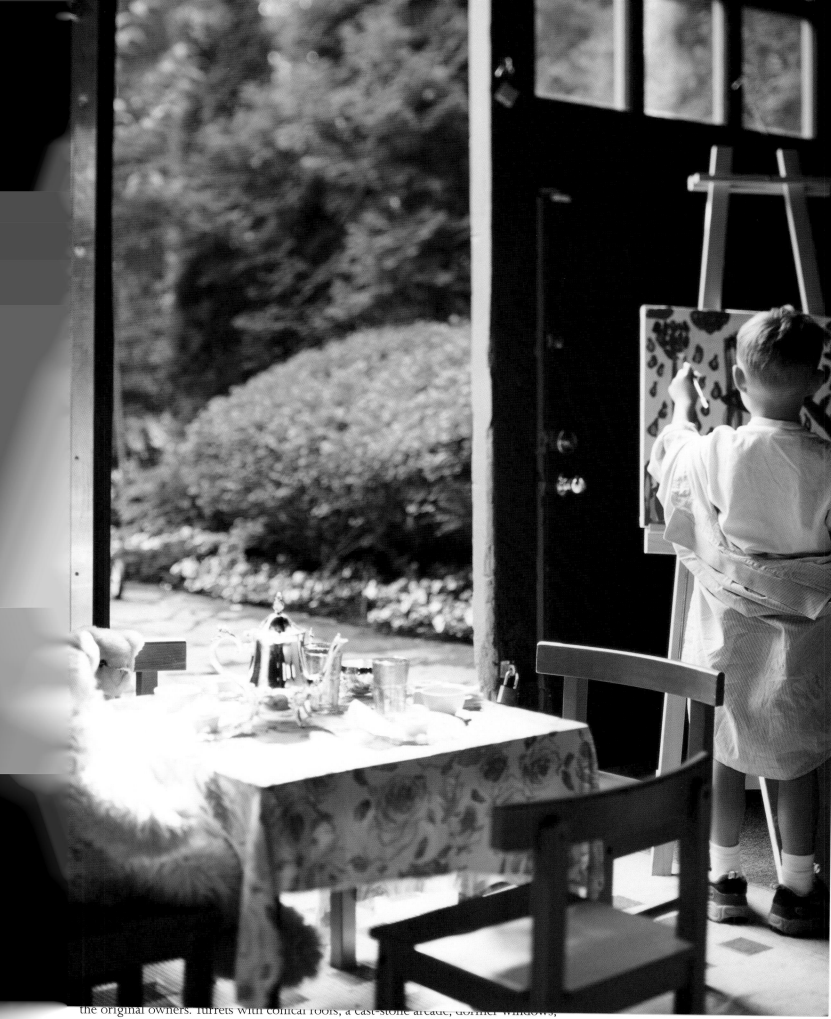

the original owners. Turrets with conical roofs, a cast-stone arcade, dormer windows, stepped gables and towers add romance and intrigue to this elaborate Gothic fantasy.

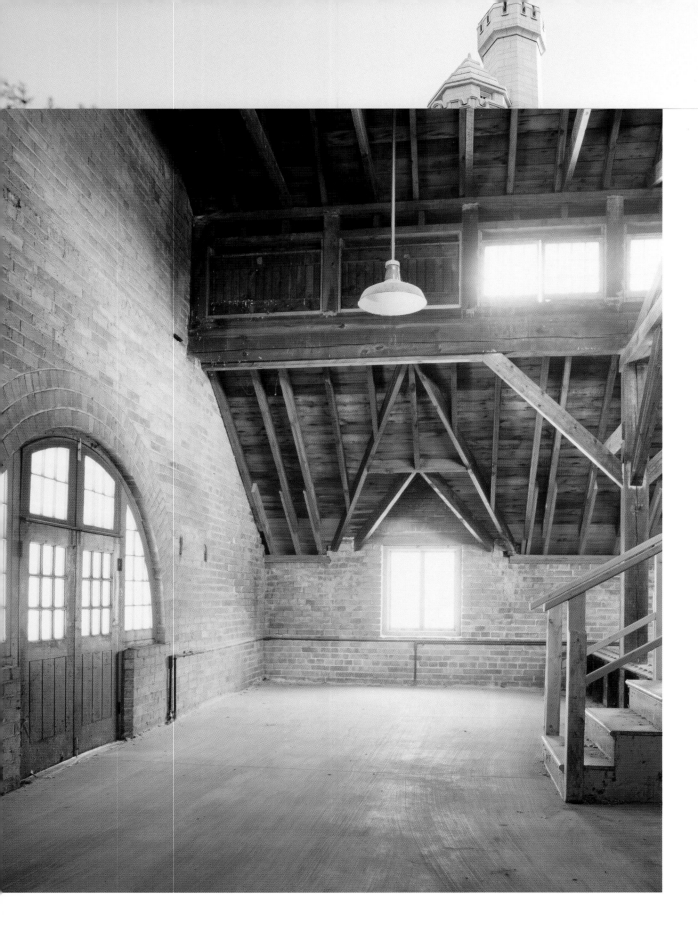

ABOVE The hayloft doors open to allow for the delivery of grain and hay.
OPPOSITE View of the hayloft showing the intricate, exposed-beam construction,
the clerestory windows and the bridge over the stalls.

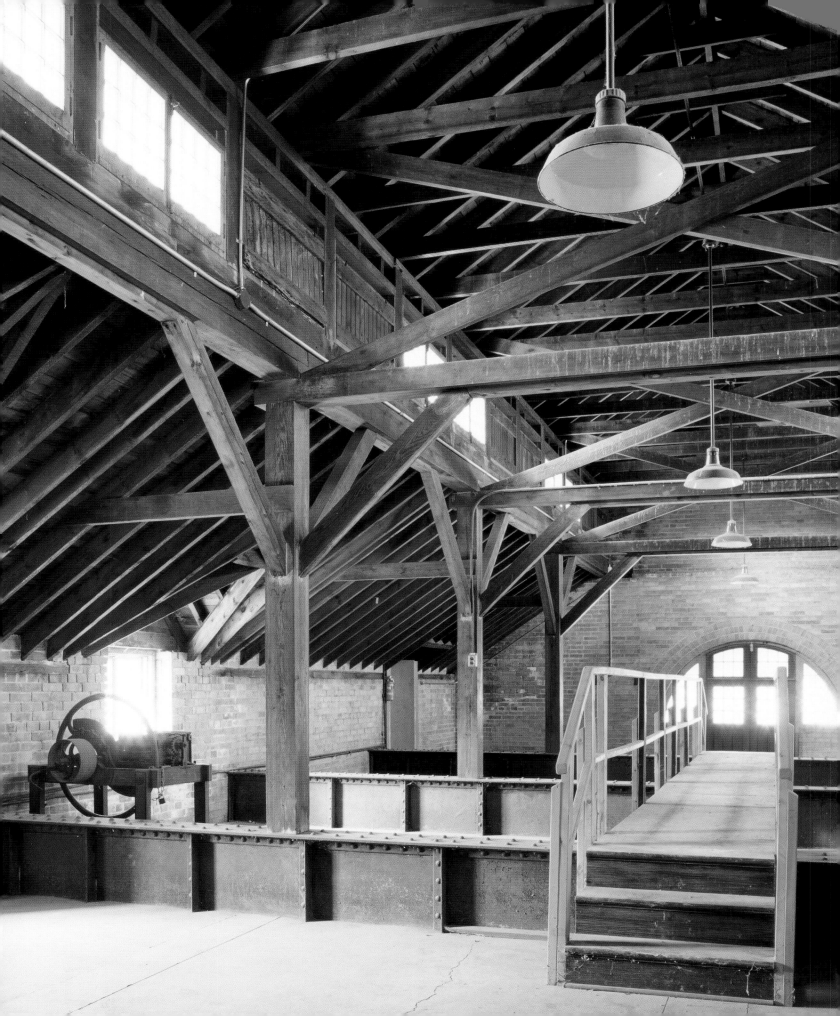

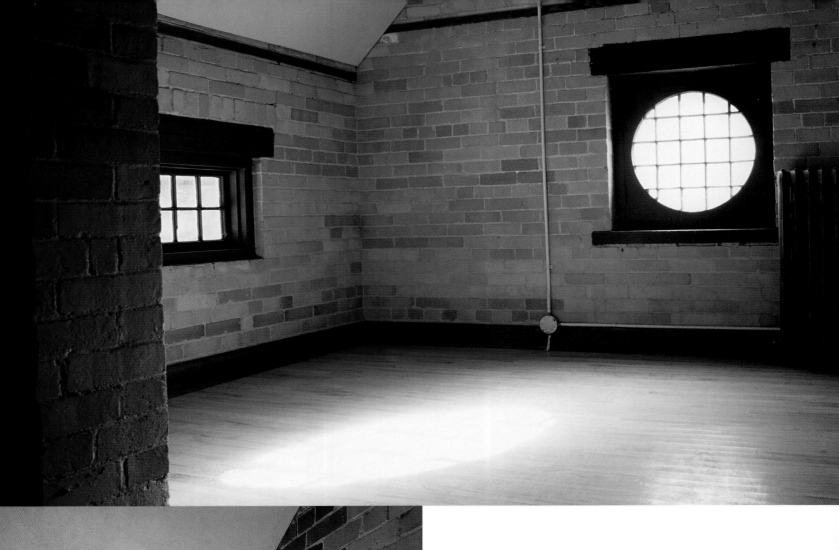

ABOVE In the head groomsman's large apartment, the red oak flooring remains in fine condition, as does the bull's eye window, red brick detailing and the original radiators. LEFT A curved wall marks one of the smaller staff apartments, probably for a stable boy. OPPOSITE The groomsmen and stable hands lived in small apartments in the tower above the carriage house. This metal spiral staircase inside the tower provided the only access to these apartments.

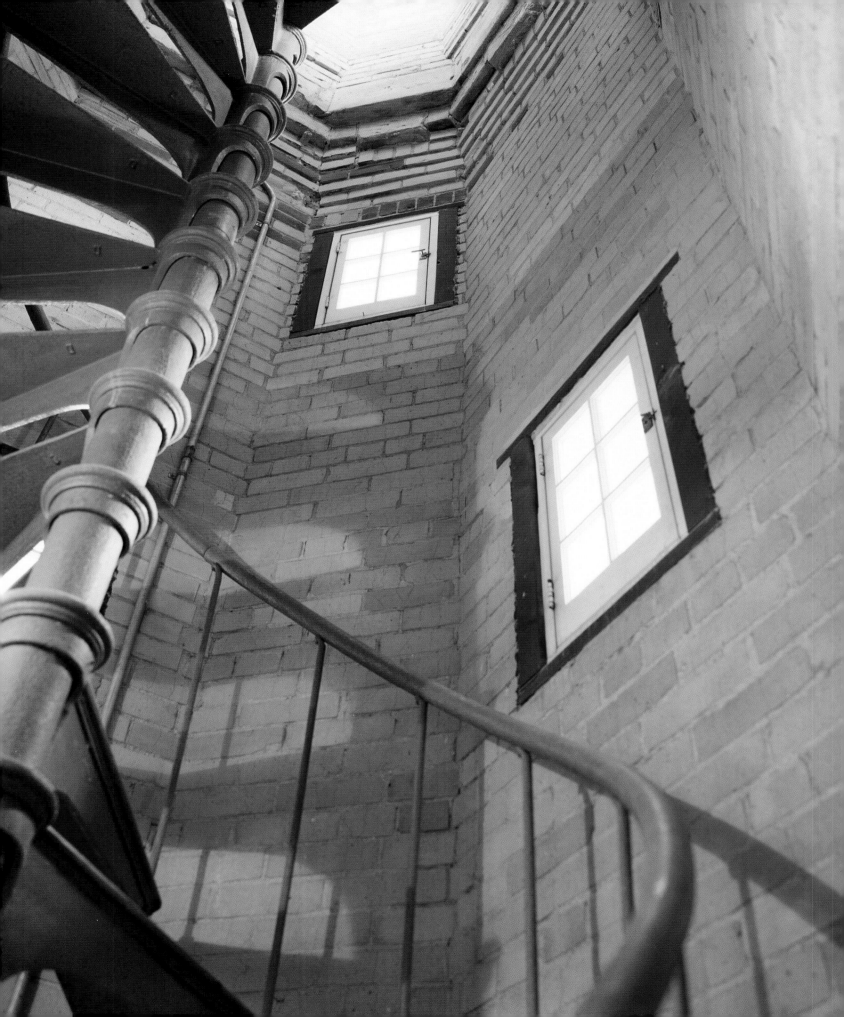

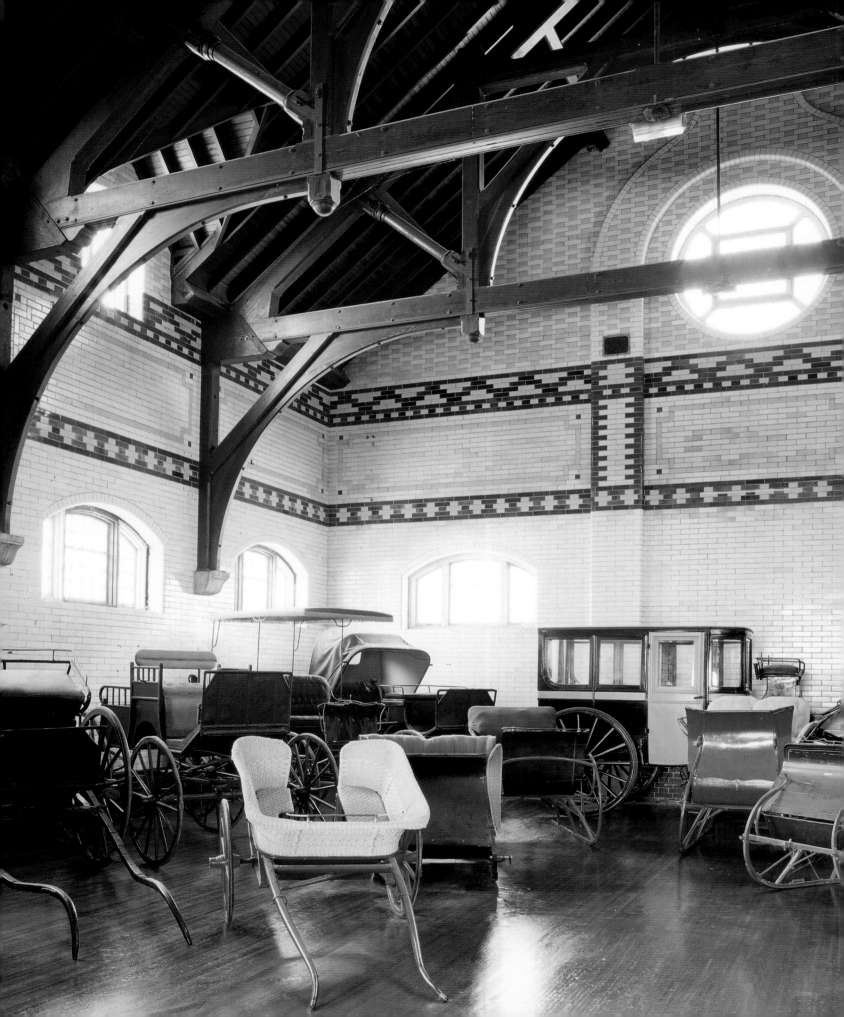

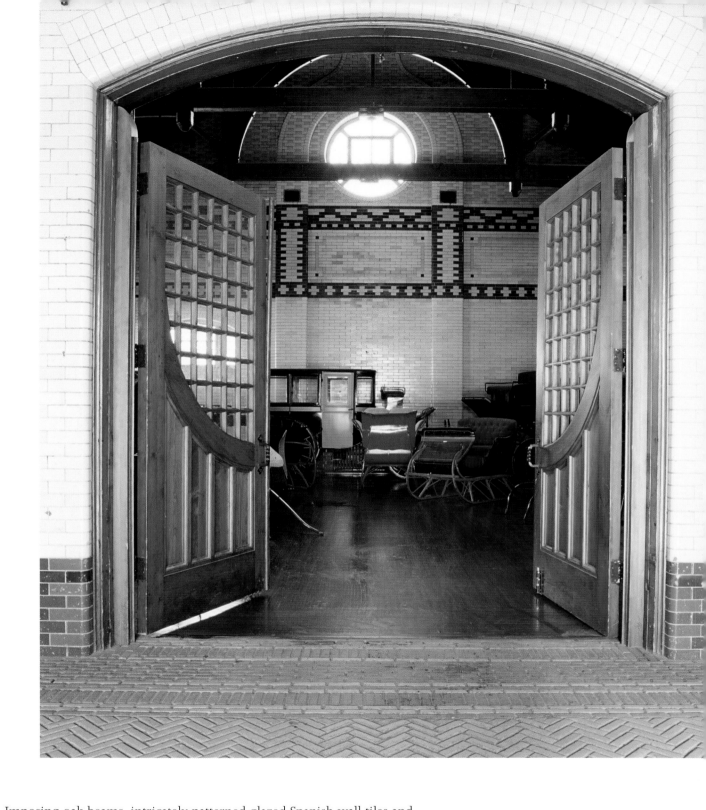

OPPOSITE Imposing oak beams, intricately patterned glazed Spanish wall tiles and
a fine oak floor create an ideal platform for a collection of vintage horse-drawn
carriages. ABOVE The magnificent oak-panelled doors of the carriage room open
to display vintage carriages, a beautiful bull's eye window and splendid open-
beam construction. Glazed tiles imported from Spain and installed by local artisans
were a perfect choice for the floor of the foyer, where mud and rain would have
been brought in by the horses and carriages.

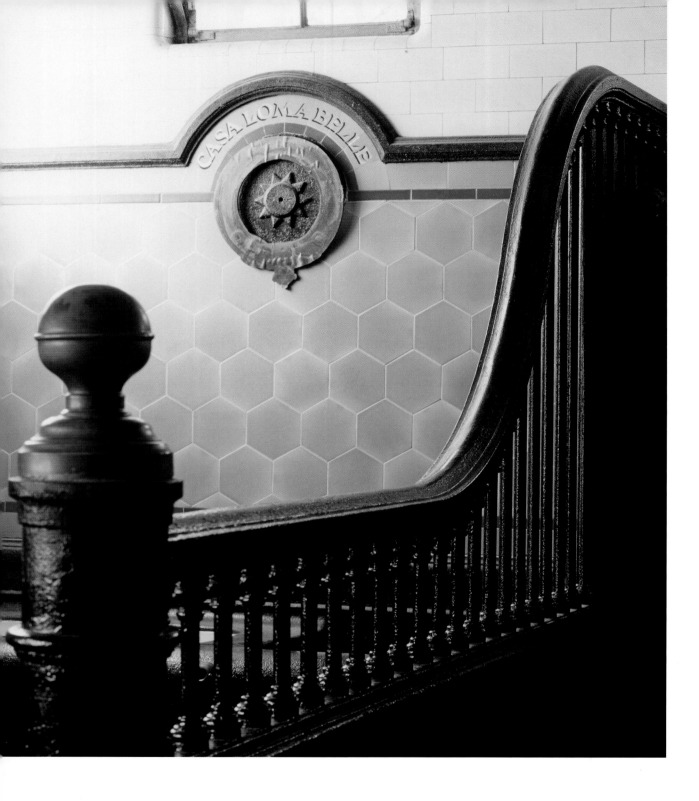

ABOVE A mahogany standing stall furnished with a slate-and-porcelain feed basin bears the name "Casa Loma Belle" engraved in gold lettering. OPPOSITE In this view of the stables the interplay is extraordinary between the wooden trusses, mahogany stalls, herringbone-pattern Spanish tile floor and glazed wall tiles in pale green and red, the colours of the Queen's Own Rifles.

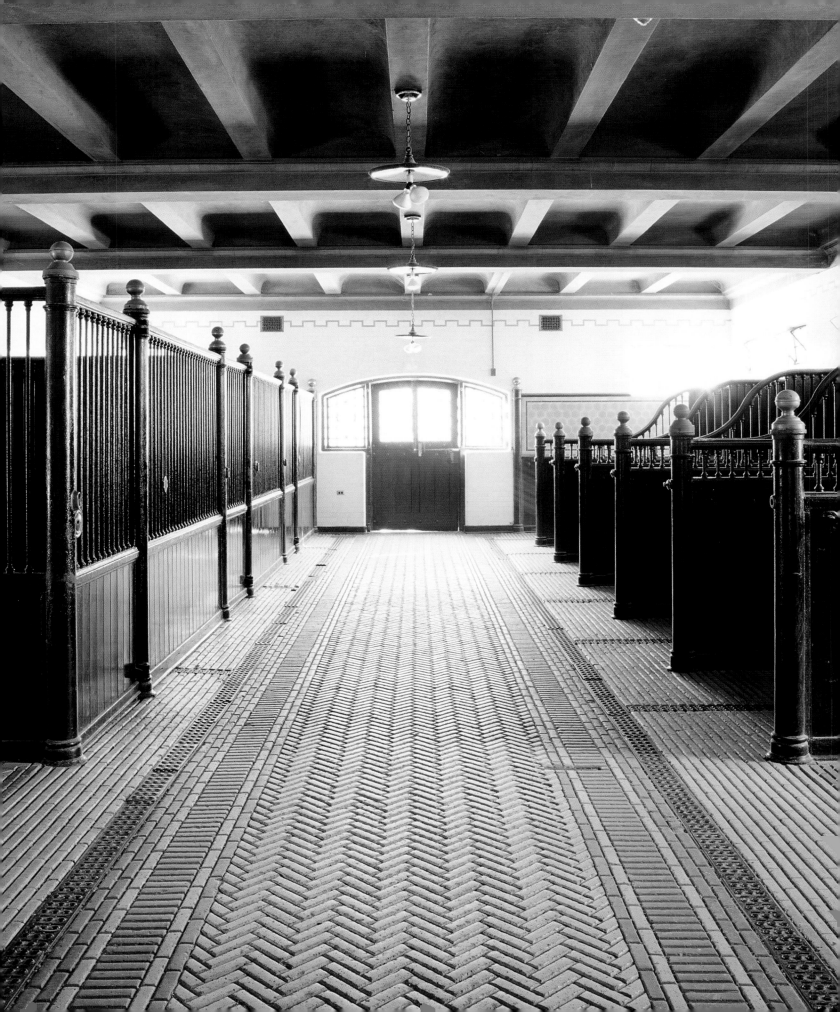

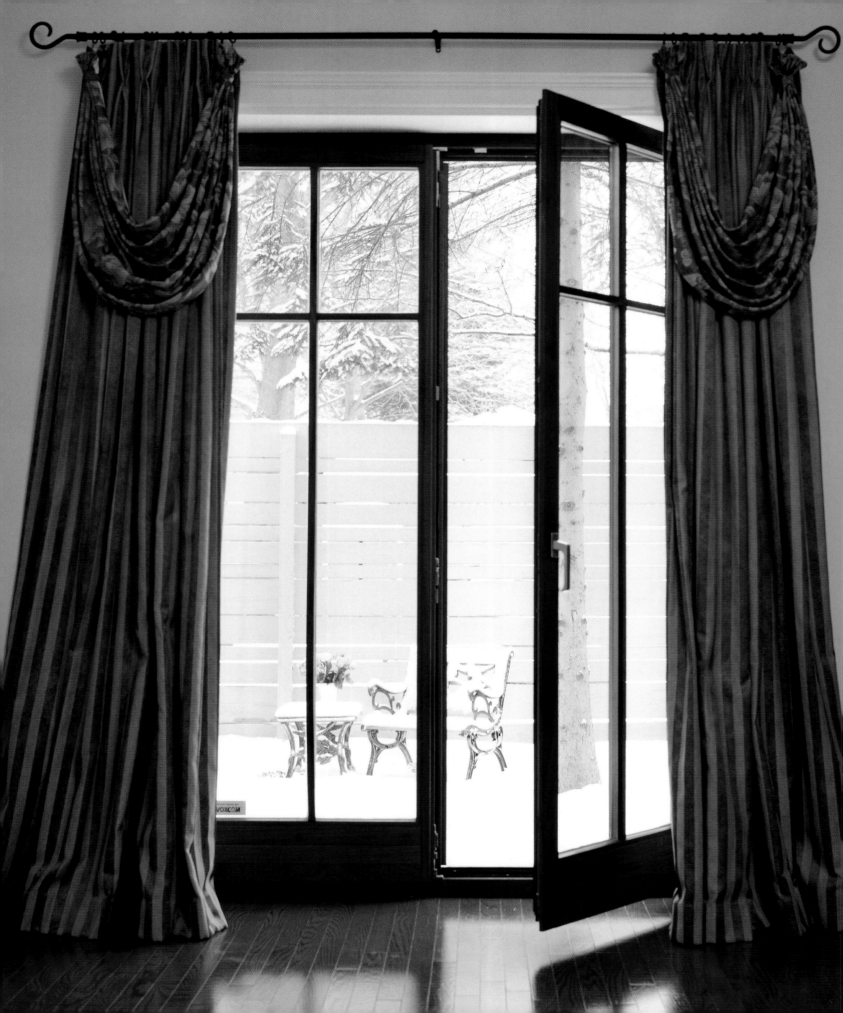

The Executive's Residence

This lovely renovated Queen Anne coach house, built in 1908,
stands beside the main house, once the residence of the heiress
of a prominent retail family. Located in the old village of Yorkville, now
part of the Annex, it is seamlessly integrated into the downtown urban
setting. In the 1960s the coach house was an infamous speakeasy
showcasing aspiring folk artists, including a few who became famous
international recording artists. The estate was purchased in 1987 by
a local architect, who divided the property, turning the main house
into two residences while renovating the coach house as a home
for his own family. "The coach house had such 'great bones.' The
English country stucco and timber exterior were just charming.
Its unobstructed north view of neighbouring backyards made it
irresistible," says the architect of the project. In 1997, an advertising
executive purchased the coach house. He too found it irresistible,
falling in love with the spacious, elegant, light-filled residence.

Theatrical, custom-designed green velvet drapes hang on a simple cast-iron rod
over the magnificent Honduran mahogany doors reflected in the gleaming oak
floors. Iron garden furniture and a seasonal flowering bouquet welcome family
and guests to the outdoors, even on a snowy winter day.

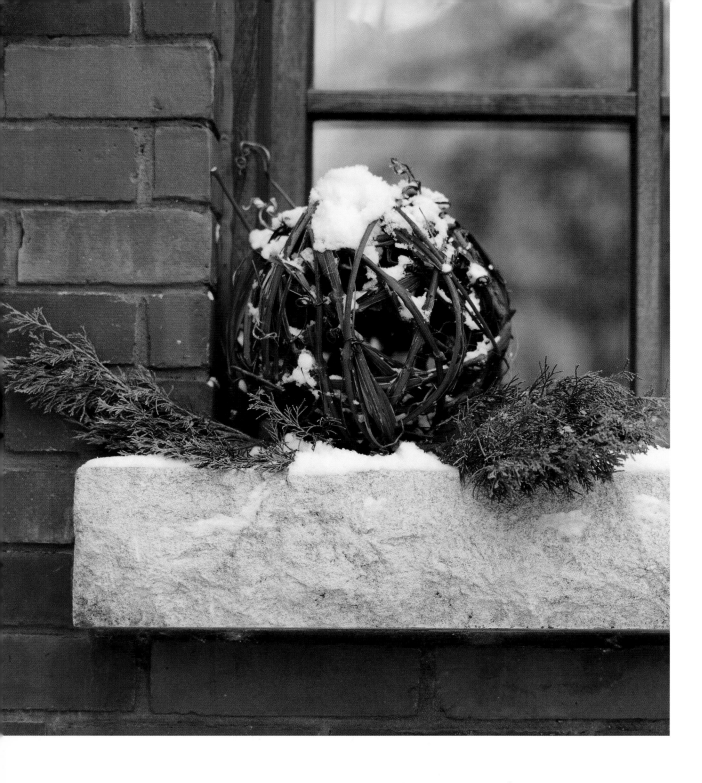

ABOVE A grapevine ball and boughs of juniper adorn the windowsill. OPPOSITE
In its "high-density" setting, the coach house sits neatly tucked beside balconies
of a neighbouring apartment building. French windows and a simple Juliet
balcony replaced the original carriage doors. A Honduran mahogany tilt window
was installed in the hayloft door, as well as a porthole window directly above, to
add interest and allow light to filter into the third floor. The exterior of the side
entrance addition is a perfect match to the original brick, stucco and timber
façade of the coach house. Festive decorations celebrate the season.

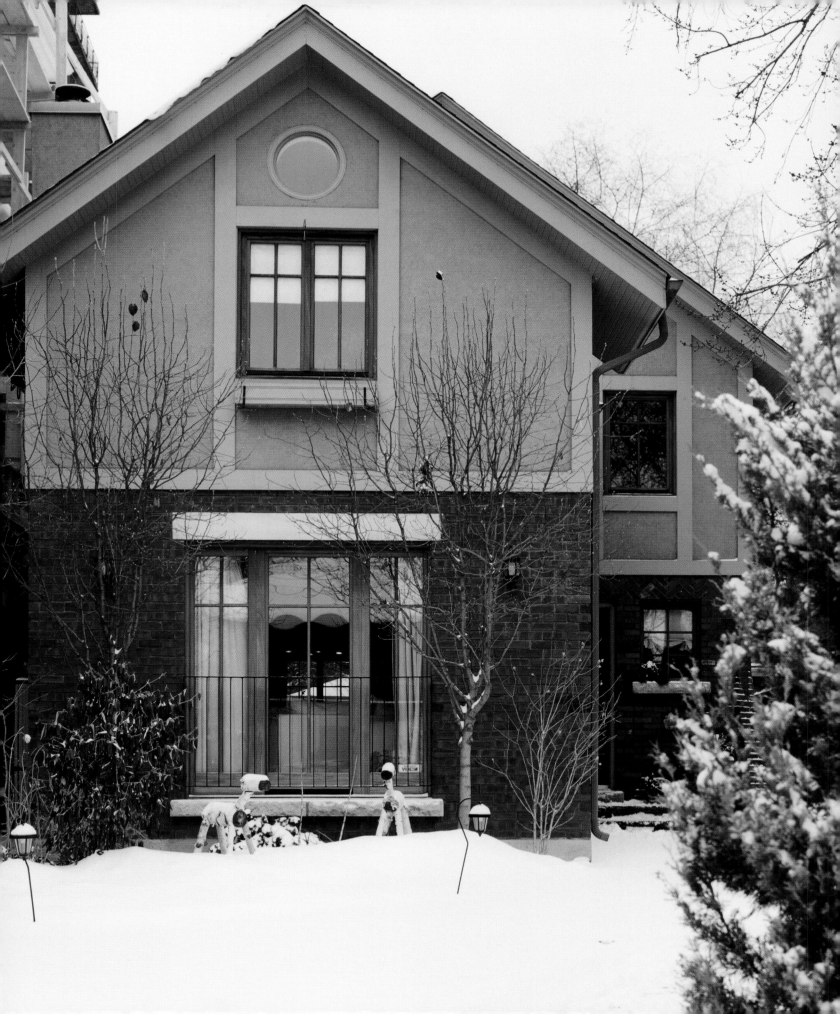

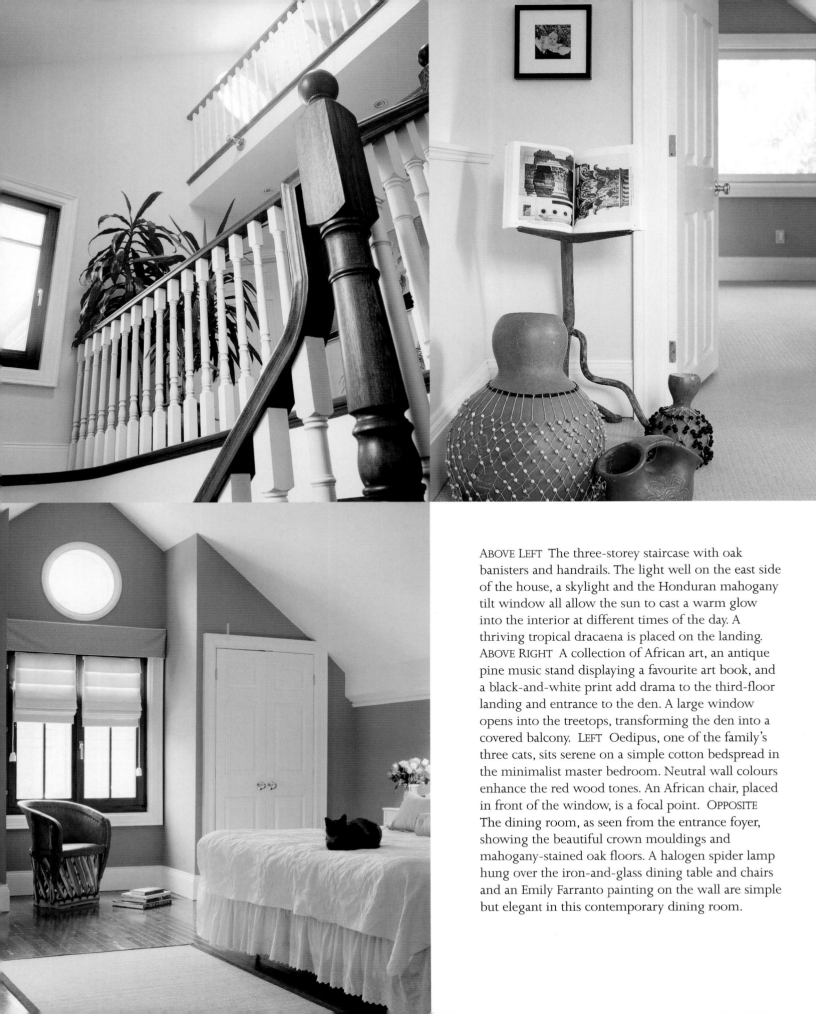

ABOVE LEFT The three-storey staircase with oak banisters and handrails. The light well on the east side of the house, a skylight and the Honduran mahogany tilt window all allow the sun to cast a warm glow into the interior at different times of the day. A thriving tropical dracaena is placed on the landing. ABOVE RIGHT A collection of African art, an antique pine music stand displaying a favourite art book, and a black-and-white print add drama to the third-floor landing and entrance to the den. A large window opens into the treetops, transforming the den into a covered balcony. LEFT Oedipus, one of the family's three cats, sits serene on a simple cotton bedspread in the minimalist master bedroom. Neutral wall colours enhance the red wood tones. An African chair, placed in front of the window, is a focal point. OPPOSITE The dining room, as seen from the entrance foyer, showing the beautiful crown mouldings and mahogany-stained oak floors. A halogen spider lamp hung over the iron-and-glass dining table and chairs and an Emily Farranto painting on the wall are simple but elegant in this contemporary dining room.

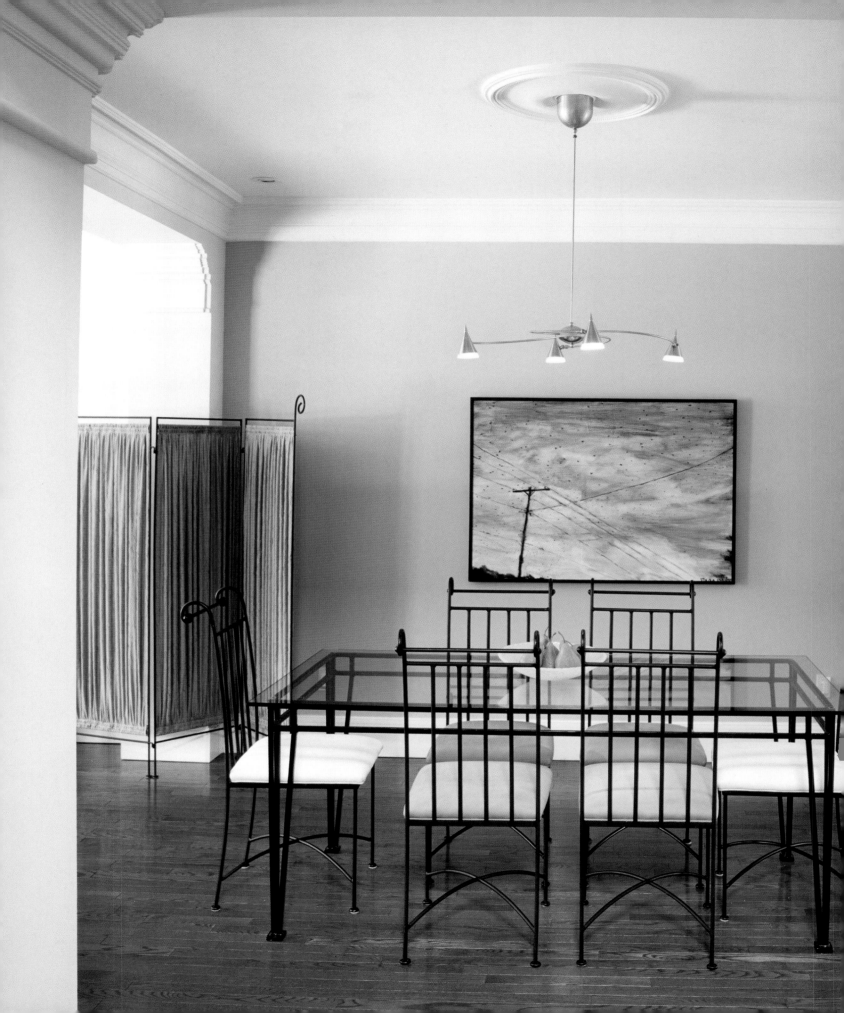

The Coach House B&B

This quaint 1902 coach house, built on land once belonging to the Baldwin family's Spadina estate, is tucked hidden behind the main house on a quiet, prestigious street in the Annex. The present owners, an artist and an architectural consultant, renovated the coach house in stages, beginning in 1988. "We purchased a pedestal sink, brought it home and plunked it down in the middle of all the junk that was stored in the coach house as an incentive to get the ball rolling. When the last raccoon was chased out, our work began. We salvaged and reused everything available in the coach house and also remnants from the main house renovation. We installed our own plumbing, taking turns digging a six-foot trench from the main house. We removed the ceiling boards and installed them on the floor of the main level. The floorboards of the hayloft were removed and used as panelling on the exterior. We then began work on the garden. As the main house had been used as a rooming house for many years, the backyard was a large gravel parking lot with rusted car parts and a dilapidated fence. We painstakingly removed the gravel, garbage and fence, and began building an English garden. Once completed, the coach house was used as a playhouse for our children and accommodations for visiting family and friends, while the gardens were enjoyed by all. In 2001, with the children grown and gone, we decided to use the coach house as an "extended-stay accommodation."

Through the garden gate and along the path to the entrance of the vine-covered coach house.

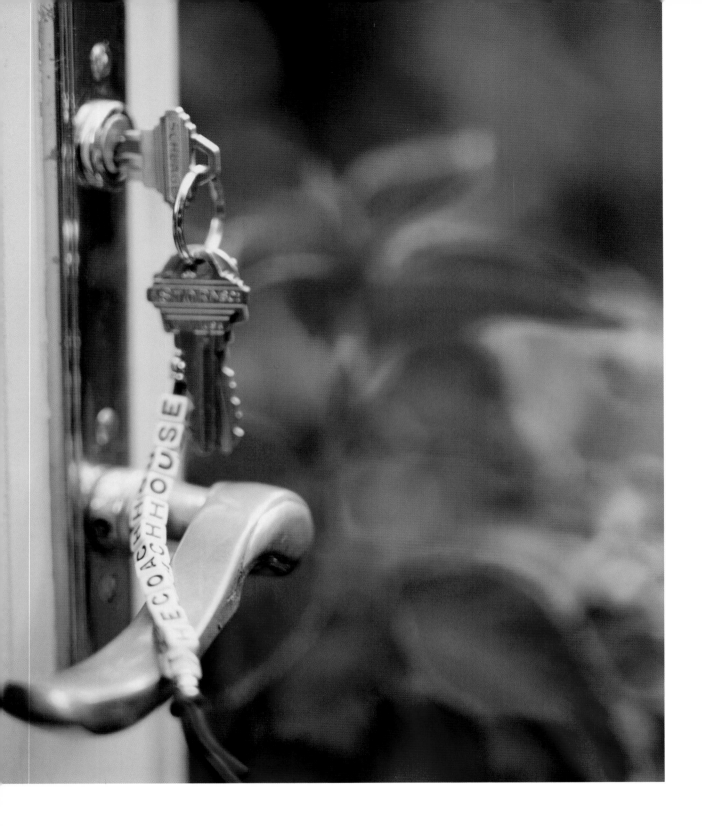

ABOVE The coach house keychain, a gift from the owner's son, celebrated the official opening of the "Coach House Extended-Stay Accommodation." OPPOSITE Dining for two on the delightful garden terrace.

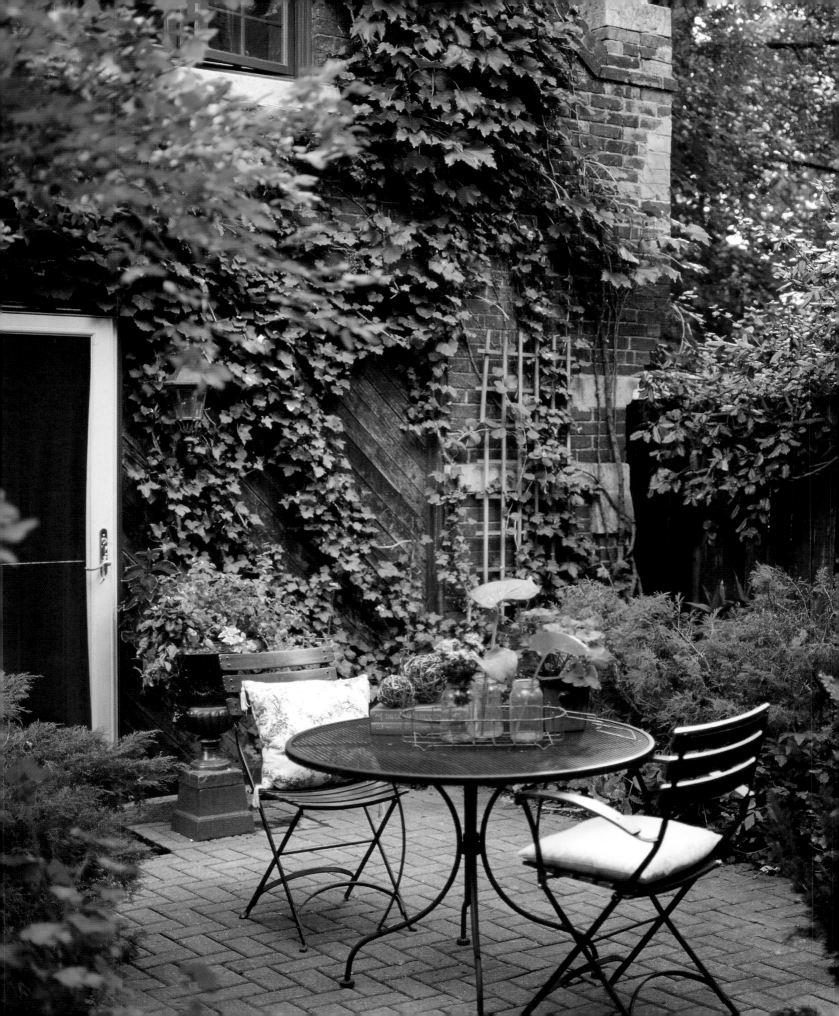

ABOVE The pine cabinets were once the kitchen cupboards in the main
house. They were removed and stored on the back deck for a number
of years before they found a new home in the coach house. RIGHT The
front door, open to the garden. The gleaming pine floorboards once
formed the tongue-and-groove hayloft ceiling. The boards were removed
from the ceiling, flipped over, installed on the ground floor, then sanded
and sealed. OPPOSITE An oversized burgundy leather chair with a soft
mohair throw and down pillows provides relaxed seating for weary guests
in a cozy corner of the living room.

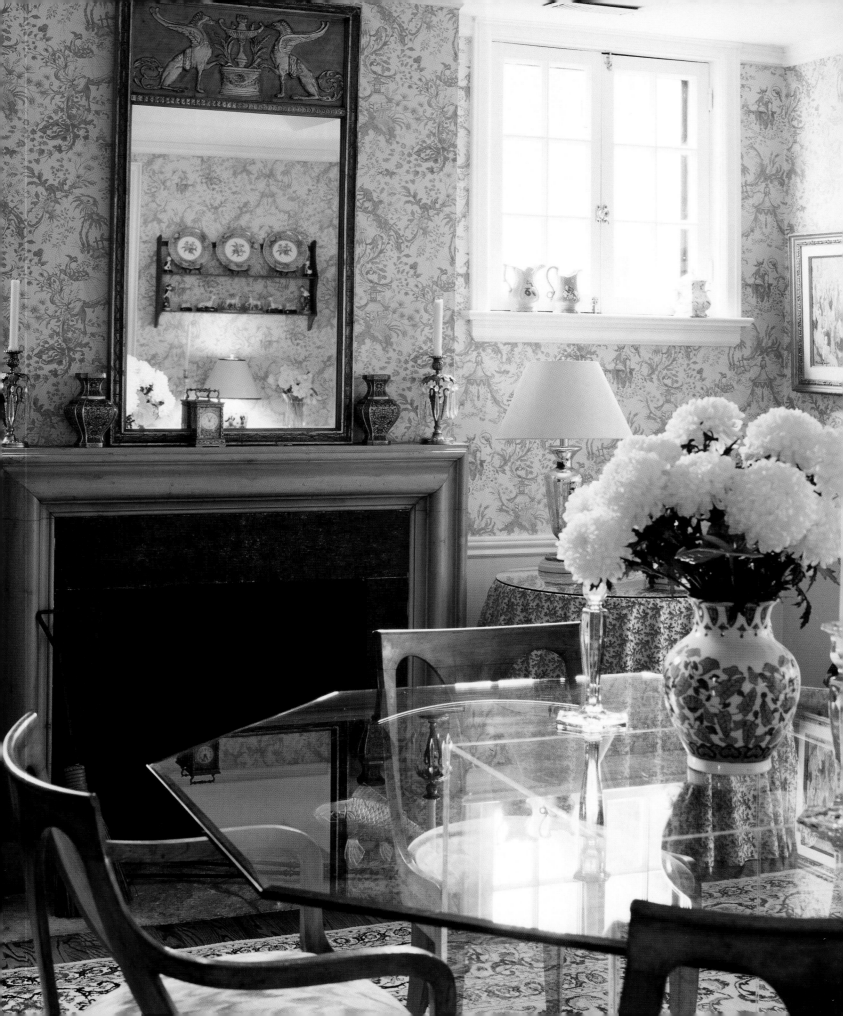

The Doctor's Residence

This clinker brick coach house, built without grooms' quarters in 1907, was one of the smaller coach houses located in the suburb of Rosedale. It is rumoured that the original owners of the main house and coach house died on the *Titanic*, leaving their daughters to be raised by a governess. In the early 1960s, a local real estate agent purchased the coach house and converted the original carriage room and horse stall into a small living and dining room and compact kitchen. A tiny staircase led to two small bedrooms and a bathroom on the second floor. In 1973, the present owners purchased this charming property and began a massive renovation that included the addition of a grand entrance foyer and a magnificent two-storey living room. The renovation includes a blend of architectural styles and design styles, with family antiquities and treasures that fill the rooms and give the owners a connection to their beloved England. "We saw the coach house in early May and were captivated by the enchanting gardens, creeping vines and informal landscape. It was reminiscent of our native England. There was no doubt in our minds that this was the property we wanted."

A vase of dahlias graces a contemporary octagonal glass table in the dining room.

BELOW The original coach house, its cupola still intact, now stands behind the new addition that includes a grand foyer and two-storey living room with fireplace. A cedar hedge planted at the front entrance provides privacy from the parking space. A neighbouring coach house and the side garden can also be seen. OPPOSITE A perfect view of the original front of the coach house, which was built with clinker brick, once discarded as seconds. As the Arts and Crafts movement grew, rough-and-ready clinker brick became popular in the early 1900s and was manufactured especially for its artistic effect. The coach house doors, long gone, have been replaced by a small solarium walkout from the kitchen. The hayloft door has become a window for the master bedroom. The owner's love of the English garden inspired her to choose an abundance of roses, yellow tickseed, purple verbena and yellow Scotch moss to enhance her garden and border the stone pathway.

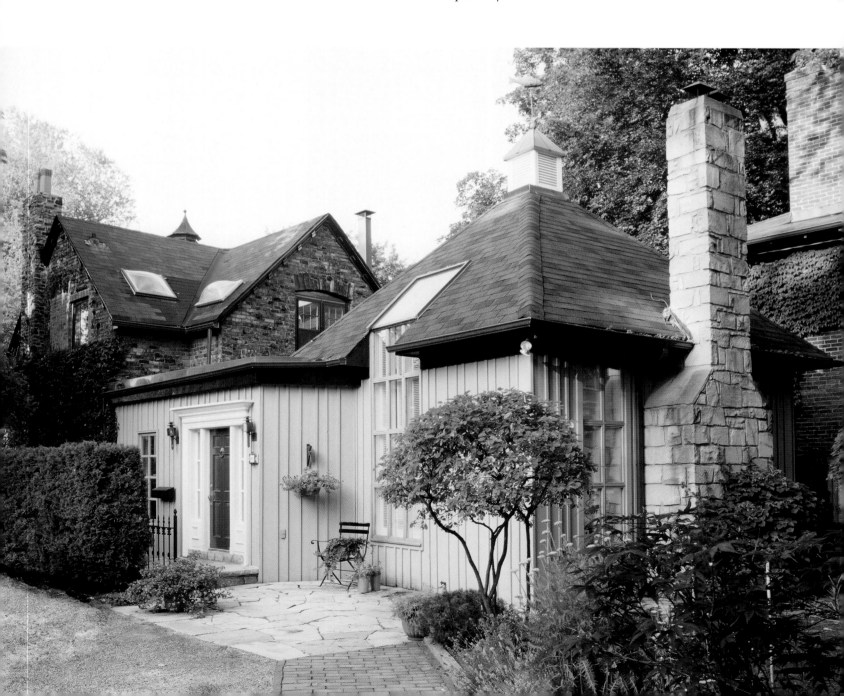

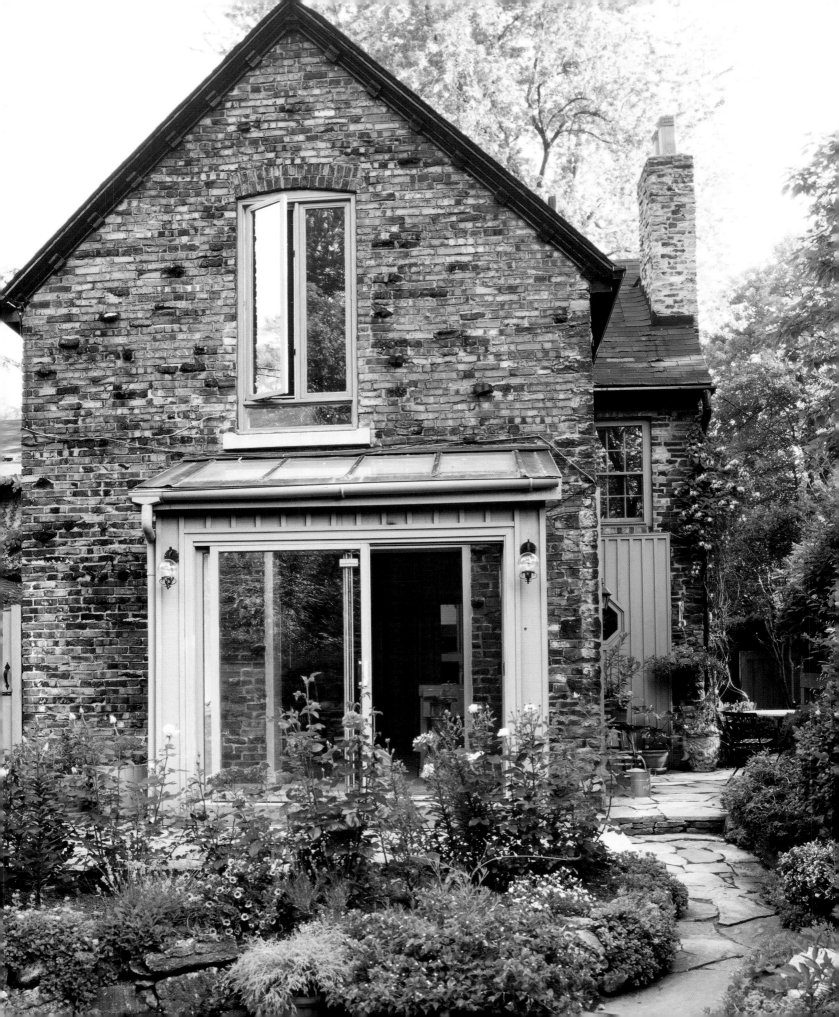

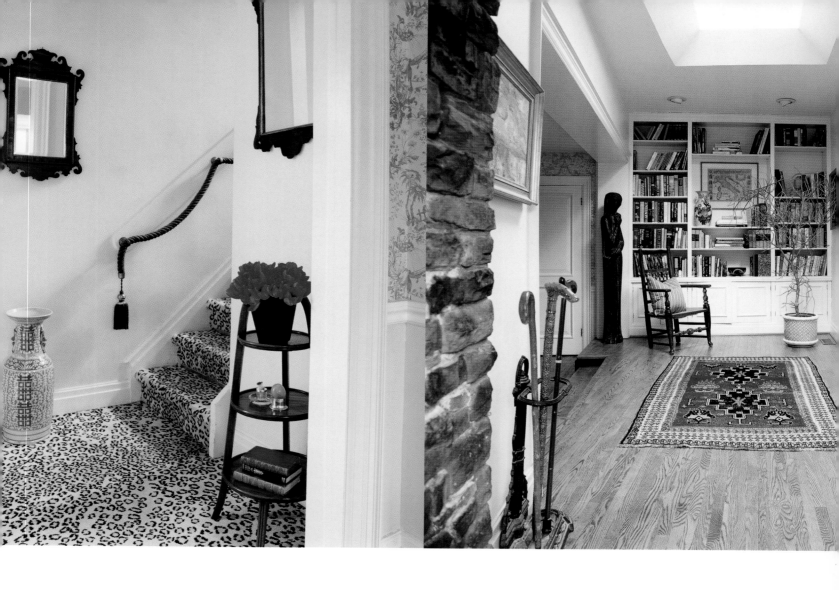

ABOVE LEFT The leopard-print broadloom and elegant gold rope handrail are luxurious and playful additions to the original staircase. ABOVE RIGHT The outside wall of clinker brick remains in the entrance foyer of the addition, which is also used as a library. A skylight allows natural illumination of the foyer and exquisite antiquities, which include a colourful antique oriental carpet, a simple Yorkshire farm chair from the 17th century and a wooden Madonna. A gold-framed speed map of Italy, circa 1600s, is hung in the bookcase, surrounded by the doctor's medical journals and favourite books. OPPOSITE The two-storey living room, with double-height windows, is a magnificent addition. A 17th-century oak desk from a convent in England is placed in front of a window, dressed with a colourful rose chintz Roman blind. A pair of gentleman's and lady's chairs with Jacobean, mahogany-spindled legs flanks an antique oak table in front of shuttered windows. A gold lantern grandfather clock once belonging to the owner's grandfather and a French antique chandelier are reflected in the magnificent gold mirror on the sandstone mantel. OVERLEAF The original carriage room and horse stall is now a spacious dining room. The owners commissioned a local artist to build a contemporary octagonal glass table to complement their favourite pine Baker chairs. A pair of 18th-century crystal wall sconces are hung on either side of a 16th-century French walnut china cabinet, and a beautiful inlaid antique mirror rests on the mantel. A small door once leading to the kitchen now opens to a storage area.

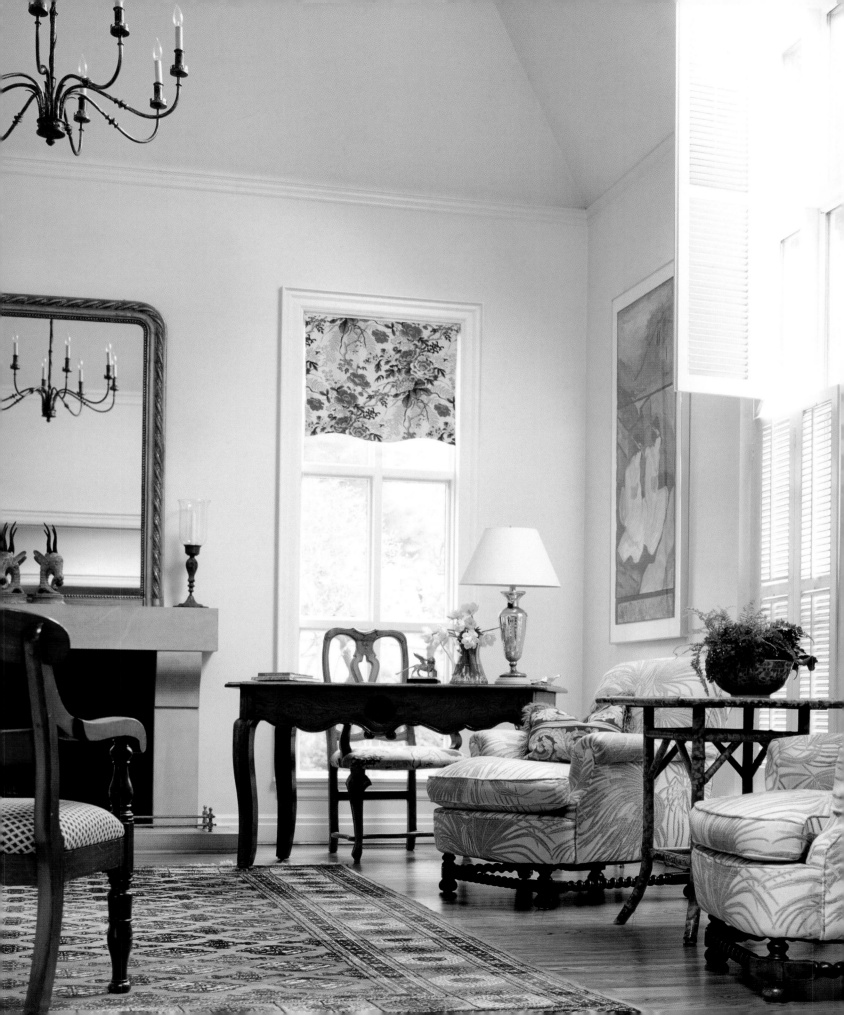

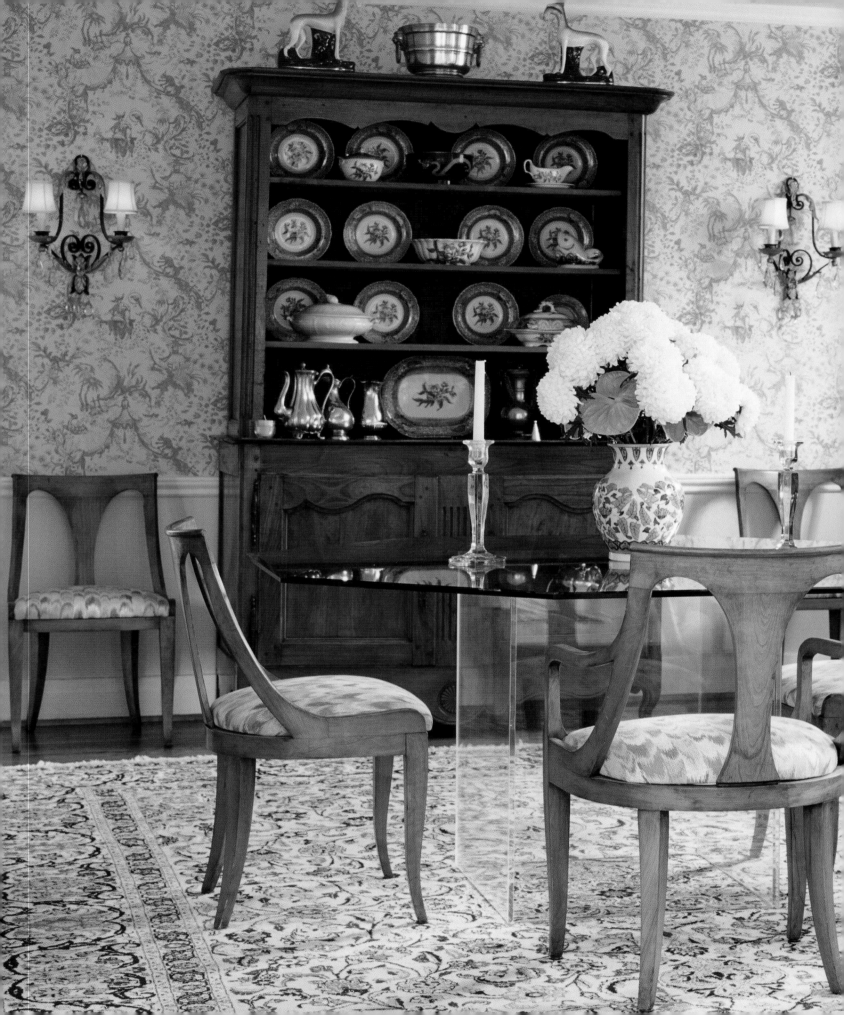

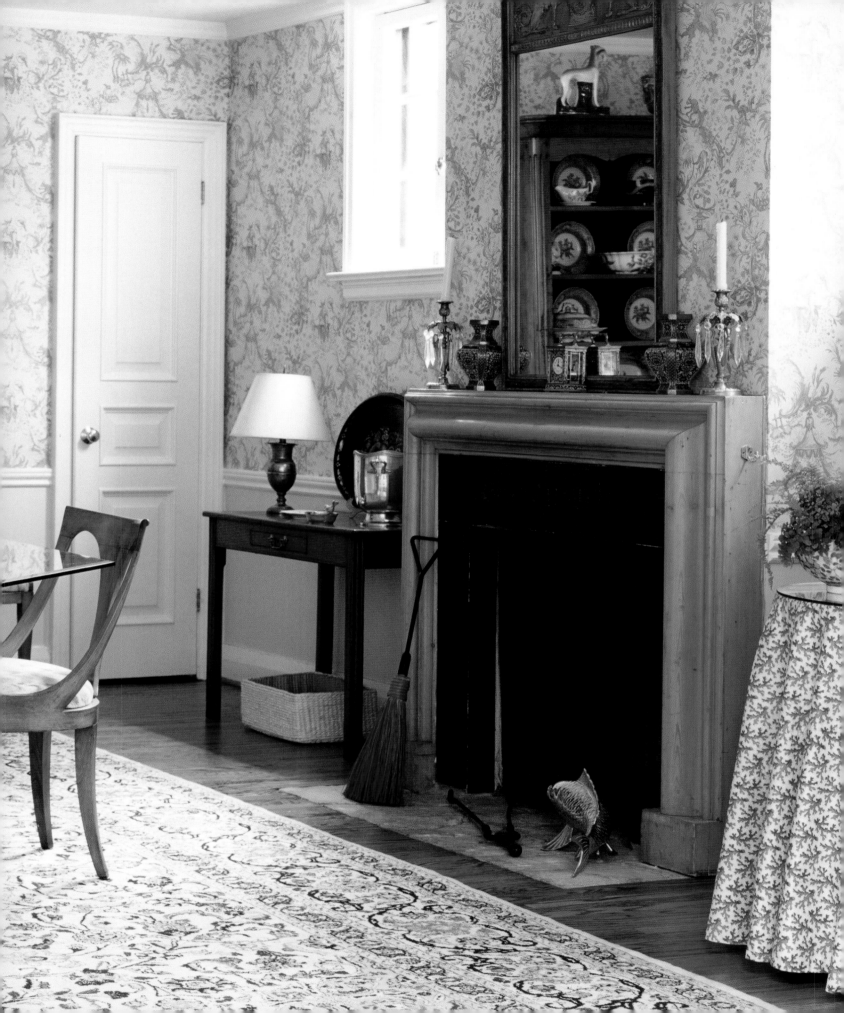

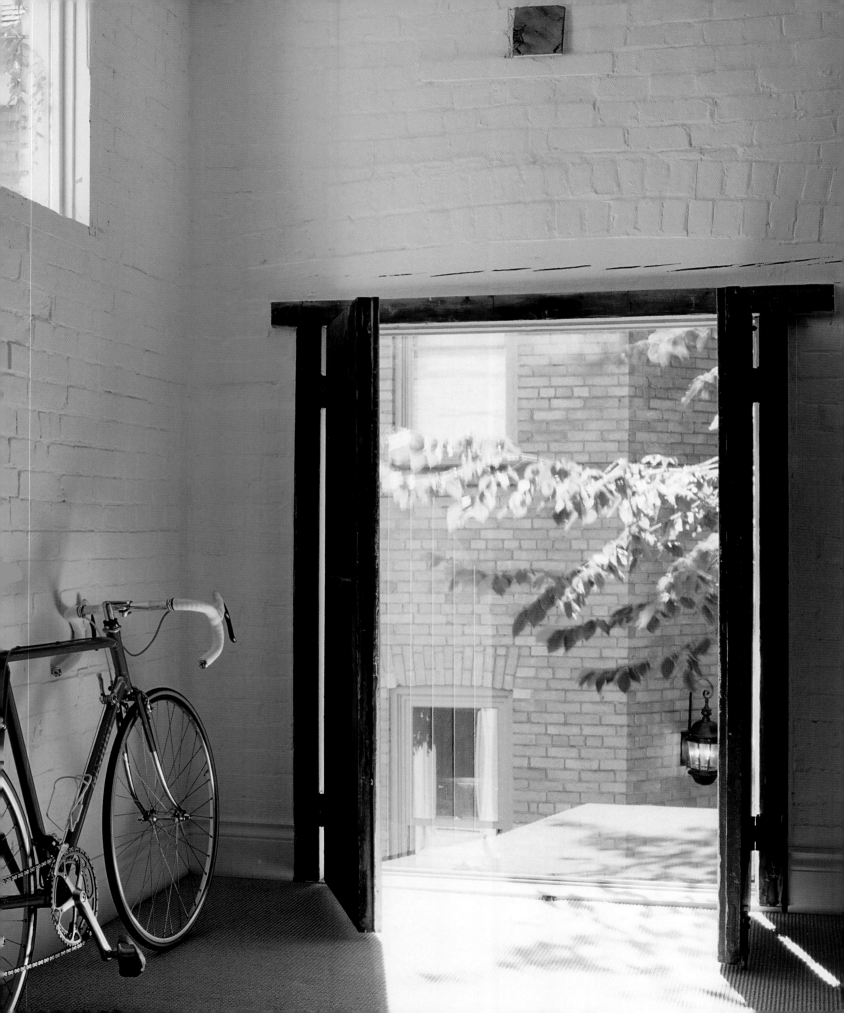

The Bicycle Gallery

This white brick coach house, substantial in size, is part of a lovely 19th-century Victorian villa located in the west village of Yorkville, now part of the Annex. Built in 1878 by city banker Donald Gordon, the villa was once inhabited by Robert Parker, founder of the Parker Cleaners empire. In the early 1970s, a local businessman with a love of historical residential architecture purchased the property and began an extensive restoration of the main house and coach house. Although the coach house interior was in disrepair, the exterior was completely intact, and once the restoration began, he discovered the building was as strong as a fortress. The coach house still had the water lines and feed troughs for the horses and the marks from the horses' stalls. His restoration was expensive and time-consuming but extremely rewarding. In 1974, the Toronto Historical Board presented him with the prestigious Award of Merit, citing the preservation of the buildings, the quality of the workmanship and the use of original materials. On completion of the restoration the owner reportedly remarked, "You would have to be crazy to destroy anything so beautiful." Today the property belongs to a bicycle enthusiast and his wife, who use the coach house as a gallery to display his collection of antique and contemporary bicycles, art and artifacts.

The original hayloft doors open, a stone's throw from the villa. The present owners found hay still in the loft.

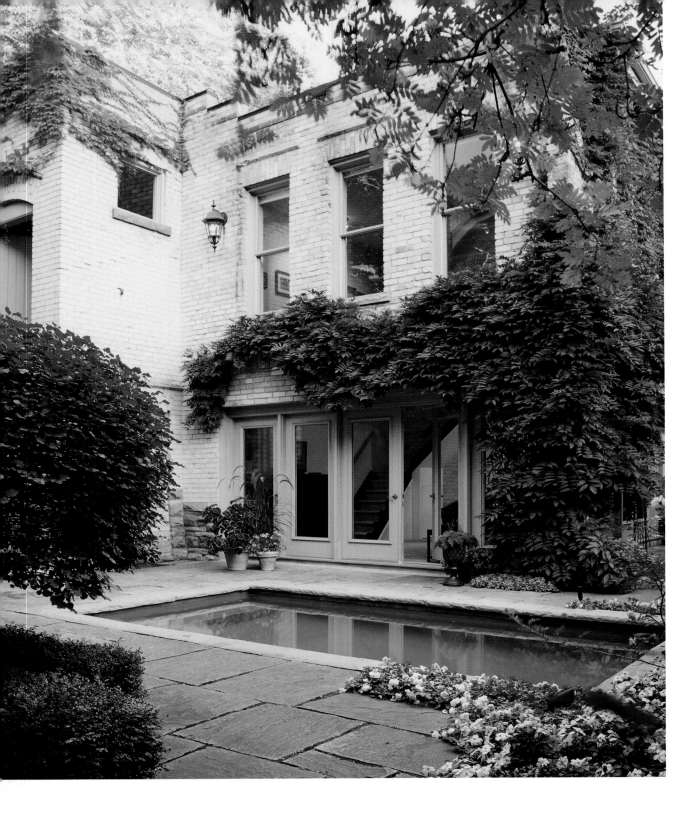

ABOVE A view of the magnificent villa coach house, courtyard and pool as seen from the main house. OPPOSITE The back wall of the main residence and the driveway leading to the grand coach house and courtyard. Lush vines and greenery abound. Groceries wait to be unloaded from one of the owner's bicycles resting against the Victorian iron fence beneath a glowing coach light.

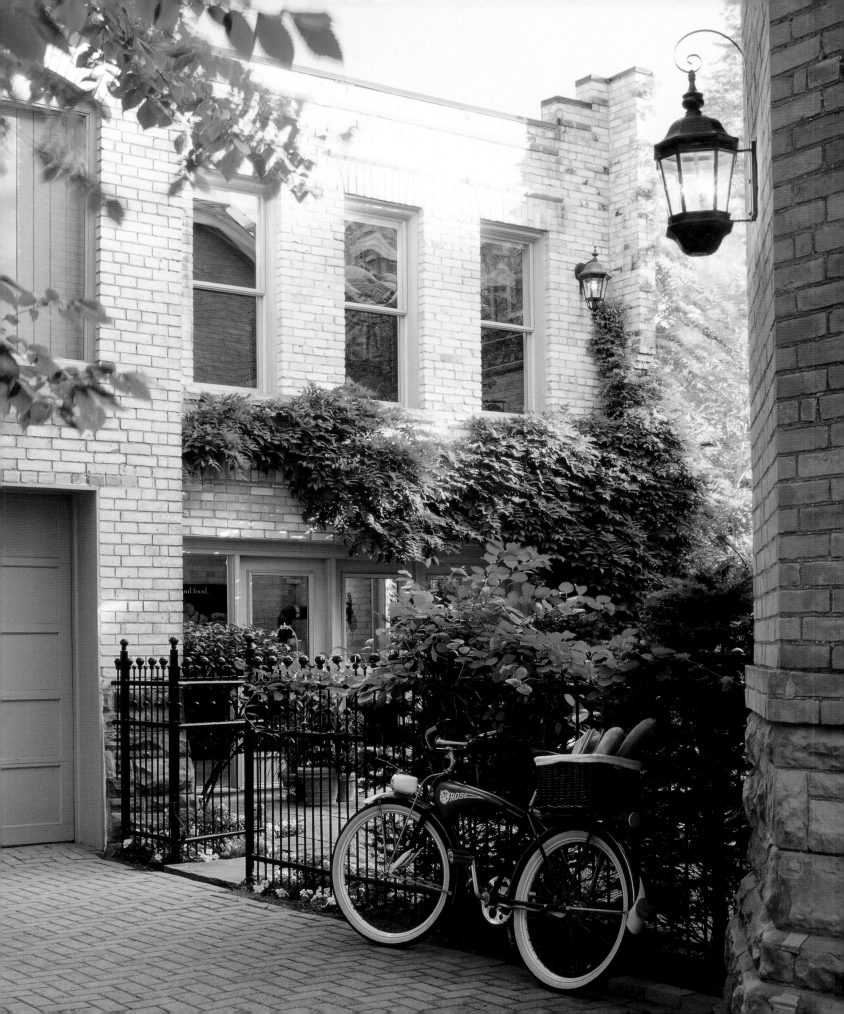

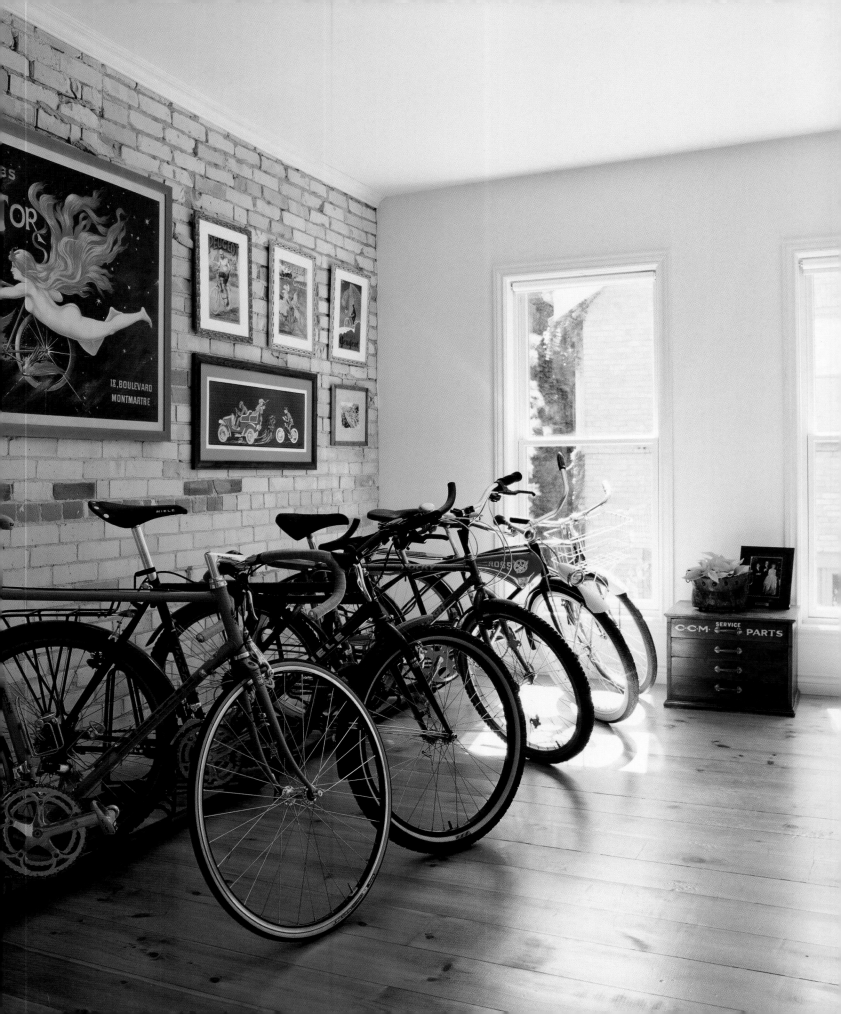

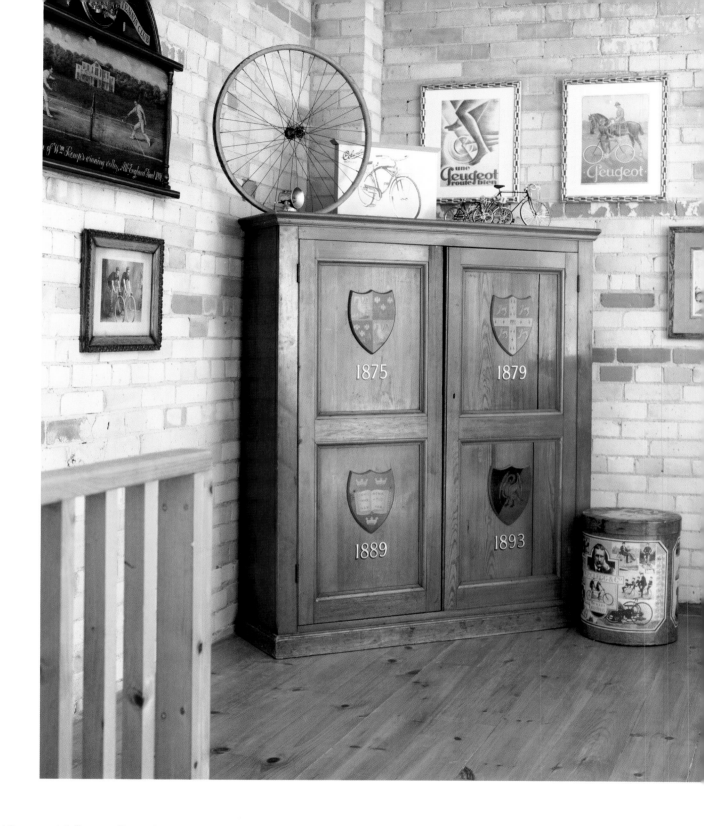

OPPOSITE The second-floor gallery, showing the owner's collection of bicycles and bicycle art displayed on exposed brick walls. The original pine floors are illuminated by sunshine through the second-floor windows. ABOVE Pine floors, railings and exposed brick create a handsome setting for the owner's antique chest, art and collectibles.

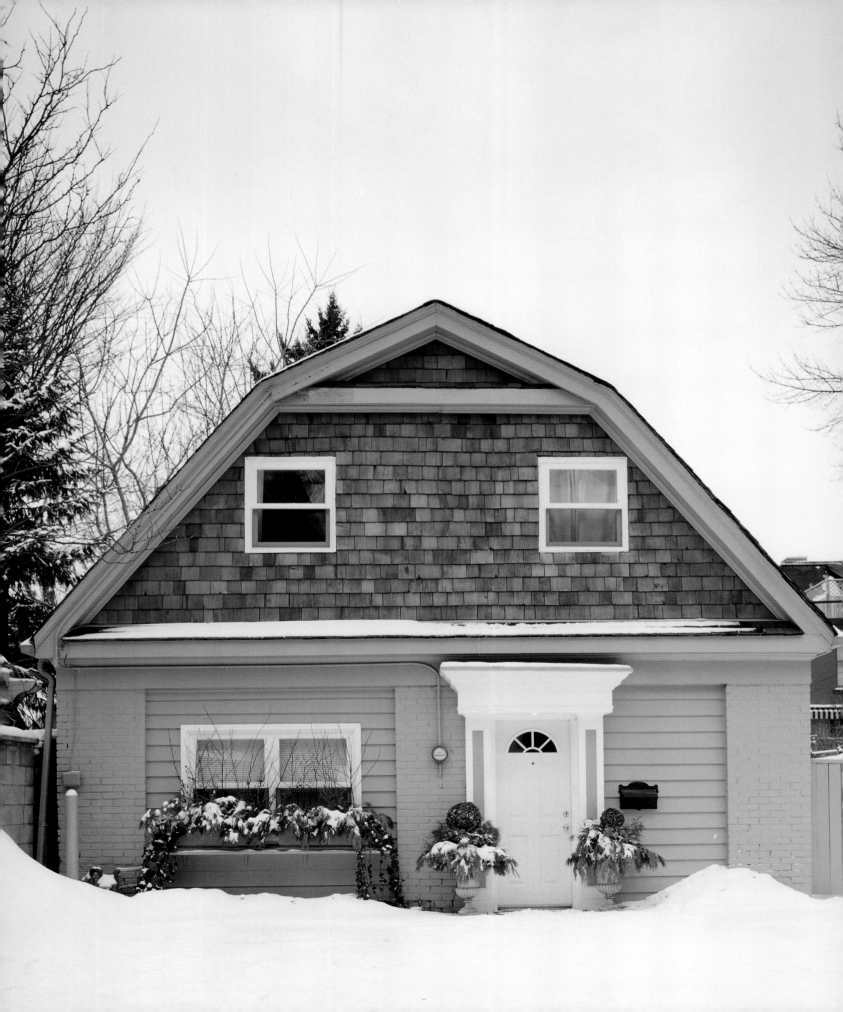

The Artist's Home

Situated behind the main house in an area where Yorkville meets the Annex, this gambrel-roofed coach house was originally built in the late 19th and early 20th centuries as a garage to house the owner's horseless carriage and chauffeur. Today it is home to an internationally renowned children's artist and illustrator. Renovated in 1986, the main floor of the coach house was converted into a living room, dining room and kitchen. The chauffeur's quarters above were tastefully renovated and include the artist's studio, bedroom and bathroom. "I rented the coach house because it was centrally located, the lighting was amazing, and it was insulated from the noisy street. It was a perfect place to live, paint and write," says the artist and author.

The exterior of the coach house shows the gambrel roof. Festive seasonal decorations adorn the front entrance.

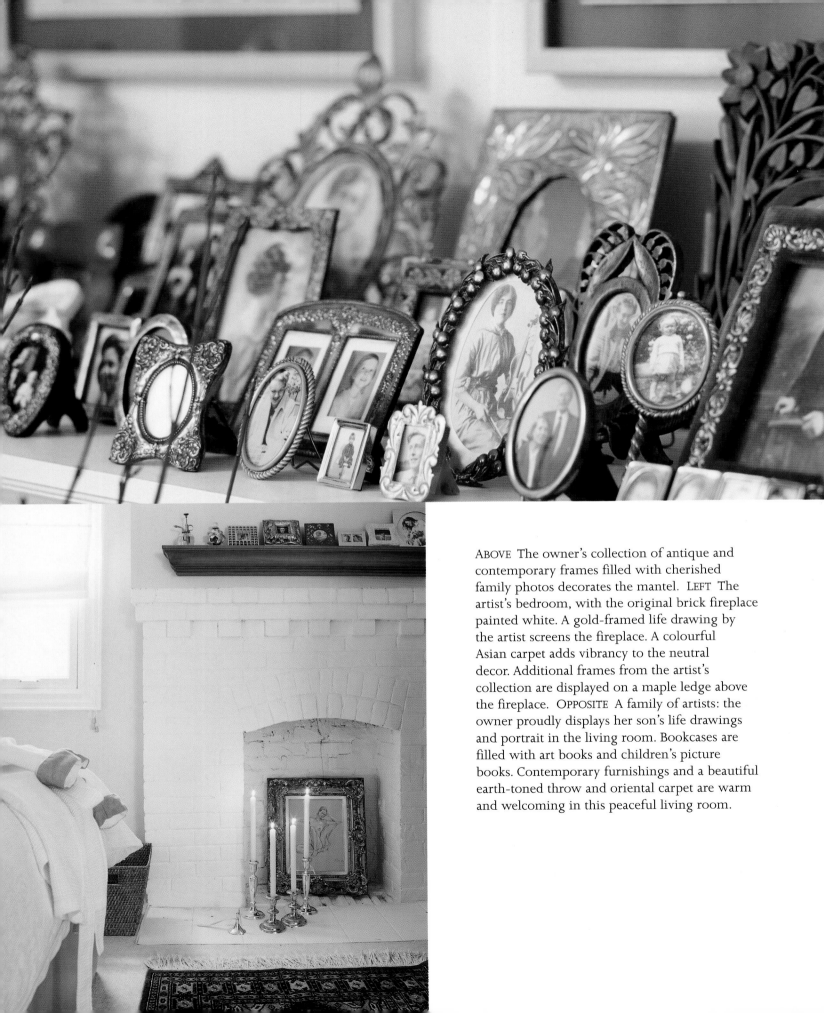

ABOVE The owner's collection of antique and contemporary frames filled with cherished family photos decorates the mantel. LEFT The artist's bedroom, with the original brick fireplace painted white. A gold-framed life drawing by the artist screens the fireplace. A colourful Asian carpet adds vibrancy to the neutral decor. Additional frames from the artist's collection are displayed on a maple ledge above the fireplace. OPPOSITE A family of artists: the owner proudly displays her son's life drawings and portrait in the living room. Bookcases are filled with art books and children's picture books. Contemporary furnishings and a beautiful earth-toned throw and oriental carpet are warm and welcoming in this peaceful living room.

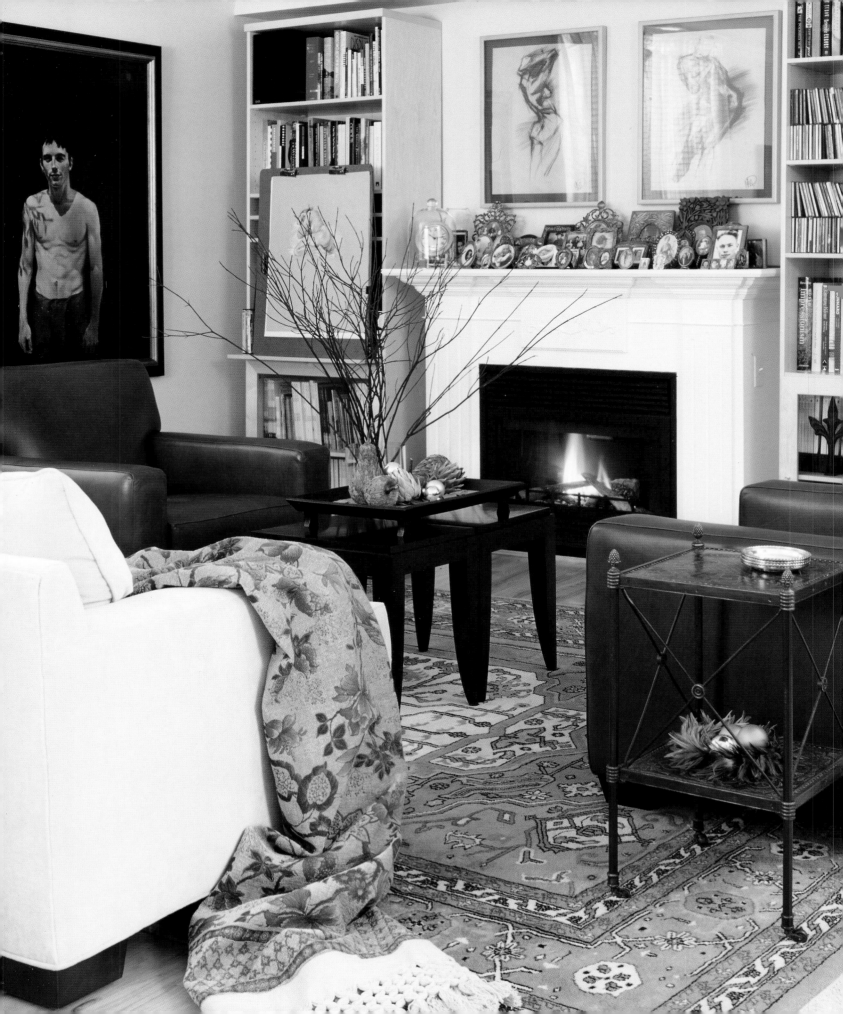

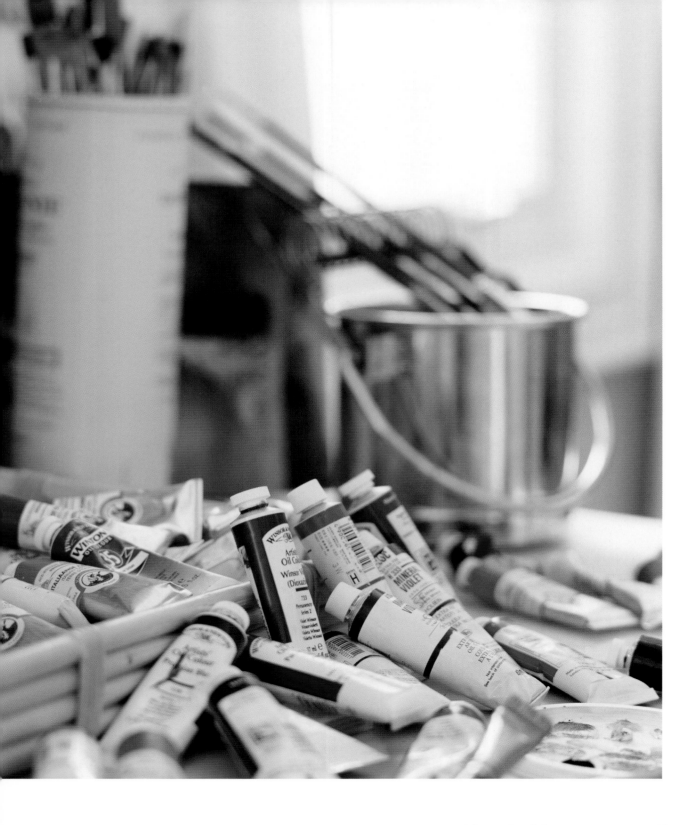

ABOVE The tools of the artist. OPPOSITE The artist busy at work in her coach house studio.

Mother's Residence

This lovely Tudor coach house was built in the early 20th century as a garage, with living quarters above, on a prominent estate in the upscale village of Forest Hill. The family, owners of the largest real estate and building company in the city, used the coach house to service not only the main house but also a sister house on the estate. The main floor of the coach house held the horseless carriage and grounds equipment, while the caretakers had a small apartment on the second floor. In the early 1980s the property was purchased by new owners, who adapted the coach house with exquisite and sometimes outrageously over-the-top detail to serve as a deluxe party palace. During that time, neighbours say, everyone from celebrities to the Hell's Angels partied in the coach house. The estate was recently purchased by a businessman and his wife, an author of children's books, and the coach house is now used as a more serene and beautiful residence for their eighty-six-year-old mother. "We wanted a property where Mother could live independently but close to us. The property had such a sense of history, and with a few adjustments the coach house was perfect for her."

An antique porcelain tub with elaborate silver claw feet and a gold handheld showerhead sits theatrically on a raised stone platform, surrounded by creamy white plaster walls and dark oak trim in this elegant bathroom.

ABOVE No expense was spared in the original renovation, which included a magnificent medieval-inspired stone fireplace, Colorado red slate heated floors and beautiful oak trim and supporting beams. Large windows with a view to the courtyard give Mother a sense of closeness and security. RIGHT Mother's bedroom furniture and personal items give a sense of her own home. OPPOSITE Mother's dining room set and favourite oriental rug cover what once was the giant turntable contraption that allowed an automobile to be turned around for easy exit. The original garage doors, replaced with exquisite oak sliding doors, give light and allow easy access to the secluded courtyard and garden shared by the main residence and the coach house.

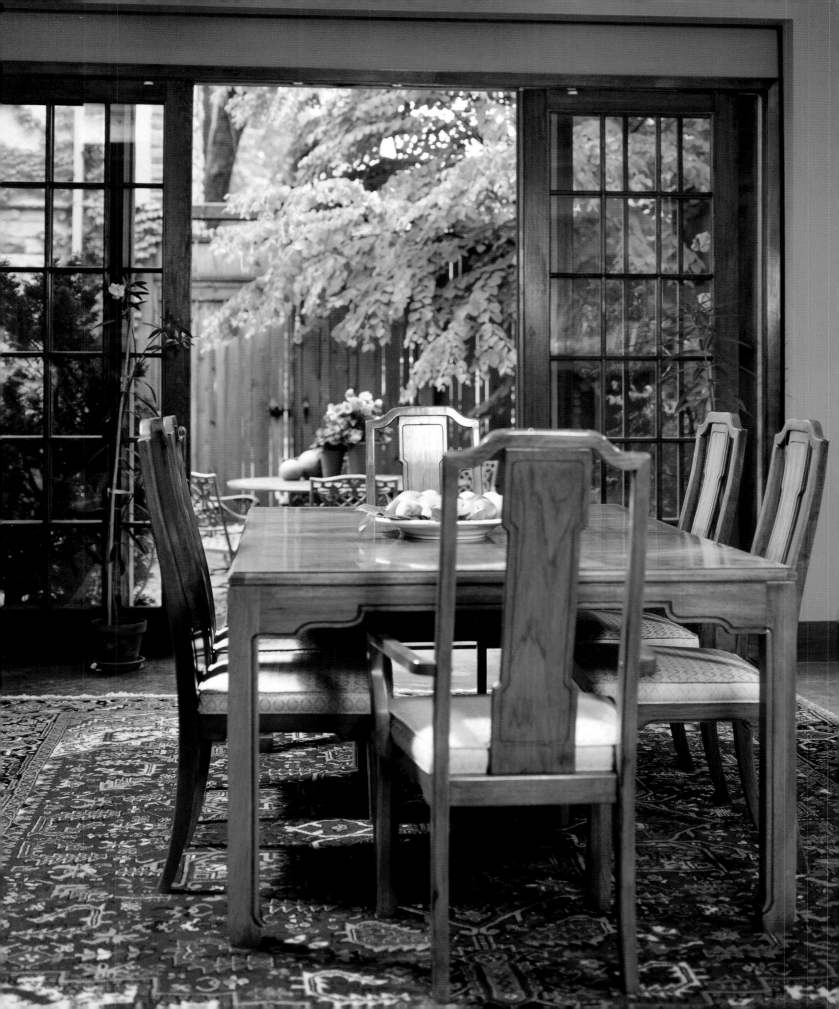

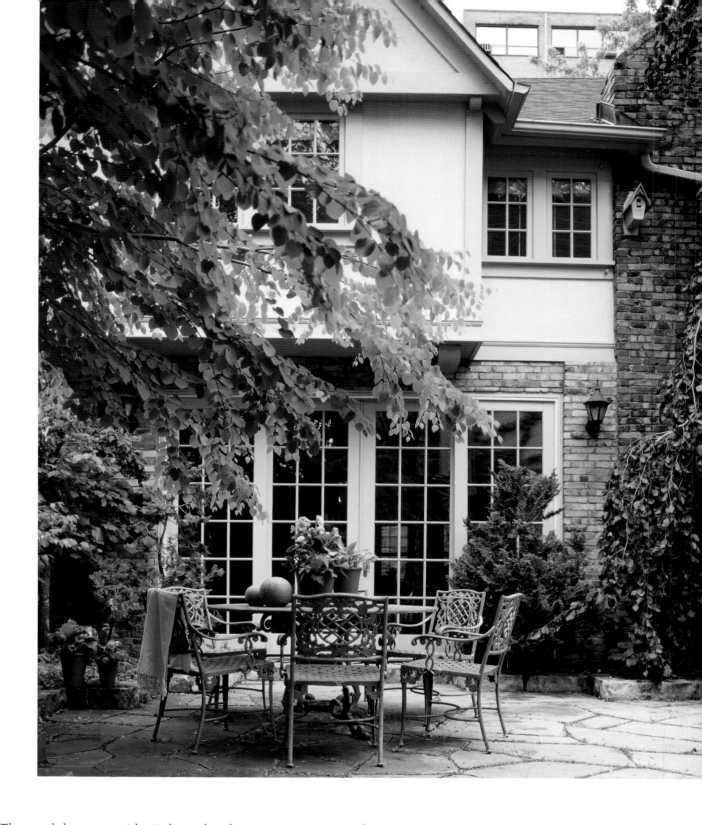

OPPOSITE The coach house provides independent living, yet nearness to the family, as is shown in this photo of the entrance, only steps from the main house. ABOVE Front view of the coach house and stone courtyard. The original garage doors, replaced with oak sliding doors, provide light and access to the garden terrace. Elegant French iron garden furniture is surrounded by pots of seasonal begonias. A katsura tree provides shade on hot summer days.

The Mayor's Estate

This stately coach house is part of the second-oldest estate in an enclave of old, established homes in Rosedale. Built in 1854 by a local lawyer, the estate is most closely identified with a one-time city mayor, George Reginald Geary, who occupied it between 1927 and 1954. The main house was painstakingly restored in 1998 with historical authenticity in mind. Even the landscaping reproduced the traditional gardens of the late 19th century. The restoration won the City's Heritage Board's Best Restoration of the Year Award. The present owners purchased the property in 2002. They decorated the coach house in a casual, chalet kind of style to provide a perfect refuge for visiting family and friends. Connected to the main house by an underground tunnel, the coach house remains today much as it did in 1854, in a peaceful setting overlooking a beautiful ravine, seemingly untouched by time.

Sloped ceilings above the hayloft window create a cozy nook, decorated with an antique pine chest and black wicker chairs.

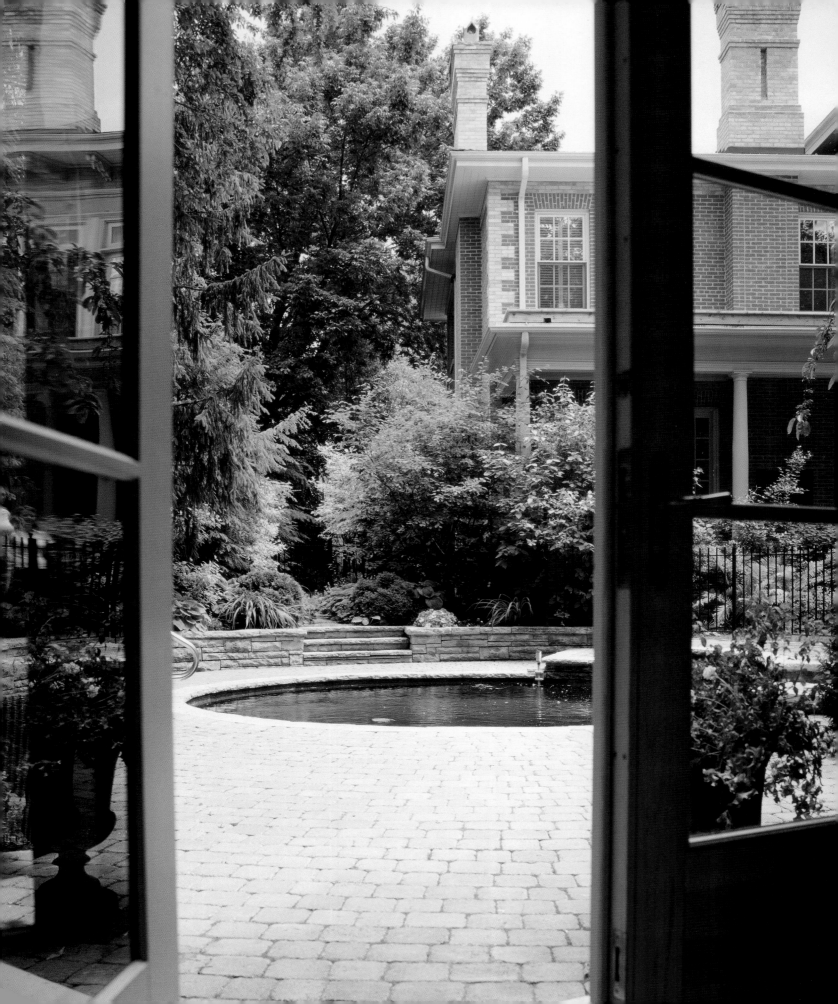

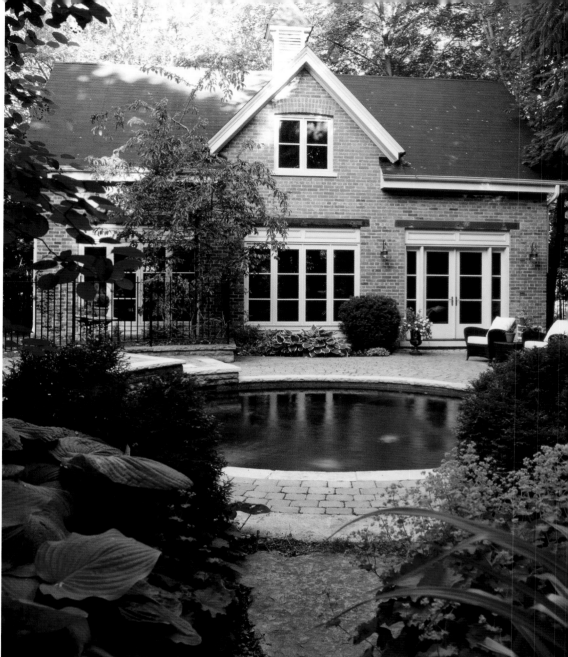

OPPOSITE French windows of the coach house open onto the courtyard and circular pool. Also on view are the massive chimneys, with intricate masonry detailing, as well as the back verandah and garden terrace of the Regency-inspired main house. ABOVE Thriving lush blue hostas almost bar passage along the stone pathway that leads from the main house to the circular pool, courtyard and coach house. The original coach house doors were replaced with a magnificent living-room window, flanked by sets of French windows on either side, one leading to an iron-gated garden and the other to the pool terrace. The hayloft door is now a pine window on the second floor. LEFT The lintel above the coach house doors, now French windows, and a gas light.

ABOVE Beautiful pine finishes, cabinetry, furniture and accessories give a cozy but elegant chalet feel to the combined living and dining area. A white, oversized slipcovered sofa provides comfortable seating in front of the fireplace. OPPOSITE The open front door welcomes guests to the simple and elegant century coach house.

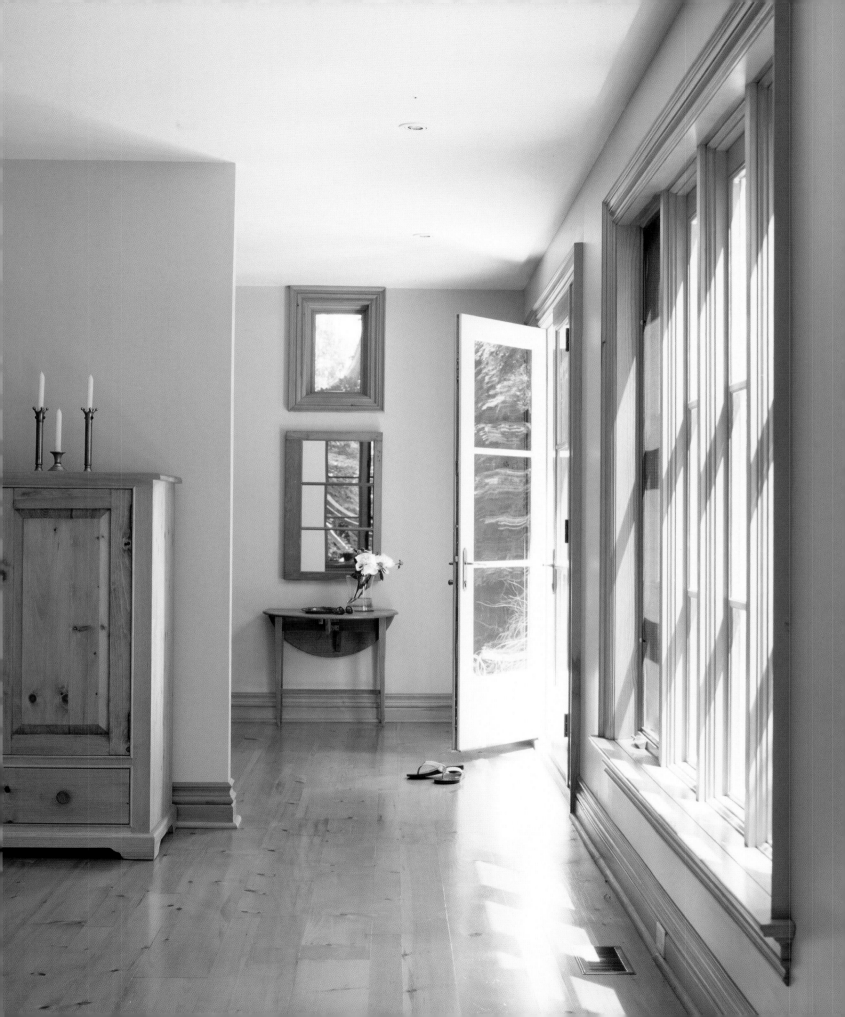

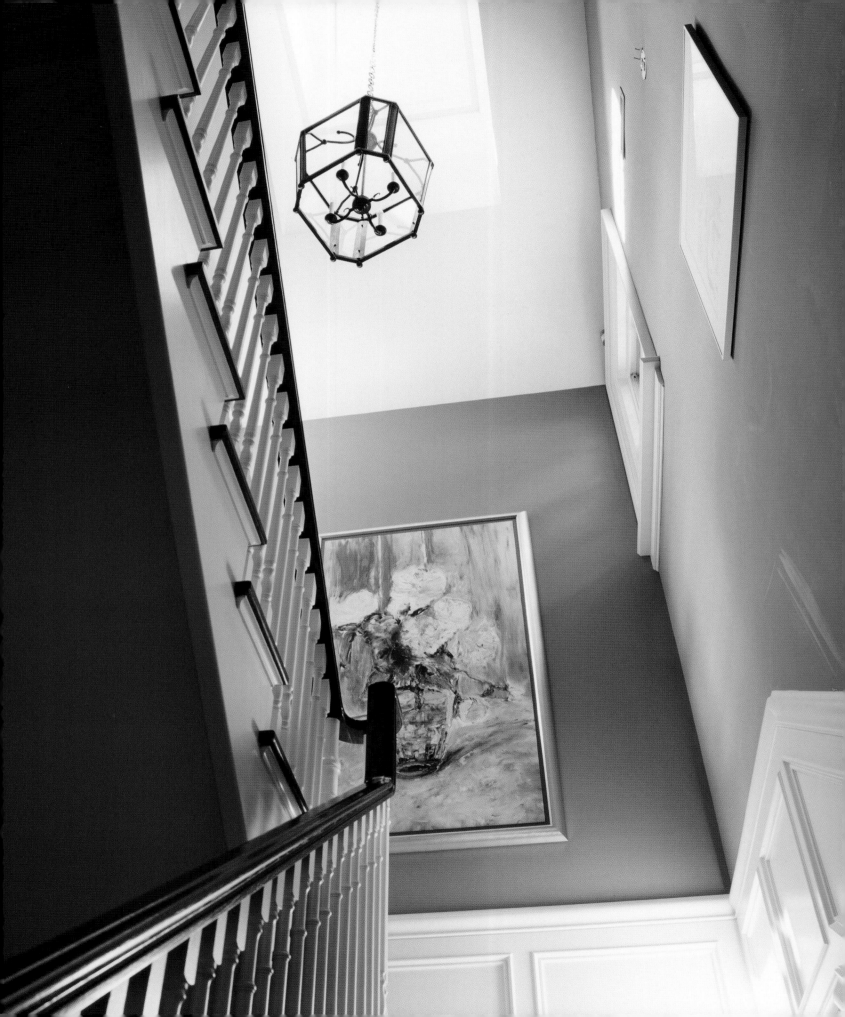

Off the Beaten Track

Built in 1911, when curving streets in Toronto's earliest and loveliest suburb, Rosedale, were filling up with Edwardian houses, this gabled coach house is still standing, tucked behind the parent house and beside a neighbouring coach house. In the 1950s, the owners of the property used the coach house as a playhouse for their little boy, who grew up to become a famous American journalist. When it passed into new hands in 2000, the coach house was renovated, preserving the original building, cupola and fireplace, while adding a large dining room, kitchen and bedrooms. The present owners purchased the renovated coach house in May of 2001: "We liked the way it was tucked away, off the beaten track, so to speak, yet steps to the subway and shops on Yonge Street." Avid gardeners, with a love of European-style courtyards, they spent their first year carefully planning a design for the entranceway garden and terrace. Their recently completed formal courtyard and gardens are a timeless enhancement to this already gracious coach house.

The original staircase to the groomsman's quarters was expanded and an elegant spindle banister added to the stairs. The ceiling was opened up and a window installed in the original cupola space. A magnificent antique lantern chandelier hangs below the cupola. An oil painting of roses in a vase has found a perfect place on the wall of the landing.

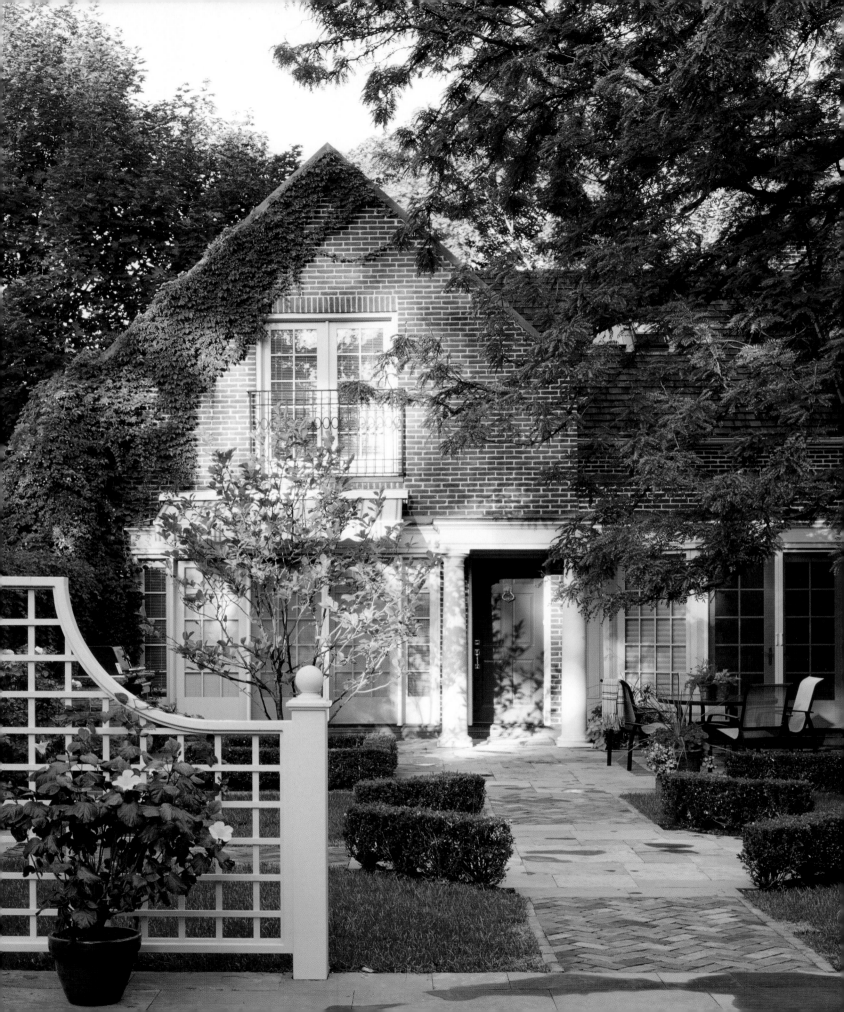

OPPOSITE The front of the coach house, the formal gardens and courtyard. French windows flank the front door — one set replaced the original coach house doors and the other set opens from the large dining-room addition. A simple iron balcony with French windows replaced the hayloft door on the second floor. A boxwood hedge encircles the Georgian Bay flagstone pathway. It leads to the front door and two stone patios designed to expand the outdoor living space. A potted flowering hibiscus grows in front of a screen fence designed to partially block the parking area and stone driveway. ABOVE Boston ivy and climbing pink roses encircle an Italian fountain in the formal courtyard. LEFT An antique light salvaged from an old carriage in Montreal replaced the original gaslight on the coach house wall.

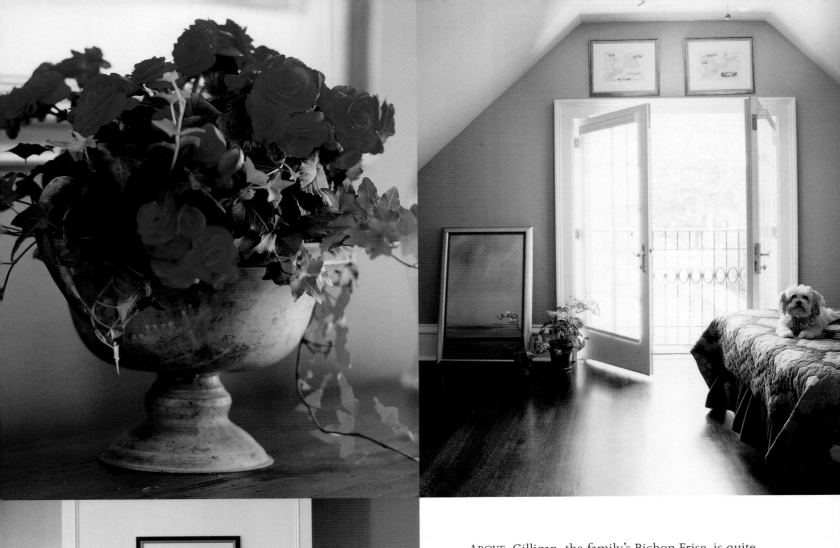

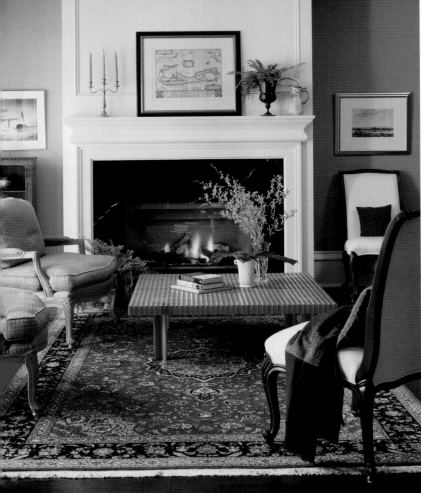

ABOVE Gilligan, the family's Bichon Frise, is quite comfortable on a colourful English garden quilt designed by the owner's mother, who has won international awards for her quilting. Sunshine floods the room and brightens the gleaming oak floors. Two antique maps of Upper and Lower Canada are cleverly placed above the French doors, adding an illusion of height to the sloped ceilings in the guest bedroom. The main house and garden can be seen through the doors of the Juliet balcony, once the hayloft door. LEFT Antique chairs surround a contemporary puzzle table in front of the fireplace in this simple and elegant living room. An antique map of Bermuda from the owner's collection is displayed on the mantel. A rose oriental carpet adds drama and colour to the dark oak floors and neutral tones of the room. OPPOSITE The formal dining room set and an antique Italian oak sideboard create an atmosphere of country elegance in the dining-room addition. A pink oriental fish-patterned carpet and burgundy upholstered chairs complement the rich raspberry-coloured walls and white vaulted ceilings. French windows open onto the courtyard.

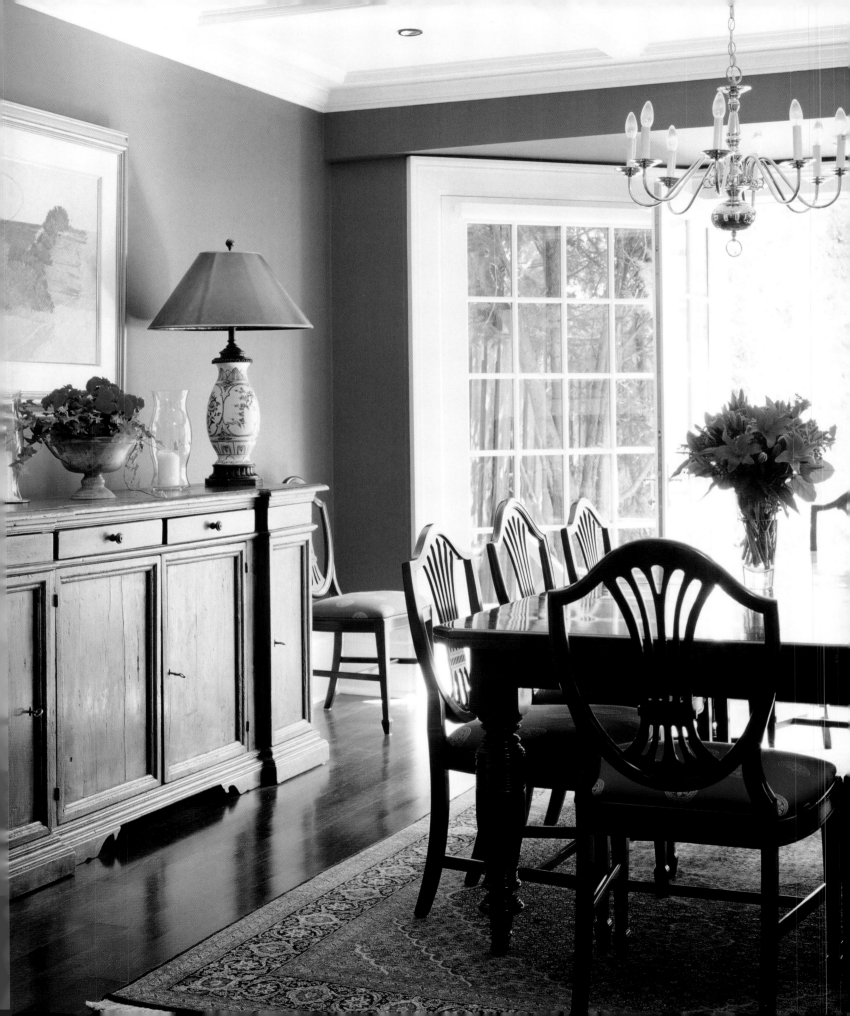

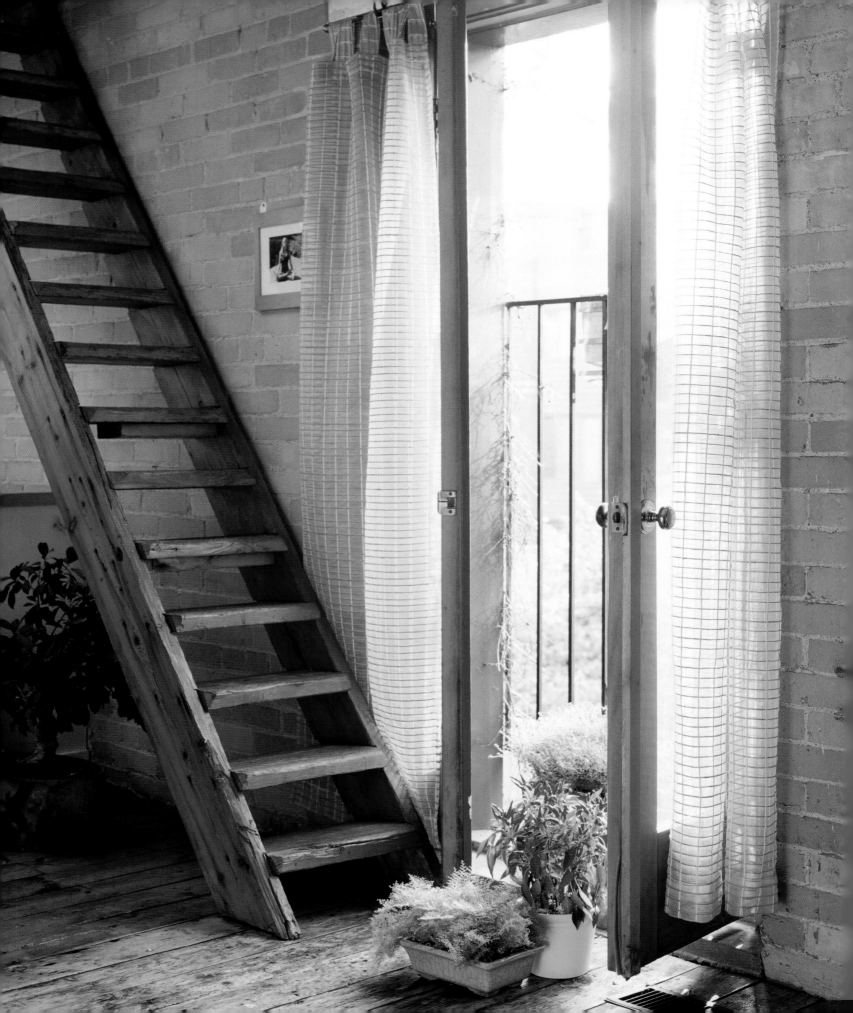

The Yoga Coach House

Built in the mid-1800s as part of a large estate in an area that was simply referred to as "On the Don," this vine-covered coach house once housed prized Clydesdales and the family's carriages, and provided accommodation for the groomsman. The property was later divided and purchased in 1919 by a wealthy scrap-metal dealer, who built his dream home and kept the coach house for his garage. In the early 1960s the coach house was used as a toffee-apple factory until it was purchased in 1972 by Darrell Kent, a local Cabbagetown real estate promoter. He renovated the coach house into a beautiful residence, preserving the exterior, exposing interior brick, refurbishing the original pine floors and dividing the main floor with magnificent oak-panelled doors salvaged from a local building that had been demolished. Today, the Cabbagetown coach house is used by a yoga instructor as a studio and residence for herself, her husband and their new baby.

The 162-year-old pine floors and stairs. The pine stairs lead to the rooftop. French windows and a simple Juliet balcony help retrofit the hayloft.

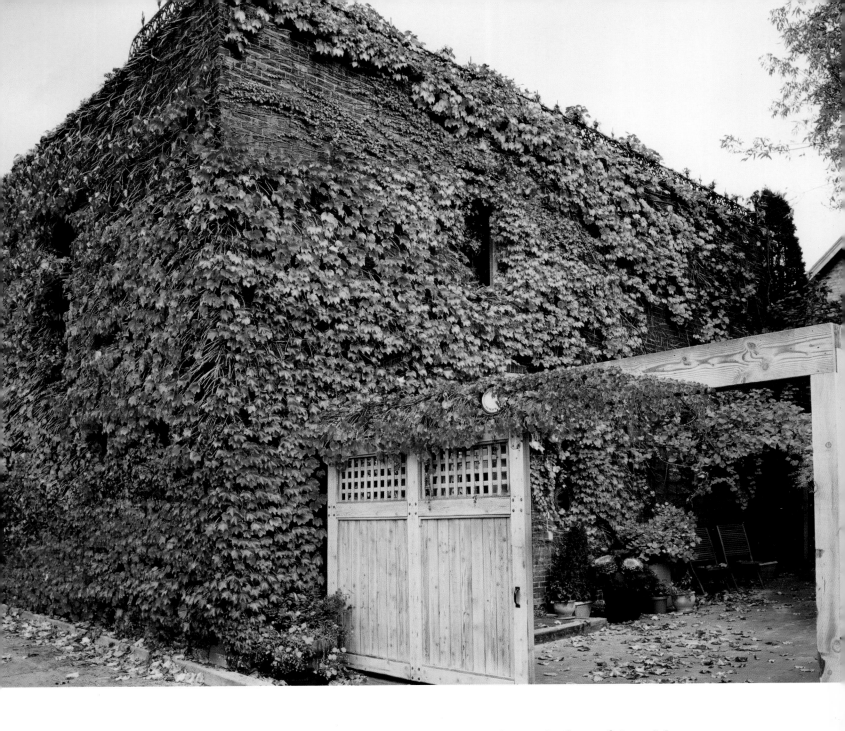

ABOVE Boston ivy completely covers the simple, flat-roofed coach house. A latticed fence provides privacy and defines the entrance off a laneway. OPPOSITE ABOVE A vintage iron table with a potted fern in the delightful leaf-covered courtyard, surrounded by purple flowering kale, rhododendrons and Boston ivy. Large, heavy, double windows are protected by decorative wrought-iron security rails. OPPOSITE BELOW A colourful stained-glass window, surrounded by the beauty of autumn-coloured ivy.

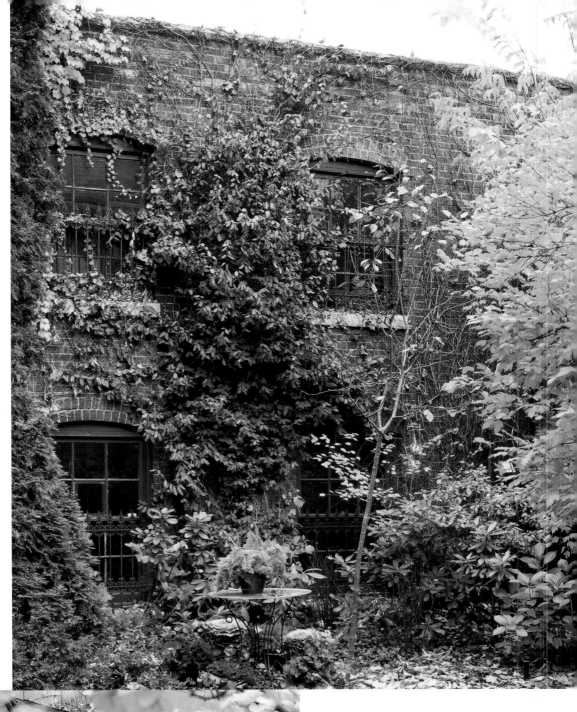

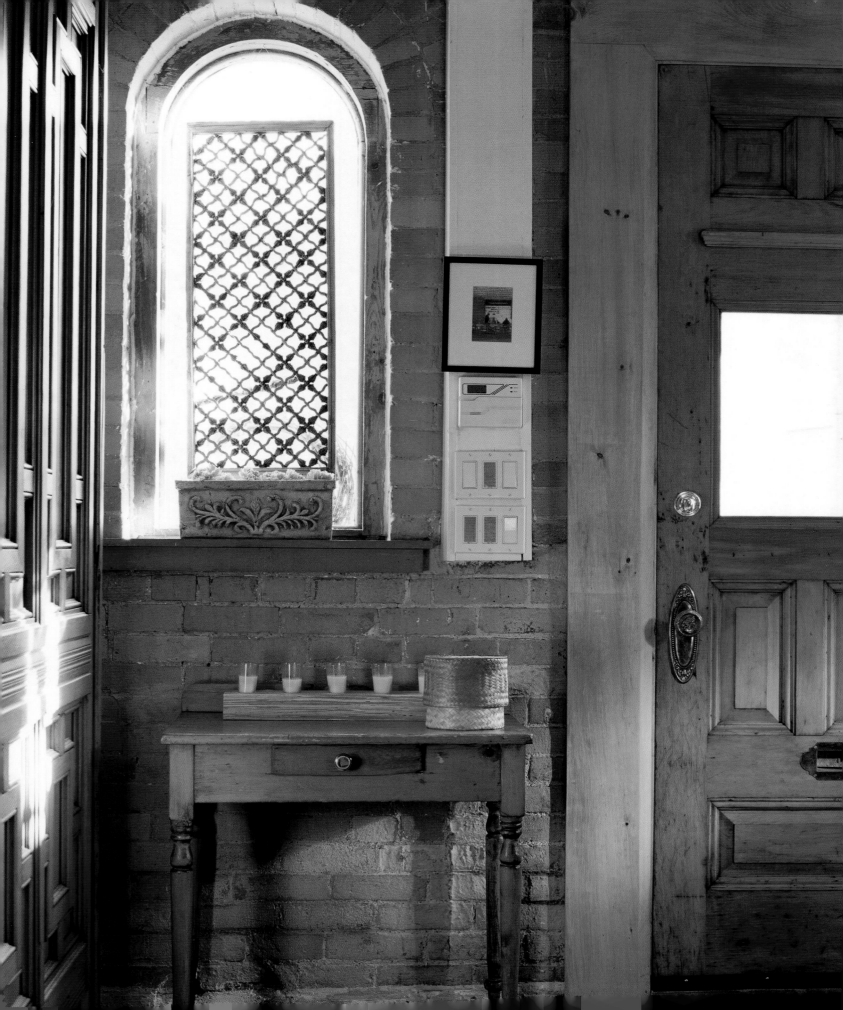

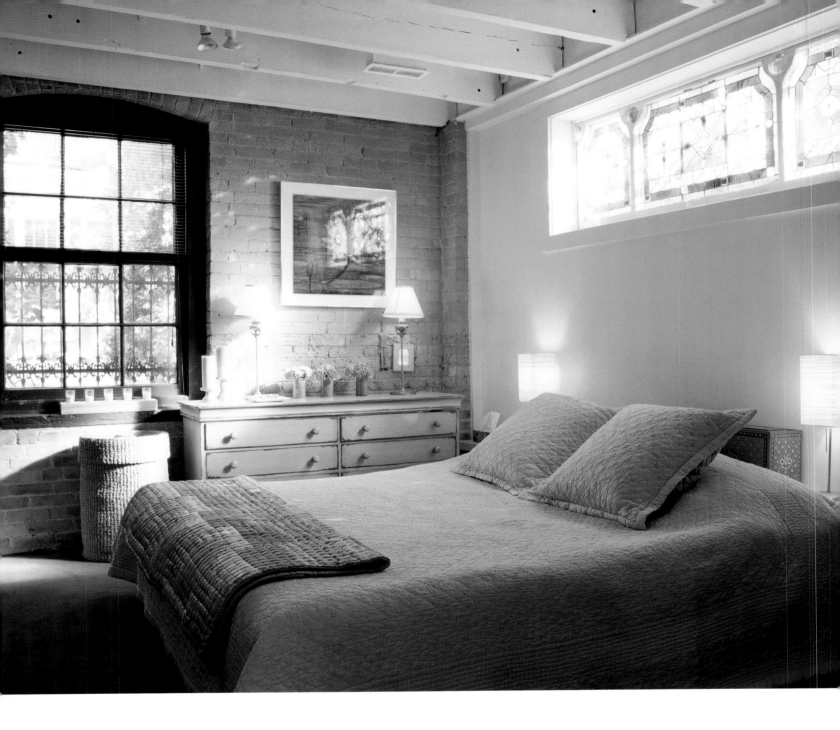

OPPOSITE An Asian antique lattice screen is fitted in the arched window above a pine table in the entrance. ABOVE A hand-sewn provincial mustard-yellow silk bedspread and a patchwork throw, both gifts from the owner's mother's French country shop, add a pure and refined beauty to the master bedroom. An Italian country yellow sideboard and a favourite print placed against the exposed brick wall add to the room's charm. The double sash window is painted a dramatic black. A stained-glass window filters soft light and adds colour to the neutral tones. The original beams are painted white.

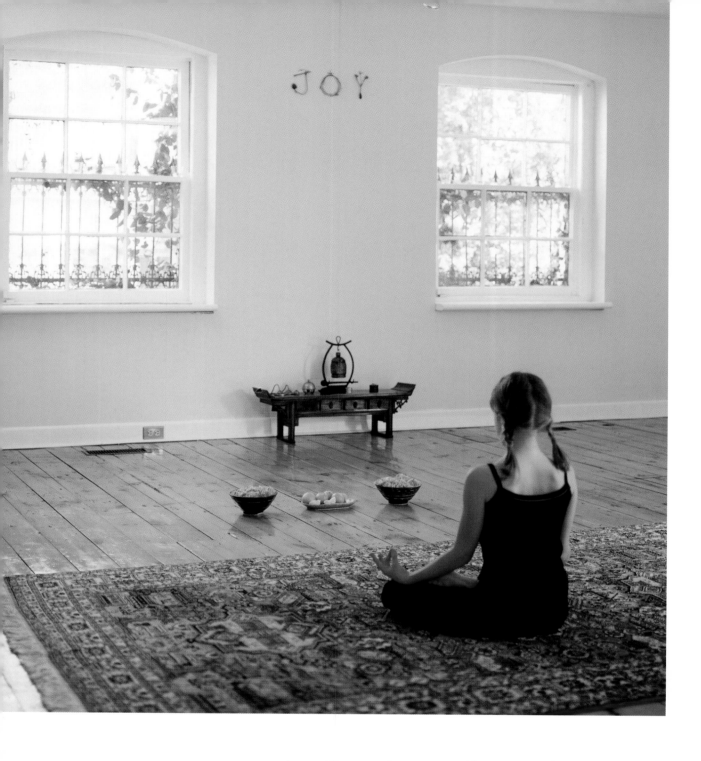

ABOVE The owner's nine-year-old niece sits in lotus position, lost in meditation on a colourful silk Persian rug. A wooden Asian altar with bell and twigs of dried organic plants that spell the word "Joy" is placed between the two double sash windows on the second floor. The pine floor, more than a century-and-a-half old is still warm and welcoming. OPPOSITE A view of the kitchen, taken from the bedroom and living room area, reveals one of the magnificent oak-panelled doors used to divide the first-floor living space. A sturdy pine staircase with steel rails gives a sense of openness to the small area. An antique pine table and a hand-carved wooden bench found in northern Ontario perfectly complement the rustic interior and natural cork floor.

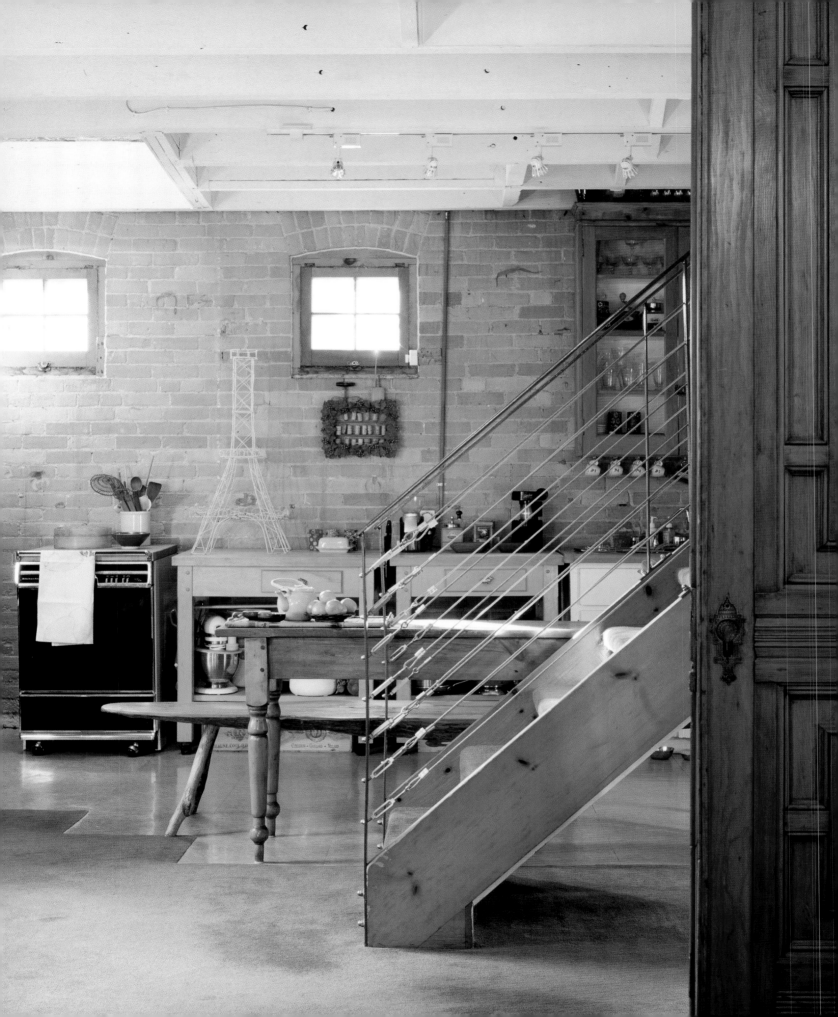

Acknowledgments

Jocelyne Côté-O'Hara, my cousin Tom's wife, was enchanted with the idea of doing a book on coach houses in Toronto. She introduced me to Catherine Mitchell of Tundra Books, which eventually led to the Boston Mills Press. John Denison at Boston Mills gave the go-ahead, and I chose a photographer for the book.

Donna Griffith, the multi-talented photographer whose photographs appear throughout this book, was so helpful. We spent many weekends and afternoons together, walking the streets of Toronto to discover and photograph potential coach houses, cataloguing over fifty. Donna also introduced me to colleagues Sabrina Linn, an interior decorator; Jennifer Reynolds, a garden specialist; and Alice Unger, an art director, who eventually became part of our team.

John Fortney, a young, successful Toronto real estate agent, spent hours driving Donna and me through the enclaves of Rosedale, the Annex, Forest Hill and Cabbagetown, pointing out beautiful coach houses to consider for the book.

My research for the coach houses that Donna and I chose began with a phone call to Kathryn Anderson at Preservation Services in Toronto. She provided me with a copy of the City of Toronto Inventory of Heritage Properties and suggested that I visit the Toronto Reference Library. With the help of friendly staff, I was able to access information on many of the addresses, including building dates, architects, original resident of the main house and articles written in the *Globe and Mail*, the *Toronto Star*, *Canadian Homes and Gardens* and the *National Post*.

An owner of one of the coach houses introduced me to Patricia McHugh's book, *Toronto Architecture: A City Guide*. Her book catalogued many of the addresses, giving me interesting tidbits to add to my stories. *Old Toronto Houses*, by Tom Cruickshank and John De Visser, was also an enjoyable source of information.

My greatest source of information was the owners of the coach houses themselves. Each owner had his or her own story to tell, which included an array of facts, family history, rumour and gossip. I was delighted that they allowed Donna and me into their homes but I was also overwhelmed by their generosity and willingness to share with us their personal space and family stories. At the end of the photographic sessions and my subsequent interviews, I came to the conclusion that we all had much in common — are all people who seek out our own paths and are happy to talk about them.

I met with a number of Toronto architects, who were very helpful in defining architectural details and helping me sort out fact from hearsay. I would like to thank Christopher Tweel of Tweel Architects for "The Advertising Executive's Residence" and his overall review of the book, Adam Smuszkowicz of Spacial Concepts for "Home Away from Home" and "The Grand Garage," Henno Sillaste of Sillaste Architects Inc. for "Down on the Farm," and Michael McClelland of E.R.A. Architects Inc. for his contributions.

Deedee Hanna of Taylor Hanna Architects, Brian Gluckstein of Gluckstein Design, and Sylvia Berg of Bergdon Galleries provided expertise on design details. Antoine Quellette of Accent on Eclectiques provided his expert advice and help in identifying antiques and artifacts for "The French Gallery." The friendly staff at Sheridan Nurseries were helpful in identifying floral elements in the beautiful gardens of many of the coach houses.

Sarah Sheard provided interesting information on the Coach House Press in her April 1997, *Toronto Life* magazine article, "Echoes Without Saying." And Joan Crosbie, curator at Casa Loma, provided interesting facts on the stables and coach house of Casa Loma.

Jack Panozzo, a multi-skilled editor, agreed to edit the first drafts, and John Denison at Boston Mills Press made the project come to life.

Most of all, I must thank my husband, Brian, for his constant encouragement and support. His words were so comforting, especially during the long hours of research when conflicting information or lack of it made the project seem overwhelming.

Thank you all for your contributions.

— Margo Salnek

First of all, I must thank Margo Salnek for dreaming up such a charming project and for asking me to collaborate with her. The experience was often challenging but always rewarding.

I was fortunate to have the help of these talented colleagues to enrich the shoots: Sabrina Linn is a Toronto stylist and interior designer who has worked with many Canadian home decor magazines.With her impeccable taste and eye for detail, she helped bring the rooms together and made the already remarkable interiors shine.

Toronto garden specialist and designer Jennifer Reynolds is well known for her appearances on gardening shows and articles in magazines. Jen brought the gardens alive with the generous support of Summerhill Nurseries. I would like to thank her for the many very early mornings she spent coaxing the gardens into all their splendour.

Alice Unger is a respected Toronto art director whose work with many Canadian magazines has won her awards and accolades nationwide. It was an honour to have her design this book.

Many thanks to Charles Chiu of Colourgenics Photo and Digital Imaging for his more than generous support.

My faithful assistant, Susan Toth, energetically helped on all the shoots, enduring sub-zero temperatures, the dubious joys of the crack of dawn and many hours on the computer. Her cheerful contribution was invaluable.

For his faith in this project and the opportunity provided, many thanks to John Denison.

Thanks to my partner, Kirk, for everything.

— Donna Griffith

Sources

Avery, Simon. "A Mansion Sold Bit By Bit," *Globe and Mail*. Toronto: May 9, 2003

Beszedits, Stephen. *Eminent Toronto Architects of the Past, Their Lives and Works*

Blumenson, John. *Toronto Star*. Toronto: Jan. 12, 2002

Carroll, Joy. "Looking For a Discreet Status Symbol? Find an Old Stable," *Macleans*. Toronto: July 23, 1966

Cruickshank, Tom, and John De Visser. *Old Toronto Houses*. Toronto: Firefly, 2003

Jukes, Mary. "Coach Houses Have a Many-faceted Appeal," *The Woman's Globe and Mail*. May 13, 1965

MacKinnon, Donna Jean. *Toronto Star*. Toronto: May 15, 1986

McHugh, Patricia. *Toronto Architecture: A City Guide*, 2nd ed. Toronto: McClelland & Stewart, 1989

Sheard, Sarah. "Echoes Without Saying." *Toronto Life*. Toronto: April 1997

Architectural Index for Ontario

The Toronto Reference Library

Joan Crosbie, Curator, Casa Loma

Heritage Toronto: The City of Toronto's Inventory of Heritage Properties

Index